JOHN SEVIER

TENNESSEE'S ★ FIRST HERO

GORDON T. BELT

WITH TRACI NICHOLS-BELT

THE
History
PRESS

Published by The History Press
Charleston, SC 29403
www.historypress.net

First published 2014
Second printing 2015

Manufactured in the United States

ISBN 978.1.62619.130.3

Library of Congress Cataloging-in-Publication Data

Belt, Gordon T.
John Sevier : Tennessee's first hero / Gordon T. Belt with Traci Nichols-Belt.
pages cm
Includes bibliographical references and index.
ISBN 978-1-62619-130-3
1. Sevier, John, 1745-1815 2. Governors--Tennessee--Biography. 3. United States--
History--Revolution, 1775-1783--Biography. 4. Legislators--United States--Biography. 5.
United States. Congress. House--Biography. I. Nichols-Belt, Traci. II. Title.
E302.6.S45B45 2014
976.8'03092--dc23
[B]
2014006739

CONTENTS

PREFACE

The revival of memory may be a benevolent compensation to an old man for the loss of hope.
Michael Woods Trimble, 1860

In an anecdote popularized by the nineteenth-century novelist James Gilmore, an old man reminisced about his youthful encounter with Tennessee governor John Sevier. Embellishing the old man's memories with romantic prose, Gilmore wrote of the "unbounded affection and admiration" that this young boy held for the man known fondly by the frontier people as "Nolichucky Jack." As Sevier arrived, the entire town gathered to greet him, and Gilmore recorded the old man's recollection of the scene:

> *Soon Sevier came in sight, walking his horse, and followed by a cavalcade of gentlemen. Nobody cheered or shouted, but all pressed about him to get a look, a smile, a kindly word, or a nod of recognition from their beloved Governor. And these he had for all, and all of them he called by name; and this, it is said, he could do to every man and woman in the State, when they numbered more than a hundred thousand. The boy's father had been a soldier under Sevier, and when the Governor came abreast of him he halted his horse, and took the man and his wife by the hand. Then reaching down, and placing his hand on the boy's head, he said: "And who have we here? This is a little fellow I have not seen." That he was noticed by so great a man made the boy inexpressibly proud and happy; but could this affable, unassuming gentleman*

*be the demi-god of his young imagination? This was the thought that came to
the boy, and he turned to his father saying, "Why, father, Chucky Jack is only
a man!" But that was the wonder of the thing—how, being only a man, he
had managed to capture the hearts of a whole people.*[1]

Traditional stories like these helped build Sevier's standing as a celebrated
frontiersman, a revered military leader of the Revolutionary War, a respected
and feared Indian fighter and an admired politician and founding father
of the state of Tennessee. Pioneer, soldier, statesman: Sevier embodied all
the patriotic qualities that his chroniclers hoped to impart to the public.
Yet as Gilmore's anecdote reminds us, Sevier remained "only a man," and
although he commanded a strong regional following, Sevier's reputation
never achieved national acclaim.

In 1860, another aging pioneer named Michael Woods Trimble recalled
memories of his father, John Trimble, who served as a captain of a
militia company in the regiment under Sevier's command at the Battle of
King's Mountain. Michael Woods Trimble took great pride in his father's
associations with Sevier, and in his memoirs, he endeavored to recall the
stories of his youth. Trimble wrote:

*As I grow old, my memory grows stronger. Especially in this case with
regards to the events of my early life. Things which had faded away from
my mind many years ago, and had passed into forgetfulness, are revived
with all the freshness of recent occurrences. Images of the dead come back to
me with faces and voices as familiar as when they lived, and all the scenes
through which I passed with them appear to me with more vividness than
the events of yesterday. This revival of memory in old age is a mysterious
and wonderful provision of Divine Providence. At my period of life, the
hopes of this world are nearly all past. But it is said, when one bodily
sense is lost, some other becomes strong. The revival of memory may be a
benevolent compensation to an old man for the loss of hope.*[2]

Over time, as Sevier's aged contemporaries passed on, his frontier adventures,
military achievements and political accomplishments faded from the public's
collective memory. During the late nineteenth century, however, Sevier
managed to capture the hearts of his people once more. Years after his death in
1815, Tennessee historians and popular writers attempted to resurrect Sevier's
legacy through highly romanticized accounts of his frontier adventures, relying
heavily on the folktales, myths and recollections of aging pioneers. Through

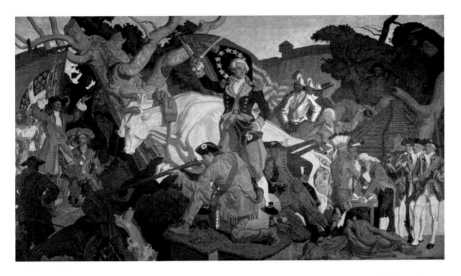

In this allegorical depiction of early Tennessee history, John Sevier is the central figure in Dean Cornwell's colorful mural *Discovery*. *Tennessee State Library and Archives*.

the memories of these elderly frontiersmen, authors and antiquarians retold the tales passed down by the descendants of Sevier and his compatriots, giving these stories a scholarly gravitas that endured for generations. Following the Civil War, the period of Reconstruction brought forth efforts of reconciliation by Southern writers who used stories from Sevier's remarkable life to mend the wounds of a broken nation. Subsequent biographers and storytellers repeated these narratives and chronicled Sevier's life in ways that reflected America's culture of patriotism and its embrace of rugged individualism.

By the early decades of the twentieth century, however, the nation's culture had changed. Global war, economic chaos and what one contemporary scholar termed "the intrusive thrust of modernism" led many writers to bring the past "down to non-heroic yet human proportions."[3] A new generation of chroniclers attempted to debunk the myths and legends surrounding Sevier's achievements. The Tennessee historian Dr. Carl S. Driver endeavored "to place this frontier hero in proper perspective" in his 1932 biography, *John Sevier: Pioneer of the Old Southwest*.[4] In his book, Driver acknowledged that "few attempts have been made to discover if the glamour and romance which surrounded [Sevier's] name have had a real or an idealized character as their source."[5] Yet the nostalgic remembrances of the past endured.

Still, Sevier remained a regional historical figure, and the stories of his achievements never resonated beyond the borders of his native land. In the

preface to the reprint edition of Driver's biography, the author's widow, Leota Driver Maiden, surmised why Sevier failed to achieve national recognition:

> *Sevier's primary interest always remained the advancement of his own State and its people. Consequently, he suffered the same neglect as other public figures who were overshadowed by the acclaim of a national hero, General Andrew Jackson. In the adulation of their first President, too many Tennesseans forgot the man who had protected the early settlements from annihilation by the Indians and later as its Governor guided their State through twelve of its first fourteen years.*[6]

Driver christened Sevier "Tennessee's first hero,"[7] and yet he remained second in the hearts and minds of his fellow Tennesseans. Jackson so dominated the annals of Tennessee's history that his influence shaped how scholars and writers remembered Sevier for generations. Thus, more than eighty years after Driver first published his biography, Sevier's story continues to elude remembrance.

Sevier's chroniclers defined his legacy as much as Sevier himself. This book aspires to draw attention to Sevier's extraordinary life once more through their narratives. By examining their use of oral traditions, storytelling, folklore, anecdotes, family narratives and historical accounts, this work seeks to achieve a greater understanding of Sevier's life and legacy. Though not purely chronological, this book views Sevier's life as a Pioneer, Soldier and Statesman through the lens of history and memory, from beginning to end and from beyond the grave.

While the narratives of Sevier's life portrayed a man who received universal adoration from the people, Sevier faced enemies throughout his life. This book also explores these conflicts, particularly the violent dispute between Sevier and John Tipton and Sevier's political rivalry with Tennessee's most celebrated hero, Andrew Jackson. Furthermore, the feud between Theodore Roosevelt and James Gilmore over their historical interpretations of Sevier's life provided an additional layer of conflict worthy of exploration.

A number of scholars and writers informed and inspired this book. In addition to Dr. Driver's work, John Haywood's *Civil and Political History of the State of Tennessee* and J.G.M. Ramsey's *The Annals of Tennessee* represented two pillars of literary achievement on which all subsequent scholars and writers have based their works. These two men were among the first antiquarians who chronicled Sevier's life, and while the affection they shared for Sevier colored their words, the portrait that emerged from their writings left an indelible impression on the canvas of Tennessee history and this volume.

Lyman Draper's resolute pursuit of the aged pioneers of the Old Southwest and their descendants produced the most tangible and direct connection to this unique time and place in American history. He published just one volume. Yet that work, *King's Mountain and Its Heroes*, and his collection of manuscripts documenting the history of the early American frontier stand as a monument of colossal achievement.

I must also extend a debt of gratitude to the Sons and Daughters of the American Revolution. Their acts of remembrance and monuments to Sevier's memory kept his legend alive in the hearts and minds of Tennesseans throughout the years. Their efforts provided me with ample stories to read and analyze for this volume.

More recent scholarship also contributed to my knowledge about Sevier and his chroniclers. Among these writings, Michael Lynch's research on the Battle of King's Mountain helped place the myths and legends surrounding Sevier's role in this "turning point" in the American Revolution into scholarly perspective.[8] Kevin Barksdale's scholarship also proved to be an invaluable resource, especially in its analysis and historical interpretation of Sevier's ill-fated Franklin statehood movement.[9]

Many of Sevier's chroniclers bemoaned the lack of published writings about this important regional figure, but I found no shortage of material. The Tennessee State Library and Archives proved particularly helpful, both as a storehouse of primary- and secondary-source material and as an intellectual resource. My professional colleagues at this institution helped guide me through the labyrinth of records detailing Sevier's life and career, and for their aid and encouragement, I am grateful.

I also want to acknowledge the readers of my blog, The Posterity Project. Over the years, they have demonstrated an enduring interest in Sevier's life, inspiring me in my journey to learn more about "Tennessee's first hero." Additionally, I am indebted to my publisher, The History Press, and its editors, who helped shepherd this project to completion.

Most of all, I thank God for His many blessings in my life. I am particularly thankful to my family for their love and support. One especially deserving of mention is my wife, Traci, who served as my editor and coauthor. I cannot begin to give her enough credit for instilling within me the confidence to pursue this project and for her patience and attention to detail in her critique of my work. Traci's love, encouragement and support led me through times when I felt the task before me seemed too daunting. Without her, this book would have never seen the light of day.

PART I
PIONEER

1

PIONEER BOY AND SON
OF TENNESSEE

When a boy reads the biography of a great man, he is especially interested in the hero's boyhood days—his joys and sorrows, struggles and victories; and he is always disappointed if nothing has been said about that period of his life.
Francis Marion Turner, 1910

Besides John Sevier's birth in 1745 and that he was raised in the Shenandoah Valley of Virginia, the historical facts concerning Sevier's earliest years remain a relative mystery. In the most scholarly account of Sevier's life, historian Carl Driver wrote only one paragraph describing Sevier's childhood. He briefly noted his date of birth, his siblings and where he attended school but little else.[10] Other more lengthy narratives of Sevier's family focused on his parentage and ancestry and described a man descended from French Huguenots who possessed the most gentlemanly of qualities. Tennessee's eminent nineteenth-century historian, J.G.M. Ramsey, described Sevier as a man who "inherited some of the vivacity, ease and sprightliness of his French ancestry." Ramsey added, "He was fluent, colloquial and gallant—frolicsome, generous and convivial…He was impulsive, but his impulses were high and honorable. The Chevalier and the Huguenot were combined in his character."[11]

Subsequent scholars and writers repeated Ramsey's narrative, often with literary embellishments, but they offered very little insight into Sevier's childhood. In the preface of the 1910 book *Life of General John Sevier*, Francis Marion Turner lamented:

When a boy reads the biography of a great man, he is especially interested in the hero's boyhood days—his joys and sorrows, struggles and victories; and he is always disappointed if nothing has been said about that period of his life. The fact that the youthful period of Sevier's life had been neglected, led me to write this little volume. During my school days, when I read about the wonderful battles which General Sevier fought with the dusky warriors of the forest, and about the terrible clash with the British at King's Mountain, I wondered about his boyhood days. Later I was disappointed to find that the biography of an American hero, a man who had been instrumental in turning the tide of the Revolution at King's Mountain, had been sadly neglected. In all my investigations I could not find a book that furnished the information I was seeking.[12]

Turner devoted a generous portion of the first chapter of his book to Sevier's early years. He described young Sevier's fondness for living on Virginia's frontier, his hunting prowess, his education and his work as a clerk in his father's mercantile store. Turner also commented on Sevier's youthful encounters with the Native American population, stating, "A great many wild tales are told of Sevier's fights with the Indians in his youth; and, while we cannot rely upon them all as true, we do know that he grappled with the dusky fellows while yet in his teens."[13] It is worth noting that while Native Americans were significant actors in the history of the region, historians and antiquarians of the late nineteenth and early twentieth centuries held them in low regard. These historians utilized derogatory terms such as "dusky warriors" and "savages" as common descriptions to characterize the native population at that time.

With so little written of Sevier's childhood and adolescence, the lines between truth and legend easily blurred, leaving fertile ground for fiction writers and novelists to fill the void that scholars left behind. Sevier's frontier exploits as an adult served as inspiration for a number of writers, who concluded that much like his adult life, Sevier's boyhood must have been full of action and adventure. William O. Steele was one such writer. Born in 1917 in Franklin, Tennessee, Steele authored several nonfiction books and biographies of well-known explorers, such as Daniel Boone, Leif Ericson and Hernando De Soto, but he achieved renown as an award-winning author of historical fiction for children, particularly fiction set in the eighteenth-century frontier of Tennessee.[14]

Steele's 1953 book, *John Sevier: Pioneer Boy*, envisioned young Sevier as a brave adventurer, an ambitious conqueror of the frontier and a leader of

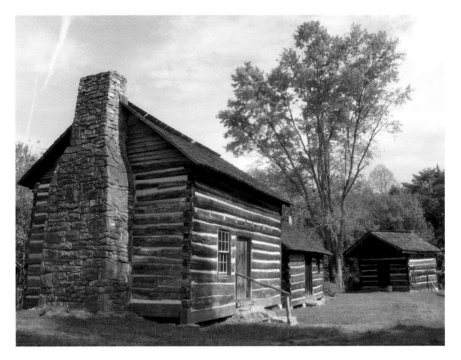

Marble Springs, John Sevier's plantation home from 1790 until his death in 1815. *Author's collection.*

men. In one of the earliest chapters of his book, Steele created a fictional dialogue between Sevier and his brother in which Sevier dreamed of becoming a great Indian fighter. "When I get big…I'm going to be a great fighter and win a hundred Indian battles!" Sevier exclaimed. "I'll make all the Indians run far, far away. Then white people can come in here and settle. Pretty soon this country will have many farms and towns."[15]

Steele's earlier works received criticism from reviewers for their stereotyped treatment of American Indians. In subsequent books, the author made attempts to remedy this by writing more sympathetic accounts of Indian life. Steele's *Pioneer Boy*, however, retained the imagery of his previous novels, with white settlers portrayed as heroes and Indians cast in the roles of villains.[16]

In another scene in his book, Steele created a scenario in which John's father considered abandoning his merchant store on the frontier for Fredericksburg because thieves stole too many supplies during the night. Young John overheard this conversation between his father and mother and reacted with defiance:

"This is the first land you've ever owned, Father. You said so once. You've got to keep it. It's good rich land. When more people come here to the frontier, you could sell it for a big price...They come by your store all the time. Hunters. Men with their families. You said you see new people every day heading south through our valley. And frontiers need stores. Folks have got to have a place to trade. What will they do if you run off and leave them now?" John stood straight and looked very serious as he made his speech. Mr. Sevier pursed his lips to keep from smiling. "Why," he thought, "the lad looks and talks like a boy twelve or fourteen years old, instead of six and a half!"[17]

Steele's fictionalized account of Sevier drew on every frontier legend and exploit ever written about him. He used the stories of Sevier's adventures as an adult as literary inspiration and painted a portrait with words that described the youthful Sevier as a brave and adventurous boy eager to claim his birthright as "Tennessee's first hero."

Other fictionalized accounts of Sevier's youth also drew on legendary tales and exaggerated historical accounts. In the first chapter of Katharine Wilkie's book *John Sevier: Son of Tennessee*, the author admiringly described Sevier as a boy with an adventurous spirit. In one particular scene, Wilkie wrote lovingly of Sevier through the eyes of his mother, Joanna, who daydreamed of her son's greatness while gazing at her children at the dinner table:

All their sons were strong and handsome, but there was something special about John, their first-born. She could not name it, but it was there. A joie de vivre that would not be denied. He always led his brothers and sisters, and yet they felt no jealousy. In every situation he was a few steps ahead of them. She pictured him, a grown man, as he would have been nearly two centuries ago at the court of Henry of Navarre, whom her husband's ancestors had served. No other nobleman could match blades with him.[18]

In another scene in Wilkie's book, the Sevier family received a warning of Indians on the warpath nearby. Soon, father Valentine gathered his brood and told them that they must temporarily abandon their home for the safety of the town of Fredericksburg. John, beside himself, exclaimed, "Father! We can't leave the tavern and the store unprotected...I don't want to run away. I'd like to stay right here, Indians or no Indians."[19]

Despite his protests, Valentine Sevier ushered his family to Fredericksburg, where John quickly became disinterested with the drudgery of town life. The

routine of school also bored him. "The wilderness is my world," John said stubbornly. "The bear and the elk—or the Indians—won't ask me if I can read Latin and Greek."[20]

Sevier's reputation as a daring adventurer inspired yet another fiction writer. John T. Faris, a prolific travel writer, newspaper editor and clergyman, published *Nolichucky Jack: A Thrilling Tale of John Sevier* in 1927. In his book, Faris noted that "the Indians held [John Sevier] in wholesome dread, but the hardy frontiersmen loved him." Faris loved Sevier so much that he proclaimed him, "the greatest Indian fighter of pioneer days, hero of thirty-five victorious battles with the savages."[21]

Again, using stories of Sevier's frontier adventures as inspiration, Faris wrote a fantastic tale from Sevier's youth in his first chapter, "A Pioneer Boy at School." After a warning of an imminent attack from Indians, the Sevier family took refuge in a nearby fort. A nine-year-old Sevier encountered one of the Indians trying to enter the fort. He instinctively reached for a pile of sharpened stakes, stabbed the intruder in the head and killed him instantly. Young Sevier dragged the body into a cellar, where his father exclaimed, "Look at his head-dress! The boy has bagged a chief!"[22]

In his introduction, Faris stated, "In all important particulars, the main incidents of Nolichucky Jack's life were as they are pictured in this volume." He admitted, however, to taking "slight liberties" with some historical facts, including an encounter with a young surveyor named George Washington.[23] Inspired by extracts from Washington's diary, Faris chronicled this meeting through a fictionalized letter young Sevier sent to his father. Faris wrote, "To-day I saw a Man who says his name is George Washington. He has seen much of ye world. He told me some of his Adventures when he was surveying beyond ye Blue Ridge, on ye Shannondoah [*sic*] River, for Lord Fairfax."[24] Faris dismissed anyone who might doubt his story. "It is possible that some extreme literalist will say that there is no proof that the young man Washington visited Staunton at the period indicated," Faris wrote. "Can they prove that he did not do so?"[25]

The tales of Sevier's frontier exploits, first penned on paper by antiquarians and early Tennessee historians, provided a model for these popular storytellers. Novelists and writers drew inspiration from these historical narratives, creating fictionalized accounts of Sevier's early life and further cementing his reputation as an Indian fighter and a fearless leader of men. Through these fantastic stories, Steele, Wilkie, Faris and others sought to elevate Sevier's legend in the nation's collective memory far beyond the pages of history.

2

THE FORGOTTEN HEROINE

A philosopher has said that [at the] *"back of the success of every man lies the heart of a woman."*
E.E. Patton, 1946

As John Sevier entered adulthood, he set his sights on building a life of his own on the western edges of civilization. The early chroniclers of Sevier's life wrote of his fondness of the wilderness beyond the mountains of Appalachia and of his love for adventure, and as more contemporary scholars pointed out, the acquisition of land proved to be an overwhelming motivation.[26] While the border country captured Sevier's imagination, a young lady named Sarah Hawkins captured his heart.[27] Their union helped to establish Sevier as a frontier hero in the pages of history and set him on a path to future greatness.

Born in 1746 in the Shenandoah Valley of Virginia, Sarah was Sevier's first wife and "the first love of his youth." Many recalled that Sarah possessed a "great strength of character" and was a "wise, capable, understanding wife and mother who commanded her husband's post in his absences."[28] Sarah married John at the age of fifteen, and in 1773, she joined her husband on the arduous journey from the Shenandoah Valley of her birth to the wilderness of the Watauga Valley, in the region known today as East Tennessee. During John and Sarah's life together, she bore ten of his children and shared in his hardships on the frontier.[29] She even helped to foil a plot to assassinate her husband by a "noted and infamous Tory" whose wife divulged the plan to

Sarah "after receiving favors [a quart of meal and a slice of meat] from the [Sevier] family."[30]

Sarah, according to one family biographer, "was for the nineteen creative, formative years of [John Sevier's] life the greatest single factor in his spectacular early rise to fame and fortune."[31] Yet memory of her life with Sevier faded over time. Historians failed to adequately chronicle her place in Tennessee history, and so the mission of remembrance fell to her descendants, most notably to the Daughters of the American Revolution (DAR).

The National Society of the DAR believed it their patriotic duty "to perpetuate the memory and spirit of the men and women who achieved American Independence." The Tennessee chapters of the DAR, in particular, proved instrumental in raising funds and securing land for memorials and markers dedicated to preserving Sevier's memory.[32] Sarah's story encompassed one important chapter in Sevier's life, and the DAR committed to preserve her contributions for posterity.

In a brief biographical sketch published in 1934 entitled *Sarah Hawkins: The Forgotten Heroine*, Jennie Prather Hyde, recording secretary, Old Glory Chapter DAR, Franklin, Tennessee, described Sarah as "a tender, delicate young lady, and her delicacy and pure modesty constituted the youth's ideal."[33] In her biography of Sarah, Hyde emphasized the hardships of life on the frontier and Sarah's steadfast loyalty to her husband:

> *It has always been a subject of speculation as to why Sevier removed to these extreme frontier settlements. In all this restlessness of his life are we losing sight of the dangers and sufferings of Sarah and her little family? A heroine indeed was she and we honor and respect her for her courage during those frontier times, for men and women had to have physical courage, facing the many dangers and hardships. Disasters which break down the spirit of a man, seem to call forth all the energies of the softer sex and give to them courage and fortitude; this can be truly said of Sarah Hawkins.*[34]

Hyde added, "Time has wrought many changes as we look at the type of young womanhood of today."[35] This fascinating account not only detailed the efforts to memorialize a "forgotten heroine" but also spoke to how society, and more specifically how the DAR, viewed women's roles during the early to mid-twentieth century. During this time, ladies of the DAR resurrected Sarah from the forgotten realm of history as a civic duty and source of feminist pride.

In 1945, near the end of World War II, Sarah's descendants began an effort to memorialize her life as a tribute not only to her but also, by extension, to women throughout our nation's history. Another Daughter of the American Revolution, Mary Hoss Headman, led one such effort. Headman, a great-great-granddaughter of Sarah and John Sevier, asked the Knox County Court for permission to erect a monument to Sarah on the courthouse lawn.

Headman became a passionate advocate for her ancestor and believed Sarah Hawkins Sevier deserved public recognition for her accomplishments. She argued that "Sarah Hawkins Sevier inspired Sevier, helped him to become great and stood by him against Indian attack[s] in East Tennessee."[36] In an interview for the *Knoxville News-Sentinel*, Headman stated that she had learned from "old court records" and "depositions taken from Sevier's and Sarah's descendants" that while Sevier led raids against the Indians, Sarah "was left to defend the fort." According to Headman, on one particular occasion, "Sevier had taken all the powder and bullets with him, so Sarah spent all the next day with her two young brothers molding more bullets to ward off the Indians when they attacked in Sevier's absence." Headman also claimed that "it was Sarah Hawkins who inspired and financed John Sevier to give him his start in the wilderness." Producing a will found among documents held in a Virginia courthouse, Headman stated that Sarah's father, Joseph Hawkins, a wealthy trader, left "an enormous estate" to his daughter, and according to Headman, "Sevier shared in it."[37]

Headman's drive and ambition to create a fitting memorial to her great-great-grandmother led her to pursue every avenue within her reach for support. "We hope to raise the money from the state, but if we don't then the Daughters of the American Revolution will subscribe the amount. Perhaps the county will want to help," Mrs. Headman said, adding, "We will raise the money in 1945 and will dedicate the monument in 1946, the 200th anniversary of Sarah Sevier's birth."[38]

A little more than two weeks later, on January 17, 1945, the Knox County Commission approved Headman's plan. The East Tennessee Historical Society also voiced its support. Plans commenced to erect a monument next to her husband's memorial and that of his second wife, Catherine "Bonny Kate" Sherrill, on the sesquicentennial of Tennessee's admission to the Union in the following year.[39]

By June 3, 1946, Headman's goal of erecting a monument to the memory of Sarah became a reality. On that day, the city of Knoxville observed "Sarah Hawkins Sevier Memorial Day." Newspaper accounts of the dedication stated that Headman held the high honor of unveiling the

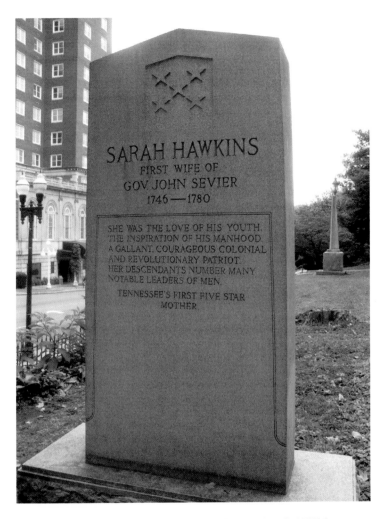

Marker dedicated to the memory of Sarah Hawkins (1746–1780) in Knoxville, Tennessee. *Author's collection.*

monument. The words engraved in stone declared Sarah "a gallant, courageous Colonial and Revolutionary patriot" and proclaimed her as, "Tennessee's first five-star mother."[40]

As DAR officials and dignitaries of state government rose to speak, each evoked the name of Sarah's famous husband time and again in their praise. Even on her special day, Sarah remained a "forgotten heroine" until the closing moments of the ceremony, when Sevier family descendant Frank J. Price Jr. read the following poem as a tribute to Sarah Hawkins Sevier:

She fought the fight—
And through her blazing faith
Kindled eternal fires that ne'er shall die.
Wherever free men walk, their path is bright,
Illuminated by the torch she held so high.

Her body frail—
Yet, fired with spirit bold
Enough to tame a wilderness untrod;
She led her children through an unblazed trail
And gave their future to Almighty God.

Where tough-hewn men
Inured to grief and pain
Fought to extend and hold a wild frontier
'Twas she who spurred them on and on again—
True spirit of the valiant pioneer.

To us who hold
This Mother of our Clan
Immortal, in her own exalted place,
Her story lives inscribed in purest gold—
The pride and inspiration of her race.[41]

Sarah died in the early months of 1780.[42] According to Sevier family historians, Sarah had just given birth to their tenth child when news of an imminent Indian attack reached Sevier's settlement. Although Sevier ushered his family to the safety of a fort located on the banks of the Nolichucky River prior to the assault, in her weakened state, Sarah did not survive the journey. As midnight approached and anticipating an attack at dawn, several men slipped out of the fort into a nearby forest and dug Sarah's grave. As the family's descendants dramatically recalled this story, "Sevier declared that all the children must be present to show respect for their mother, even the newborn baby. So there in the heart of a forest of darkness, gloom and pouring rain, amid flashes of lightning and claps of thunder, John Sevier laid to eternal rest Sarah Hawkins."[43]

Soon afterward, Sevier married a young lady whom he had first met four years earlier during another Indian uprising at Fort Caswell on the Watauga. On that fateful day, Sevier's chance encounter with Catherine Sherrill—a

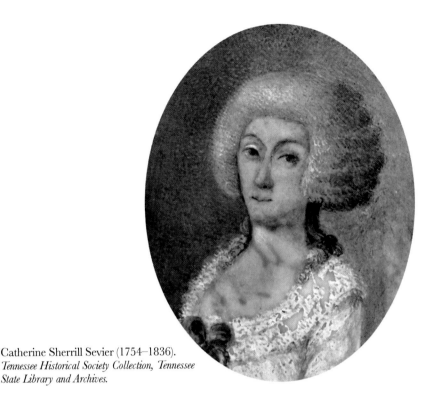

Catherine Sherrill Sevier (1754–1836).
*Tennessee Historical Society Collection, Tennessee
State Library and Archives.*

woman fondly remembered in many historical accounts as "Bonny Kate"—further mythologized his image as a frontier hero.[44] Sevier's rescue of young Bonny Kate at Fort Caswell is so remarkable one might think it originated in a movie script or a romance novel. According to legend, on July 21, 1776, a large force of Cherokees attacked the fort. By one account, up to five hundred women and children crowded inside the fort, protected by only forty or fifty men, though the exact number is a source of dispute.[45] Although outnumbered, the well-armed men served under the capable command of John Carter, James Robertson and John Sevier.

At sunrise, Bonny Kate stood outside the fort milking a cow when the surprise attack commenced. As the men made haste to secure the fort, Bonny Kate suddenly found herself locked outside its walls and at the mercy of the Cherokee attackers. What happened next has been embellished to such a degree that it is impossible to distinguish myth from reality. In one account of this story, young Catherine Sherrill, "active and swift on foot as a frightened doe," ran toward the palisades of the fort, and "having heard

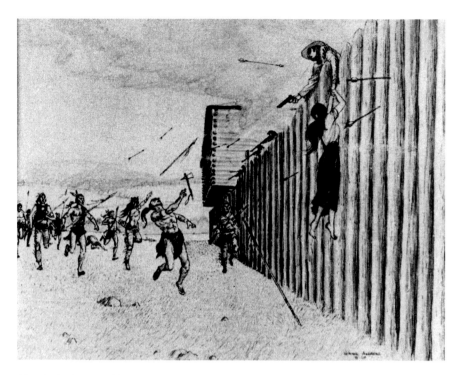

Siege of Fort Watauga, July 20, 1776. An artist's sketch of Catherine "Bonny Kate" Sherrill's escape from Cherokee pursuers. *Tennessee State Library and Archives.*

the screams of the fleeing girl, the gallant Lieutenant Sevier leaped to the top of the wall to help her over." According to this version of the legendary tale, "With one hand he shot down the foremost pursuer; with the other, he assisted her in the long leap over the wall. She fell into his arms out of breath and nearly exhausted."[46]

Theodore Roosevelt provided another vivid account of Bonny Kate's rescue in his book *The Winning of the West*. Roosevelt described Bonny Kate as "a tall girl, brown-haired, comely, lithe and supple 'as a hickory sapling.'" Roosevelt endorsed previous literary comparisons with his account. "One day while without [sic] the fort she was almost surprised by some Indians," he wrote. "Running like a deer, she reached the stockade, sprang up so as to catch the top with her hands, and drawing herself over, was caught in Sevier's arms on the other side; through a loop-hole he had already shot the head-most of her pursuers."[47]

In another version of this story published in *Tennessee During the Revolutionary War*, Samuel Cole Williams embellished the details of the rescue with a quote allegedly from Bonny Kate herself:

The first approach and attack of the Indians was about daybreak and made stealthily. Some of the women and girls were up early and had gone out to milk cows. The first alarm to the defenders was the screaming of these women-folk in their flight to the fort, closely pursued by the savages. In this party of females was Miss Catherine Sherrill, a tall and athletic young woman. As the Indians blocked the direct path to the gate of the fort, she made a circuit to reach the enclosure on another side, resolved, as she afterwards said, to scale the palisades. "The bullets and arrows came like hail. It was now leap or die, for I would not live a captive." While she was scaling the stockade, the hand of a man reached down to aid her, and she fell into the arms of this man—John Sevier—whom she thus met for the first time. She was to become his second wife a little more than four years later.[48]

It is worth noting that Williams was a judge, not a trained historian, and his method of sourcing and note taking left him open to criticism. In the introduction to the 1974 edition of Williams's book, Frank B. Williams Jr. acknowledged this weakness in the narrative. He wrote:

His forte was compiling, and like many untrained but energetic antiquarians and local historians—buffs and amateurs they are—he could not write well. "It may be well ventured," to borrow from the judge, that he had a cavalier attitude and would not take the trouble to master the scholarly minutiae of style and form. He could have afforded an editor, and he could have saved himself from many mistakes and criticisms. He, as his daughter said, liked dangling participles, and resented her calling them to his attention. Some footnotes bore no relation to the texts. He failed to cite sources for quotations on occasion, and at other times he cited the sources incorrectly. The judge did not always tell readers where he found original sources; to the contrary, he resorted to a form of literary cannibalism by often citing one of his own books which contained errors. As a result, students and scholars should be careful when they use his books. Surely he did not intend to be inaccurate or to mislead; he simply was too busy collecting and writing, too happy in his work, and too sure of himself to take the trouble to polish, to check, and to double-check.[49]

Another account of this incident went even further to paint a more heroic picture of Bonnie Kate's rescue. Elizabeth Fries Ellet wrote in her 1852 book, *Pioneer Women of the West:*

Miss Sherrill was already somewhat distinguished for nerve, action, and fleetness. It was said [that] *"she could outrun or outleap any woman; walk more erect, and ride more gracefully and skillfully than any other female in all the mountains round about, or on the continent at large." Although at other times she proved herself to know no fear, and could remain unmoved when danger threatened, yet on this occasion she admits that she did run, and "run her best." She was very tall and erect, and her whole appearance such as to attract the special notice and pursuit of the Indians; and as they intercepted the direct path to the gate of the fort, she made a circuit to reach the enclosure on another side, resolved, as she said, to scale the walls or palisades. In this effort, some person within the defenses attempted to aid, but his foot slipped, or the object on which he was standing gave way, and both fell to the ground on opposite sides of the enclosure. The savages were coming with all speed, and firing and shooting arrows repeatedly. Indeed, she said, "The bullets and arrows came like hail. It was now—leap the wall or die! For I would not live a captive." She recovered from the fall, and in a moment was over and within the defenses, and "by the side of one in uniform."*[50]

Ellet continued, describing Bonny Kate's uniformed rescuer as "Capt. John Sevier." She wrote:

This was the beginning of an acquaintance destined in a few years to ripen into a happy union, to endure in this life for near forty years. "The way she run [sic] *and jumped on that occasion was often the subject of remark, commendation, and laughter." In after life she looked upon this introduction, and the manner of it, as a providential indication of their adaptation to each other—that they were destined to be of mutual help in future dangers, and to overcome obstacles in time to come. And she always deemed herself safe when by his side. Many a time did she say: "I could gladly undergo that peril and effort again to fall into his arms, and feel so out of danger. But then," she would add, "it was all of God's good providence."*[51]

The story of Bonny Kate's rescue became one of Tennessee's most cherished historical traditions and endured mythologized in print, poetry and pageantry. One particular poem, written by E.E. Miller and published in the September 20, 1922 edition of the *Nation*, captured this moment with artistic flair:

A keen-eyed lass at the fort gate cried
To the women who milked the cows outside.
They ran, a whoop and a gun's report
Speeding their steps as they fled to the fort.
Farthest of all from its sheltering wall,
Latest to catch and heed the call.
Was Katharine Sherrill, fairest of maids
In all Watauga's forest glades.
Hearing, she sprang like a startled deer
And fled on feet that were winged with fear.
But the call had come a moment late:
The redskins cut her off from the gate,
And while the rifles blazed away
Rushed yelling and gloating to seize their prey.

At the gate of the fort bold John Sevier,
Statesman and warrior and pioneer,
Was grasped by a dozen hands and stayed
As he tried to rush to the fleeing maid;
Grasped, held back, and the great bar dropped—
It was certain death if he were not stopped,
And better a girl be captive led
Than the foremost man of the West lie dead.

The Indians rushed to seize their prey,
But she whirled aside and sped away—
Away from the gate, but toward the wall.
Eight feet it stood. The maid put all
Her strength in one great leap and flung
Her arms across the top and clung
One instant, trembling, out of breath;
Then over the top and away from death
Strong arms had caught and drawn her clear—
The eager arms of John Sevier.

Such is the story; so it was told
To our fathers by theirs in the days of old;
So will our children the tale repeat
To children clustered about their feet.

For as long as beauty is loved, and youth,
And deeds of valor, and manhood's truth.
Will a place be kept in the heart of the State
For John Sevier and his Bonny Kate,
For the hero brave and the bride he won
And the love that lived till their lives were done.[52]

Nearly every account of this story originated from oral tradition. Only one of Sevier's sons ever mentioned the rescue of Bonny Kate, and he failed to connect it at all with the marriage of his mother and father. Another son made no mention of the rescue in his recollections of his father's frontier adventures.[53] While the core details of Bonny Kate's rescue in each recollection remained consistent, the tales that emerged from written accounts of this story frequently overstated the event.

Another legend told of Bonny Kate recalled the days leading up to her husband's victory over the British Loyalists at the Battle of King's Mountain. As Sevier's Overmountain Men gathered at Sycamore Shoals to prepare for the march, the call came forth for all able-bodied men in the settlements to join their ranks. As Sevier's eighteen-year-old son, Joseph, stepped forward to fight alongside his father, Bonny Kate brought his second son, James, by the hand—a boy merely sixteen years of age—delivered him to his father and, "with words that would have honored a Spartan mother," begged her husband to let the boy fight too.[54]

History recorded and recognized "Bonny Kate" as a heroic figure in her own right. An inscription on the reverse side of Catherine Sherrill Sevier's grave marker in Knoxville, Tennessee, reads in part, "Her fame has flourished as the brightest star among the pioneer women of this state until her immortality in history is as secure as that of her heroic husband by whose side she at last sleeps her last sleep."

The personal stories of Sarah Hawkins and Catherine Sherrill embodied femininity on the frontier—strong, courageous women, who both demonstrated loyalty and devotion to their husband and family. In his book *Winning of the West*, Roosevelt noted:

The women, the wives of the settlers, were of the same iron temper.
They fearlessly fronted every danger the men did, and they worked quite
as hard. They prized the knowledge and learning they themselves had
been forced to do without; and many a backwoods woman by thrift and
industry, by the sale of her butter and cheese, and the calves from her

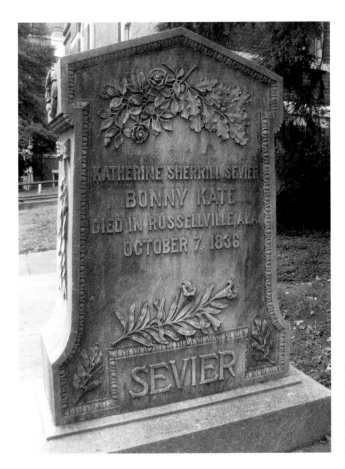

Catherine Sherrill Sevier's grave marker on the grounds of the Old Knox County Courthouse in Knoxville, Tennessee. *Author's collection.*

cows, enabled her husband to give his sons good schooling, and perhaps to provide for some favored member of the family the opportunity to secure a really first-class education.[55]

These expressions of bravery and fidelity created a vision of womanhood that society sought to honor and emulate, particularly in the years following World War II, when the ladies of the DAR realized their greatest success spearheading their memorial efforts. Headman argued that Sevier's first wife, Sarah, "who is not remembered by Tennesseans, is the one whose money, influence and loyalty carried John Sevier to fame."[56] Furthermore, countless writers and storytellers recalled how Bonny Kate Sevier sheltered, clothed and fed her husband's fellow militiamen during respites between their frequent battles with the Cherokees.

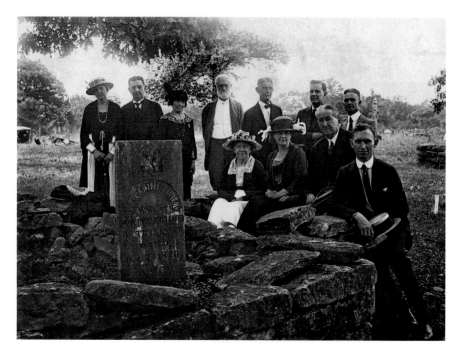

In 1922, mourners gathered around Catherine Sherrill Sevier's original grave site in Decatur, Alabama. *Tennessee State Library and Archives.*

Catherine Sherrill became Sevier's "First Lady" in the public memory. Sarah Hawkins embodied a "forgotten heroine" of Tennessee history. Each woman's story provided unique insights into Sevier's life, and each woman contributed greatly to her husband's reputation as a rugged frontiersman with unwavering courage. The narratives written of their lives not only bolstered Sevier's legend across Tennessee but also established Sarah and Catherine as pioneering historical figures in their own right. During "Sarah Hawkins Sevier Memorial Day," Tennessee state senator E.E. Patton stated, "A philosopher has said that [at the] 'back of the success of every man lies the heart of a woman.' It may be a sainted mother; it may have been a sister who sacrificed that she might send her brother to college; it may have been a wife who would brave the dangers of a living in hell in order to contribute to her husband's success and happiness."[57] Indeed, the strength and courage of these two women propelled Sevier's legend even further, contributing greatly to his reputation as "Tennessee's first hero."

3

A DANGEROUS EXAMPLE

In nothing that has been written about John Sevier, and the amount written has not been large, is there an adequate explanation of why he took up with the mountain men, unless it be his love of adventure.
Samuel Gordon Heiskell, 1920

True to the adventurous spirit described by his chroniclers, John Sevier sought to establish himself as a landowner and prominent citizen on America's first frontier. He set his sights to the West, toward the untamed wilderness lying between the Cumberland Plateau and the Great Smoky Mountains. In this "great hill-strewn, forest-clad valley," where the Clinch, Holston, Watauga, Nolichucky and French Broad Rivers carved the landscape, Sevier's legend first took root.[58]

Sevier's biographer Carl Driver observed, "The West fascinated Sevier...It was a land where all ills were remedied and where men were free and untrammeled by restrictive conventions. It symbolized opportunity."[59] In the years preceding the settlement of the Watauga Valley, the accounts of Daniel Boone and other early explorers tempted many brave adventurers to this "American Canaan."[60] Writers frequently used superlative language to describe Sevier and the cast of characters who first settled the region. Judge John Haywood, pioneer jurist and scholar of early Tennessee history, personally knew many of the settlers of the Watauga settlement.[61] Haywood characterized the settlers as "men of industrious habits and of honest pursuits, who sought for good lands to

Judge John Haywood (1762–1826), known as the "Father of Tennessee History." *Nell Savage Mahoney Papers, Tennessee Historical Society Collection, Tennessee State Library and Archives.*

reward their toils in the tillage of the earth."[62] J.G.M. Ramsey stated that these frontiersmen exhibited "enthusiasm, vivacity, shrewdness and self-respect" as independent thinkers not prone to act according to the dictates of any master.[63] Theodore Roosevelt called the Wataugans "a sturdy race, enterprising and intelligent, fond of the strong excitement inherent in the adventurous frontier life." He continued, "Their untamed and turbulent passions and the lawless freedom of their lives made them a population

very productive of wild, headstrong characters…men of sterling worth fit to be the pioneer fathers of a mighty and beautiful state"[64]

Driver heralded Sevier's arrival at the Watauga Valley as the beginning of "one of the most romantic careers in the conquest of the West. Daring and impetuous, magnetic and powerful, [Sevier] came to represent the heroic life of the border."[65] Sevier made several trips to Watauga prior to settling there. In 1771 and 1772, John, along with his brother Valentine, scouted the region in search for suitable land. By Christmas Day 1773, he moved his entire family—his wife, Sarah, and their children; his father and mother; and his siblings and their families—to the Keywood settlement on the north side of the Holston River, where he opened a mercantile business.[66] Within a few years, Sevier and his family moved to the Watauga settlement. There he acquired several hundred acres of land and established himself as a frontier merchant, Indian trader and, more importantly, a leader within the region.[67]

By the time of Sevier's arrival, James Robertson, an early leader of the Watauga settlement and another heroic figure of the period, had lived there for nearly a year.[68] Writers and scholars of early Tennessee history singled out both Robertson and Sevier as leaders who "towered head and shoulders above the rest in importance."[69] While writers described Robertson as a man of "self-contained strength" who had a "singular mixture of cool caution and most adventurous daring," they portrayed Sevier as a charismatic figure of "high-mindedness and dauntless, invincible courage" and "a gentleman by birth and breeding."[70]

In his book *The Winning of the West*, Roosevelt relied on stories told by the settlers themselves—recorded in their later years by the antiquarians of the Tennessee Historical Society—to describe Sevier's physical features and temperament in heroic terms. He wrote:

> *Sevier was a very handsome man; during his lifetime he was reputed the handsomest in Tennessee. He was tall, fair-skinned, blue-eyed, brown-haired, of slender build, with erect, military carriage and commanding bearing…From his French forefathers he inherited a gay, pleasure-loving temperament that made him the most charming of companions. His manners were polished and easy, and he had great natural dignity. Over the backwoodsmen he exercised an almost unbounded influence, due as much to his ready tact, invariable courtesy, and lavish, generous hospitality, as to the skill and dashing prowess which made him the most renowned Indian fighter of the Southwest. He had an eager, impetuous nature, and was very ambitious, being almost as fond of popularity as of Indian-fighting.[71]*

Not every man who journeyed to the Watauga Valley equaled in virtue. Haywood noted, "Some transient persons who had come to the Watauga previously to Robertson, intending to become residents there, were men of bad character."[72] Roosevelt wrote, "Among the first comers were many members of the class of desperate adventurers always to be found hanging round the outskirts of frontier civilization. Horse-thieves, murderers, escaped bond-servants, runaway debtors—all, in fleeing from the law, sought to find a secure asylum in the wilderness."[73] As Sevier entered the scene, he encountered this lawless element of the frontier, and these ruffians nearly led him to abandon his plan to make Watauga his home.

Following a successful negotiation of a land lease with the Cherokees in 1772, the Watauga settlers celebrated the occasion with a horse race.[74] They invited the Cherokees, and according to varied accounts, Sevier also attended. As stated in one particular narrative, during the festivities, a "frontier bully" named Shoate took a horse by force from another man, claiming to have won it, although the owner insisted he had made no bet. Following a heated argument, a violent altercation occurred. In the aftermath, one Cherokee lay dead, and the rest of the tribe left the scene in anger, promising retaliation for the attack. This incident threatened the peaceful exchange of land that the Wataugans had worked so hard to achieve.[75]

Sevier, outraged by this spectacle, mounted his horse and left in disgust, determined that he would not settle in so barbarous a community. Legend held that Sevier met General Evan Shelby along the way. Shelby, too, considered settling within the Watauga region. Sevier relayed the incident to Shelby. "Never mind those rascals," Shelby told him. "They'll soon take poplar and push off," meaning that they would take canoes and leave. Indeed, the frontiersmen had their own methods of dealing with horse thieves, and Shoate soon found himself dangling from the end of a rope.[76] Meanwhile, Robertson left Fort Watauga under Sevier's command while he journeyed alone into Cherokee territory to negotiate a truce.[77]

Accounts of this story varied depending on the author and the time period of the written narrative, and some versions of this story unfolded embellished with literary flourishes.[78] During the Tennessee Centennial Exposition, it was noted that "the infant community on the Watauga existed without law but nevertheless existed in profound peace and perfect security. Every man being honest was a law unto himself and lived up to the Golden Rule. But as Satan entered Eden in the form of a serpent so he entered this little Utopia of the Wilderness *in the guise of a horse thief* who at once kindly awakened the settlers to the necessity of organized government."[79]

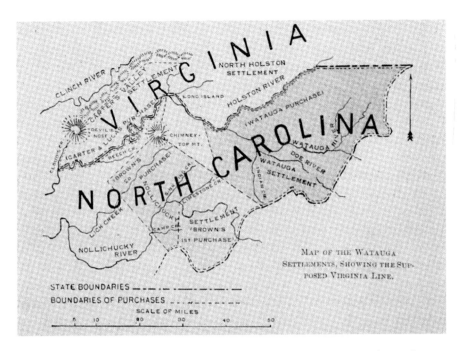

"Map of the Watauga Settlements, Showing the Supposed Virginia Line." *Tennessee State Library and Archives.*

The violent encounter between the Wataugans and this horse thief served as an example of the problems faced by these early pioneers. At first, the Wataugans believed that governance over their settled territory belonged to Virginia, but in 1771, a survey of the Virginia boundary line westward revealed that the Watauga settlement actually rested within the confines of North Carolina territory. North Carolina, however, demonstrated no eagerness to claim the territory, as the colonial government frequently proved incapable of enforcing laws even in well-established districts. Since neither Virginia nor North Carolina claimed sovereignty over the area, the Wataugans "suddenly found themselves obliged to organize a civil government, under which they themselves should live, and at the same time to enter into a treaty on their own account with the neighboring Indians, to whom the land they were on apparently belonged."[80] They built their settlements on land just out of reach of the boundaries of British colonial government and within recognized Cherokee territory.[81] The Wataugans established their own rule of law so men like Shoate would not go unpunished for their crimes.

In 1772, the settlers founded the "Watauga Association" to organize the region.[82] Ramsey described the government as "paternal and patriarchal—simple and moderate, but summary and firm."[83] Five elected commissioners functioned as a court and conducted the business of government, including all executive, legislative and judicial matters. James Robertson, John Sevier, John Carter, Charles Robertson and Zachariah Isbell served as the court's first commissioners. Although no copies of the original articles of the Watauga Association exist, Ramsey provided as evidence a 1776 petition of the "Washington District" for annexation by the State of North Carolina that mentioned the Watauga settlement. Ramsey claimed to have found the document "in an old bundle of papers, lying in an upper shelf, almost out of reach, and probably not seen before for seventy-five years." After careful examination, Ramsey concluded, "The document appears to be in the handwriting of one of the signers, John Sevier, and is probably his own production."[84]

The early Tennessee historians Haywood and Ramsey largely agreed concerning Sevier's inclusion in this list of commissioners. Subsequent scholars, however, disputed this claim, stating that Sevier moved to Watauga in 1775 and, therefore, could not have been involved in framing the government.[85] Sevier's biographer Driver, nonetheless, disputed this assertion. Driver noted that deed records verified that Sevier purchased land in the region prior to his arrival, and accounts given by Sevier's sons James and George validated these claims. "It is entirely possible that Sevier had already possession of the land to which he later moved," Driver observed, "and that he had remained there for a time during the year in which the Association was formed." Sevier's move to the edges of civilization indeed placed him in a position of power and influence.[86]

The Watauga Association never intended to function as a deliberate renunciation of British sovereignty. The Watauga settlers considered themselves British subjects, but this "simple and moderate" republic represented the first attempt by American-born colonists to form an independent constitutional government.[87] British authorities, however, viewed this as an act of defiance and a threat to their monarchical rule. In a 1774 letter to the British secretary of state for colonial affairs, Virginia's royal governor, the Earl of Dunmore, warned of dire consequences if this rebellion in the wilderness remained unchallenged. He wrote in part:

> *In effect, we have an example of the very case, there being actually a set of people in the back part of this colony, bordering on the Cherokee country,*

who, finding they could not obtain titles to the land they fancied, under any
of the neighboring governments, have settled upon it without, and contented
themselves with becoming in a manner arbitrary to the Indians, and have
appointed magistrates, and framed laws for their present occasions, and to all
intents and purposes, erected themselves into, though an inconsiderable, yet
a separate State; the consequence of which may prove hereafter detrimental
to the peace and security of the other colonies; it at least sets a dangerous
example to the people of America, of forming governments distinct from
and independent of His Majesty's authority.[88]

More recent historical scholarship suggests that the Earl of Dunmore exaggerated the situation. Phillip Hamer argued that the Wataugans "simply designed their government to meet a particular emergency and had no intention of exercising within it all the purposes of a sovereign and independent state."[89] The early chroniclers of Tennessee's history, however, seized upon the idea that the establishment of the Watauga Association represented America's first cry of freedom from the tyranny of the British Crown. Ramsey declared that the Wataugans "exercised the divine right of governing themselves."[90] Roosevelt believed that the settlers who established the Watauga Association "outlined in advance the nation's work," establishing the first "free and independent community on the continent," giving their history "its particular importance."[91] Another writer called the Watauga Association "one of the most thoroughly democratic instruments ever penned in the new world."[92]

This "dangerous example" provided inspiration for writers and scholars who envisioned Sevier as one of the first statesmen of the Early Republic. In 1888, James Phelan, a Tennessee lawyer and politician, wrote an account of the Watauga settlement in his book *History of Tennessee, the Making of a State.* Although James Robertson primarily received credit for embracing the leadership role among the five commissioners of Watauga's government, Phelan noted his belief that Sevier alone guided the Wataugans to self-governance. Phelan even praised Sevier for inspiring the U.S. Constitution. He contended:

It is a remarkable fact that Sevier alone of all the men of his times inhabiting
what subsequently became Tennessee had a definite idea of what should be
the logical limits of the future State. These limits were not recognized in
the statutes of North Carolina, except the one drawn most probably by
Sevier and in the cession to the United States. The act of cession cedes a

certain district in direct terms, and by implication allows the United States to follow their pleasure in reference to the rest. When the constitution was framed, the limits of the State were fixed according to the ideas of Sevier of twenty years before.[93]

Sevier forged his identity as a frontiersman, Indian fighter and statesman of the Early Republic in the Watauga Valley. Stories of his accomplishments carried forth through oral tradition from one generation to the next. Antiquarians, writers and storytellers repeated the narrative, for they saw him as a man "of sterling worth fit to be the pioneer father" of the state of Tennessee. Haywood wrote, "For about twenty years John Sevier stood guard and protected the women and children on the Watauga and Nolichucky."[94] In these rolling hills and deep river valleys, Sevier first established his reputation as "Pioneer, Soldier, Statesman." This, coupled with his later exploits, provided future writers and scholars a reason to include his name among the pantheon of heroes of the Early Republic and establish Sevier as "Tennessee's first hero."

SOLDIER

4

THAT MEMORABLE VICTORY

The gallant and fearless pioneers of the West have been ungratefully neglected
almost to a man.
Lyman C. Draper, 1839

The Battle of King's Mountain arguably stands as the most decisive battle in the southern campaign of the American Revolutionary War.[95] On October 7, 1780, on a small mountain on the South Carolina border with North Carolina, a frontier militia, under the command of Colonel William Campbell and led into battle by Colonels Isaac Shelby, John Sevier, Joseph McDowell and Benjamin Cleveland, fought against Loyalists to the British Crown led by British major Patrick Ferguson. In a little more than one hour, using battle tactics that Sevier and his Overmountain Men had learned while fighting the Cherokees, these frontier Patriots totally decimated Ferguson's American Tories, with every last man either killed or taken prisoner.

George Washington called the battle "an important object gained" and "a proof of the spirit and resources of the country."[96] General Horatio Gates described the victory as "great and glorious."[97] Congress commended "the spirited and military conduct of Colonel Campbell, and his officers and privates of the militia under his command."[98] Thomas Jefferson hailed, "That memorable victory was the joyful annunciation of that turn of the tide of success which terminated the Revolutionary War with the seal of independence."[99]

Of all the Patriot leaders, Sevier received the most political benefit from participation in the battle. His biographer Carl Driver pointed out that "his

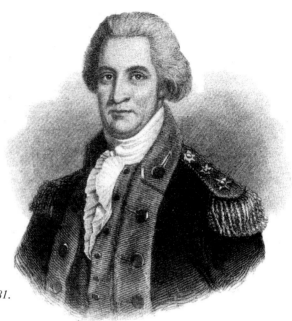

Governor John Sevier.
From Lyman Draper's King's
Mountain and Its Heroes, *1881.*

place in the hearts of his neighbors had been definitely established before King's Mountain, but his participation in this spectacular victory greatly enhanced his prestige as a frontier leader...This engagement introduced him to the country at large and made him a respected character in all parts of the nation."[100] Of all his heroic exploits, the Battle of King's Mountain was, literally, Sevier's finest hour.

King's Mountain established Sevier as a Revolutionary War hero, and his participation in this battle helped to launch his political career and ambitions. Today, however, very few people recognize the importance of the Battle of King's Mountain within the context of the American Revolution. The Battles at Lexington and Concord, Bunker Hill, Trenton, Saratoga and Yorktown remain well known across the nation. Yet the battles that occurred in the southern theater of the Revolutionary War wane as largely forgotten episodes in American history. Regional, and particularly southern, writers and historical scholars considered the Battle of King's Mountain and similar southern battles of the Revolutionary War distinctly regional conflicts, thus explaining this difference in perceptions.[101]

Antiquarian, author and historical scholar Lyman Copeland Draper's book, *King's Mountain and Its Heroes*, not only detailed the events of the Battle

of King's Mountain but also, more importantly, laid the foundation for how future writers and scholars chronicled the battle and the lives of the Patriots who fought in it. Born in Erie County, New York, on September 4, 1815, Draper grew up listening to tales of the heroic deeds of his ancestors, told to him by members of his family. His first American ancestor, James Draper, immigrated to Massachusetts in 1647. Three generations later, his grandfather Jonathan Draper fought alongside the minutemen at the Battle of Lexington during the Revolutionary War. His father, Luke—a farmer, grocer and tavern keeper—served in a local militia unit in Buffalo, New York, during the War of 1812. British troops twice captured Luke during that conflict.[102]

The stories of Jonathan's heroism in Lexington and Luke's captivity in Buffalo passed down through the generations in the Draper family. These stories served to foster within young Lyman an intense appreciation for the men who fought in the American Revolution and the early pioneers who staked their claim to the western frontier. These men built settlements, established governments and created civilizations where vast areas of wilderness once reigned. They conquered the rugged landscape beyond the Appalachian Mountains, as well as the Indian tribes who first laid claim to it. Draper viewed these early pioneers as exceptional characters and saw within them brave and patriotic spirits.

A diminutive man barely over five feet in height, Draper constantly suffered from debilitating fits of hypochondria and illness, and he lacked the physical strength to live up to the daring exploits of his ancestors. He chose, instead, to focus on his education and set out to become a writer.[103] He vowed to publish twenty titles focusing on the "Western Heroic Exploits" of Daniel Boone, George Rogers Clark, John Sevier, James Robertson and many others.[104] Following a series of health and financial difficulties, Draper eventually accepted an appointment as the first librarian and secretary of the Wisconsin Historical Society, where he continued his work to document the history of the Old Southwest.[105]

During this time in Draper's life, he came to the conclusion that history deplorably neglected these courageous men. America remained quite a young nation during Draper's childhood, and so educators still taught history through the classics. Any mention of the important figures who had shaped the early history of this country concentrated on the lives of those who lived in the original thirteen colonies. Draper believed that Americans ignored the bravery and heroism displayed by the hearty frontiersmen of the South, and he vowed to correct the oversight.[106]

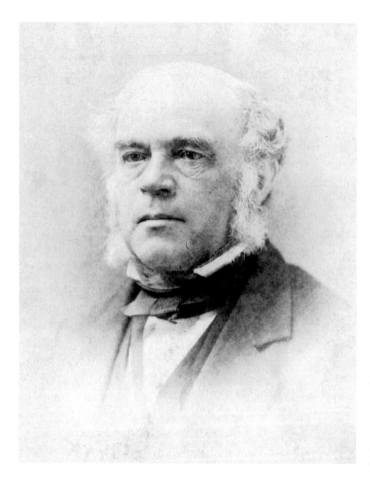

Lyman Copeland Draper (1815–1891), librarian, historian and author of *King's Mountain and Its Heroes*. Tennessee Historical Society Collection, Tennessee State Library and Archives.

Draper firmly held that "very much precious historical incident must still be treasured up in the memory of aged Western Pioneers."[107] As early as 1839, Draper began collecting manuscripts and reminiscences in what one scholar described as "the first oral history project in America."[108] For decades, Draper wrote to the early settlers of the Old Southwest and their descendants in an effort to "rescue from oblivion the memory of its early pioneers and to obtain and preserve narratives of their exploits."[109] In a January 1843 letter to Congressman William B. Campbell of Virginia, Draper explained his motivation for collecting the stories of these early frontiersmen. "While I do not wish to make every hero Pioneer a paragon of perfection," Draper wrote, "I shall feel bound to present their prominent better qualities in bold relief, and speak of their great services in founding the great Empire of the West, as they deserve."[110]

From 1844 to 1852, Draper made nine major research trips to the South. Twice in 1844, he journeyed into Kentucky and Tennessee to interview pioneers and their descendants and to gather up documents, letters and memoirs.[111] In February, Draper visited Nashville, where he met men with direct knowledge of Sevier's Indian campaigns and copied verbatim from Sevier's manuscripts. In October, Draper traveled to Knoxville to purchase miniature copies of portraits of Sevier and Robertson. By the close of the year, he had acquired a mountain of historical data on several notable pioneers, including Sevier.[112]

Though he was a prolific collector, Draper only managed to publish one book. That volume, *King's Mountain and Its Heroes*, laid the cornerstone of scholarship on the battle for generations of historians and writers. Draper largely based *King's Mountain and Its Heroes* on the notes taken from his interviews and correspondences with Sevier's contemporaries who recalled their participation in the battle and Sevier's descendants.

Draper conducted face-to-face interviews with three living veterans of the Battle of King's Mountain—Sevier's son James of Tennessee and John Spelts and Silas McBee, both of Mississippi.[113] By the summer of 1839, when Draper first initiated contact with him, Major James Sevier was an old man. Yet the major possessed an active mind. Draper requested from Sevier a sketch of his father's life based on his personal recollections. In response, Sevier wrote "A Memoir of John Sevier." This brief narrative described his experiences during the Battle of King's Mountain and his numerous engagements with the Cherokees. "As I write from memory, I may in some things err, but not materially, as my memory is still retentive," Sevier wrote. He, however, observed, "There may have escaped my memory many little incidents that happened, which might serve to amuse, but they are lost to me and the public."[114]

Sevier detailed his participation in the Battle of King's Mountain, testifying that his father "had in his regiment four brothers besides himself, and two sons—myself the youngest, being at that time sixteen years old. There were only seven of our family able to bear arms; they all fought in the battle." He noted that his uncle Robert was fatally wounded "nobly fighting for his country" and paid homage to all the men who fought there stating, "Sparta never raised a better set of men than those that fought the battle of King's Mountain."[115]

John Spelts also participated in the battle. Known within the ranks as "Continental Jack," Spelts served under the command of Major Joseph McDowell. In December 1843 and early 1844, Draper interviewed

Spelts at his home in Marshall County, Mississippi. Draper affectionately characterized Spelts as "a jolly old soldier, then in his ninety-fourth year" and noted that "from him were derived many interesting reminiscences of the Revolution."[116]

Draper described Spelts's memory of the Battle of King's Mountain as "clear and vivid."[117] In fact, much of the detail described in Draper's narrative could not have been written without the eyewitness account from the elderly "Continental Jack." Spelts's vivid description of the scene following the battle read something like a novel. "The groans of the wounded and dying on the mountain were truly affecting—begging piteously for a little water," Spelts recalled, "but in the hurry, confusion and exhaustion of the Whigs, these cries, when emanating from the Tories, were little heeded."[118]

Draper's correspondence with Spelts also revealed a rift between three of the commanders of the Battle of King's Mountain—William Campbell, John Sevier and Isaac Shelby. The controversy surrounding these three men began after Sevier's son Colonel George Washington Sevier, with whom Draper frequently corresponded, published a series of letters written by John Sevier and Shelby several years after the battle. The correspondence between these two men, published in the July 1, 1822 edition of the *Nashville Gazette*, called into question Campbell's character and level of participation in the battle. In one letter written by Sevier to Shelby on August 27, 1812, Sevier recalled observing Shelby valiantly urging his men to take the fight to the enemy. He remembered Campbell's role in the battle, however, quite differently:

> It is well known you were in the heat of the action. I frequently saw you animating your men to victory. At the surrender, you were the first field officer I recollect to have seen. I have no doubt you must recollect Col. Campbell was some considerable distance from that place, at that time, and that you and myself spoke on that subject the same evening. I perfectly recollect on seeing you at the close of the action, that I swore by God they had burnt off your hair, for it was much burnt on one side. It is well known by some hundreds in Tennessee, that you were Colonel on that campaign, and that we were the only persons who set foot the expedition, and had considerable trouble to get Campbell to join us.[119]

Shelby's letters to Sevier confirmed their mutual belief that Campbell failed to directly participate in the Battle of King's Mountain but rather commanded his forces from behind the lines. Shelby responded with anger to claims made by William C. Preston, a grandson of the late Campbell,

that Colonel Campbell deserved "the chief honors of that victory" at King's Mountain. Shelby testified:

> *About ten o'clock on the day after the battle, I was standing alone, about forty yards south of the spot where Col. Campbell came to me after the surrender, enjoying the warmth of the sun, when I saw Col. Campbell leave the line of guards that surrounded the prisoners, and walked slowly towards me with his sword under his arm, till he came near touching me. He then, in a lower tone of voice than usual, and with a slight smile on his countenance, made the following expression:* "Sir, I can not account for my conduct in the latter part of the action."[120]

Shelby later declared:

> *Sacred as the memory of Col. Campbell may be, it will be recollected, that I also have a character and reputation which are dear to me, and which it is one of my highest duties to maintain and defend. The history of my life has never before been stained by an imputation of falsehood and dishonor. I am now in my seventy-third year, and almost the only object of worldly ambition that remains between me and the grave, is, that my memory may descend untarnished to my posterity and to my country—that country which has appreciated my services, perhaps too highly, and with a bountiful and generous hand heaped upon me rewards and honors far beyond my poor deserving.*[121]

Both Sevier and Shelby used their participation in the Battle of King's Mountain to propel themselves into public office—Sevier as governor of Tennessee and Shelby as governor of Kentucky. Building on their reputations as leaders of the battle, they achieved a great deal of political success evoking the memory of their role in this "turning point of the American Revolution."[122] Their fame and political fortune profited, to some degree, at the expense of Campbell, whose reputation suffered by these inferences of cowardice on the field of battle.

Just as he vowed to redeem the memory of America's earliest pioneers, Draper sought vindication for Campbell. Draper repeatedly referred to Spelts's testimony in footnotes throughout his book and relied heavily on Spelts's recollections to cast Campbell as a hero. Draper expressed regret that "such patriots as Shelby and Sevier should have been deceived into the belief that the chivalric Campbell shirked from the dangers of the conflict."

Draper maintained, "It is evident that such heroes as Shelby and Sevier had quite enough to do within the range of their own regiments, without being able to observe very much what was transpiring beyond them."[123]

Silas McBee also recalled his experiences for Draper's manuscript. Born on November 24, 1765, McBee was not yet fifteen years old when the fighting at King's Mountain commenced.[124] Draper held several interviews with McBee and frequently referenced their conversations in the footnotes of his book. McBee served under the command of Colonel James Williams. His recollections provided many details about the battle. In his statement, McBee testified that he witnessed Shelby and Sevier rally their troops and drive the enemy to surrender. He further claimed to have aimed his rifle at Ferguson and shot him. McBee later noted that even after the British Loyalists gave up, "Sevier and the other officers had some difficulty in getting the men to cease firing."[125]

After the Revolution, McBee continued to lead an adventurous life. Following an assault on Ziegler's Station by Creek Indians in 1792, he engaged with a party of men raised to avenge the attack.[126] He later served as a member of the first legislature of Alabama. At the time of his interview with Draper in 1842, he lived in Pontotoc County, Mississippi, where he died three years later.[127]

Draper further corresponded with two other men who fought in the Battle of King's Mountain—William Snodgrass of Tennessee and Benjamin Sharp of Missouri.[128] A year prior to the Battle of King's Mountain, Snodgrass served in the military campaign against the Chickamauga Cherokees. He fought under Joseph McDowell's command at the Battle of King's Mountain.[129] Benjamin Sharp also participated in the battle, and though he never witnessed Sevier's actions, he acknowledged that "his bravery was well attested." Sharp further stated, "I'm led to believe that three braver men or purer patriots never trod the soil of freedom than Campbell, Shelby, and Sevier."[130]

Draper not only corresponded with the veterans of the Battle of King's Mountain but also wrote to their descendants, seeking their papers. In his quest to chronicle the lives of these patriots, he "mingled with the children of Campbell, Shelby and Sevier" and made numerous acquaintances with several other family members.[131] Often, when families refused to give their papers to him outright, Draper requested to borrow them so he could transcribe the information into his own notebooks. He tended, however, to horde family papers for extended periods of time. This led to some resentment and distrust of Draper's activities in parts of the South, especially in Kentucky and Tennessee. Southerners described Draper as the "man

who stole all our documents and carried them off to Wisconsin."[132] More frequently, however, the owners of these family papers gladly turned over their original manuscripts, resting on the assurance that he would properly honor and praise their ancestors.[133]

Draper's gift for flattery and passion for preserving these stories for posterity easily manifested itself to the families of these veterans.[134] In one particular case, Draper again reached out to George Washington Sevier to solicit information about his father, who Draper called the "patriarchal father of Tennessee." After receiving a biographical sketch from Sevier's son, Draper gratefully acknowledged its receipt. In a letter dated May 3, 1839, Draper wrote:

> *The sketch you have so kindly furnished, places me in possession of many interesting facts hitherto unknown to myself, and such, I trust, as will prove serviceable to present and future generations...The gallant and fearless pioneers of the West have been ungratefully neglected almost to a man. Relative to many of them I have collected scattering facts; and in but a few instances have I anything like regularly connected sketches. Gallant fellows they were who composed that hardy band; and, to gratify my own passionate predilections as a biographical antiquary, I can afford to take especial pains to collect the scattering facts and incidents in the career of these men of iron nerve, and record for the instruction and admiration of future generations, their deeds of noble daring.*[135]

Draper's correspondence with George Sevier proved fruitful, particularly in his efforts to chronicle the details of the Battle of King's Mountain. In his book, Draper cited a statement by Joseph Sevier that George provided that conveyed a dramatic moment during the battle when it was falsely rumored that John Sevier had been mortally wounded. Draper recorded:

> *Joseph Sevier, son of Col. John Sevier, at the Battle of King's Mountain, had heard that his father had been killed in the action—a false report, originating, probably, from the fact of the Colonel's brother, Captain Robert Sevier, having been fatally wounded; and the young soldier kept up firing upon the huddled Tories, until admonished to cease, when he excitedly cried out, with the tears chasing each other down his cheeks— "The damned rascals have killed my father, and I'll keep loading and shooting till I kill every son of a bitch of them." Colonel Sevier now riding up, his son discovered the mistake under which he had labored, and desisted.*[136]

As Draper prepared his book for publication, he continued to make research trips and gather manuscripts. Even as the Civil War raged, Draper journeyed thousands of miles by rail, carriage, boat and on foot throughout the South "in quest of border historical facts and documents."[137] As Union forces marched through the Confederacy, burning courthouses and destroying documents and artifacts held in Southern repositories, Draper persisted in collecting the manuscripts of these early pioneers and saved many of these legendary tales from certain destruction. What Draper amassed, in many cases, served as the only documented evidence left of the early settlement of the Old Southwest in the aftermath of the Civil War.[138]

If collecting historic manuscripts remained his only goal, Draper would have achieved unparalleled success in his life's work, but such was not the case. Draper aspired to become a popular writer and to publish the biographies of the heroes of the western borderlands. Nevertheless, between his continual physical afflictions and his proclivity to collect manuscripts and compile research notes rather than write, Draper lacked the motivation to finish his projects. As Draper's biographer William Hesseltine noted, "All his life Draper was planning to write books, but some psychological quirk made it impossible for him ever to realize his dreams."[139]

Draper's fellow antiquarian Dr. James Gettys McGready Ramsey followed his career with interest and continually prodded Draper to finish his biographies, even proposing a collaborative effort to complete the work.[140] In a professional career that spanned more than six decades, Ramsey worked as a renowned physician and a visionary entrepreneur. He served as a canal commissioner and a railroad financier and actively promoted economic and business activity throughout East Tennessee. As a school commissioner and trustee of three colleges, he supported education in a region not known for institutes of higher learning. He devoted himself to the Presbyterian Church as an elder. As a committed secessionist during the Civil War, Ramsey worked as a treasury agent for the Confederacy.[141] Yet for all his talents and aspirations, Ramsey established his vocational legacy as a scholar and chronicler of early Tennessee history.

Born on March 25, 1797, just a few miles east of Knoxville, Tennessee, Ramsey could trace his lineage back to Tennessee's infancy, and his ancestry remained a source of great personal pride. Ramsey once described himself as "one of the first born of the sons of the State of Tennessee" and as "the connecting link between the pioneers and their successors in the Volunteer State."[142] His father, Colonel Francis Alexander Ramsey, worked as a surveyor and as an official with Sevier's failed state of Franklin.[143]

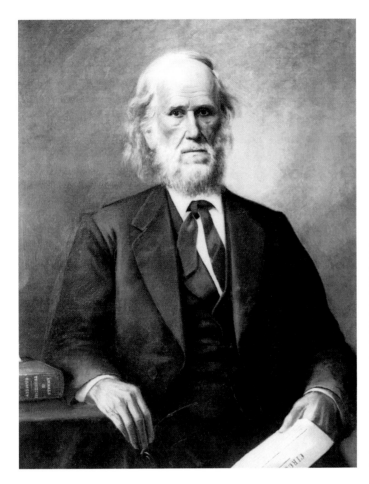

In 1853, Dr. James Gettys McGready Ramsey (1797–1884) published his most enduring work, *The Annals of Tennessee to the End of the Eighteenth Century. Tennessee Historical Society Collection, Tennessee State Library and Archives.*

Ramsey considered it his civic duty and patriotic mission to document "the adventures and perils of Tennessee pioneers."[144] In 1834, he supported the formation of the East Tennessee Historical and Antiquarian Society and its mission to collect materials and publish works related to the settlement and early history of Tennessee.[145] The society gave Ramsey the title of perpetual corresponding secretary. In that role, Ramsey cataloged historic documents and provided a home for artifacts owned by the society. For years, his estate housed the organization's library and museum, and Ramsey served as its chief historian.[146]

By the middle of the nineteenth century, Ramsey had built what he described as the best library "in the western states."[147] Ramsey made frequent visits to repositories throughout the southeast, transcribing

documents found in the archives. Ramsey's brother, William, also served as the secretary of state for Tennessee—a connection that gave him privileged access to the state archives in Nashville. There he copied the "messages of the governors, the Senate and House journals, and other necessary materials."[148] He gathered the personal papers of several early Tennessee pioneers, including those of Sevier, given to the society by his son George.[149] Ramsey further communicated with Sevier's contemporaries, documenting their stories through personal interviews and letters. On one occasion, Ramsey recorded, "I dropped all other business to linger around the pension office for several days, take the old and feeble Revolutionary soldiers home with me, [and] take down their services and their recollections of the past in my note book."[150] Ramsey placed a great deal of emphasis on these oral traditions—a practice later criticized by historians who viewed his reliance on the memories of elderly men as a weakness in his scholarship.[151]

Eventually, all his work to chronicle the lives and adventures of these "worthy pioneers" culminated in the 1853 publication of his book *The Annals of Tennessee to the End of the Eighteenth Century*. A massive tome of 744 pages, *The Annals* covered the state's earliest history to 1800 in great detail, focusing primarily on the key battles and biographies of the "prominent actors" of Tennessee's past, with particular attention paid to Sevier.[152] "If my book has one fault greater than another it is the minutiae and details of Sevier," Ramsey wrote. He continued, "It reads too much like a biography of him rather than the history of Tennessee. But his life is the history of East Tennessee."[153] Ramsey later told his friend and fellow antiquarian Draper, "When you come to Sevier my book makes him its hero. Indeed, his life is Tennessee history itself. He is not only in every chapter, but every page."[154] In *The Annals*, Ramsey regretfully remarked, "The account of the lives of all these pioneers is so meager and unsatisfactory. The biography of each of them would be now valuable and interesting."[155] This shared passion for Tennessee's frontier founders forged a lasting bond between Ramsey and Draper that endured for decades.

Ramsey and Draper corresponded often, detailing their research discoveries and communications with the aging veterans of Tennessee's pioneer past. Draper, however, continually lost focus. Besides his constant health problems and penchant for research rather than writing, Draper also allowed other pursuits to distract him from his life's work. During one particular letter exchange with Ramsey, Draper expressed his desire to turn his attention to farming—a particularly odd choice considering his frail health. On February 1, 1870, Ramsey wrote to Draper, congratulating him on his noble pursuit.

"I am glad to see you have turned your useful attention to that greatest of all services, farming," Ramsey wrote. Still, Ramsey challenged Draper to continue his literary pursuits. He wrote, "You must not let border biography cease to be your chief object. What has prevented you from publishing? Do not delay any longer. Others may write about fields and planting and stock raising no one but Mr. Draper can write of Boone, Clark, Robertson and Sevier but you. Finish and publish at once."[156] By the spring of the same year, Ramsey continued to urge his friend along, hoping that perhaps money would provide motivation. "I have wondered why you have not already published one of your subjects as an experiment," Ramsey wrote. "If Boone or Sevier or Clarke was before the reading public I know, impoverished as some of our western and southwestern states are, that would sell well."[157]

Ramsey long admired Draper's efforts in building the collections of the Wisconsin Historical Society and seemed almost envious of Draper's achievements. In 1873, after receiving Draper's annual report of the Wisconsin Historical Society, Ramsey wrote to his friend with overflowing adulation, "When I compare your achievements for Wisconsin with the little that has been affected for Tennessee I blush and feel mortified, exceedingly so."[158] By May 1873, Ramsey again wrote Draper offering to assist with his "research and investigation of Tennessee History or the biography of her people."[159] In the postscript to his letter, Ramsey once more pleaded with Draper to publish his work. "I do hope before I die that you may publish some of your *Border Warfare*. Especially Sevier, Robertson, Boone, Sumter, and others. Put one of them out now as a feeler. We are all satisfied about the work, but we old men in Tennessee want to see even a part of your *magnum opus*."[160] When Draper answered his mentor, he complained of poor health and the fact that he had made little progress on his writings. Ramsey urged him to soldier through his physical limitations and continue his work. Ramsey wrote, "You are doing and have done more than any ten men in this wide world. The Plutarch of the West shall not say this to me who knows all about this matter. You are overworked and have been so ever since I knew you. Hence the neuralgia in your right arm, your dyspepsia, and the consequent debility. I must volunteer a prescription for you: Not to quit work—that would be fatal."[161]

As the centennial anniversary of the Battle of King's Mountain approached, Ramsey continued to encourage his friend to complete his work. On March 11, 1880, Ramsey implored, "Lay down everything else and give *King's Mountain and Its Heroes* to the press. I think there will never be a more suitable or opportune an occasion to inaugurate the business of your life…All the surroundings of the situation point out 1880 as the very

time for beginning of the ceremonials."[162] By the summer, Ramsey's appeals grew more intense. "The celebration at King's Mountain will wind up the centennial and will indeed be its most prominent feature. If your publisher can get out the volume and have some of them on hand the sixth, seventh, and eighth the book will be canonized at once—its fortune assured."[163]

Despite these words of encouragement and the interest expressed by the families of the veterans of the Battle of King's Mountain, Draper achieved very little commercial success after he published his "magnum opus." Draper's frequent illnesses and distractions delayed his writing to the point that he missed a golden marketing opportunity to publish his book during the centennial anniversary of the Battle of King's Mountain on October 7, 1880. By the time his book finally reached publication in September 1881, the centennial moment had passed and sales of *King's Mountain and Its Heroes* suffered. The public perceived Draper's book as a work of regional, not national, interest. Even Draper's publisher, Peter G. Thompson, disclosed reservations about the success of the book. "I fear you will be disappointed in the sales so far. I am, but can do no better," he wrote. "The great trouble is that the book is *too local* in character, and the people in the section of the country where it should sell best are too poor to buy it. But you know this as well as I do. The book, however, will pave the way for one that will sell better later on."[164]

Thompson's words proved prophetic. Although *King's Mountain and Its Heroes* initially failed as a commercial venture, subsequent generations of writers, scholars and critics appreciated Draper's work. Draper never realized his full potential as an author, but as a collector of the history of America's first frontier, he knew no equal. Draper was, as Hesseltine noted, "a maker of heroes."[165] His work to "rescue from oblivion" the memory of the South's early pioneers and "to obtain and preserve narratives of their exploits, perils, hardy adventures, and patriotic achievements" paved the way for other writers to begin documenting the early history of the region and Sevier's important role in its settlement. These storytellers linked the Battle of King's Mountain with more famous accounts of revolutionary heroism and mythology and created a climate of opinion that the frontier stories chronicled in *King's Mountain and Its Heroes* deserved to be remembered.[166] In doing so, they delivered Sevier from the shadows of regional obscurity and placed him among the legendary Patriots of the American Revolution.

5
OLD TALES RETOLD

The ardor of Sevier's own spirit was ablaze in every heart.
Octavia Zollicoffer Bond, 1906

Many of the legends and folktales surrounding the Battle of King's Mountain originated from oral traditions passed down through generations. The descendants of the Overmountain Men who fought at the battle desired that their ancestors be remembered for what they had accomplished on that fateful hour on October 7, 1780. Even the veterans of the battle, many years after the fact, held great pride in what they achieved for freedom in the southern theater of the Revolutionary War. From that longing for recognition, a brand of storytelling emerged that transcended historical facts. The facts alone would have honored the Overmountain Men's victory and John Sevier's leadership in the Battle of King's Mountain, but patriotism and pride led southern writers and historical scholars to embellish the facts with a bit of legend and lore.

"The Ride of the Rebel," led by a man named James "Jimmy" Blair, became one of several folk legends that emerged from the stories told by those elderly veterans of the battle and their descendants. Blair served the Patriots' cause in the Revolutionary War as an orderly sergeant, ensign and Indian spy. As one of several "express riders," he alerted troops that the British Loyalists had gathered for a battle at King's Mountain. He roused the Overmountain Men to meet at Sycamore Shoals, where they began their march toward the enemy and subsequently handed the British Crown its most stunning defeat in the southern campaign.[167]

Monument at Sycamore Shoals, erected in 1909, marks the spot where the American Patriots assembled in 1780 to march toward King's Mountain. *Department of Conservation Photograph Collection, Tennessee State Library and Archives.*

A pension statement Blair submitted in 1832, over five decades after the Battle of King's Mountain, documented his ride through the backwoods of North and South Carolina. After several daring encounters with the Tories along his journey, the enemy shot Blair in the shoulder, but he managed

to escape and continued his ride through the countryside to muster up the troops.[168] His story on its own factual merit certainly demonstrated heroism, but many years following his pension application, author and antiquarian John Trotwood Moore popularized Blair's ride with a poem. Entitled the "Ride of the Rebel," Moore's tribute to Blair published in the August 1907 issue of his literary publication the *Taylor-Trotwood Magazine*. Evoking feelings of patriotism, Moore described Blair as the "Paul Revere of the South."[169] Moore's poem endeavored to create a distinctly southern hero of the American Revolution:

This is the ride of Jimmy Blair,
This is the race he ran—
Through forest wild and Tory lair
To summon the King's Mountain men.
You will find it not on the gilded page
With the pampered steed of fame,
You will find it not in this hireling age
Where they run for money and shame,
But on King's Mountain starlit stage
'Twill live in deathless name.

Over the border the British came,
Their jackets red as the sun;
City and hamlet had felt the flame
From the flash of the red-coat's gun.
Over the border Ferguson rode—
He never rode back again,
For Jimmy Blair his horse bestrode
And galloped with might and main.

Through Surry and Wilkes to Cleveland's tent,
Over hill and through valley he sped,
And he roused the patriots as he went
As Gabriel will rouse the dead;
"Go! For your country's life!" he said,
And away like a ghost he was gone,
Riding from morn to midnight deep,
From midnight on to morn—
O, never was a race like that
Since gallant steed was born!

The moon rose up to see it,
And the great red-yellow eye
Of the morning star new luster took
As the game boy galloped by.
The lurking savage hid in his path,
The Tory lay in his road—
He swam the river with a ball in his breast
And gained the fort at the ford.

And Shelby came, and Williams,
And Cleveland and Sevier,
Fifteen hundred rifles
In the morning answered "Here."
They killed and captured Ferguson,
With all his Tory clan,
The patriots stormed their crested heights
And took them to a man.
They turned the tide of the war that day,
Which, turning swept the land
Of every British musket,
Of every Tory hand.

This is the ride of Jimmy Blair;
This is the race he ran—
The greatest race that ever was run
In the record of horse and man.
For Fame that day rode horse of gray,
And Glory guided the rein—
The purse? Our own great country—
Say, will it ever be run again?[170]

In the years that followed the publication of "Ride of the Rebel," Moore became Tennessee's state librarian and archivist. He not only established himself as a literary man and a local color writer who wrote chiefly as a novelist, poet and magazine editor but also as Tennessee's chief historian. This gave Moore's version of Blair's ride historical credibility, despite being a work of poetry.[171]

Moore's literary effort to chronicle Blair's journey gained significance, in part, because so little had been written about the South's influence on

the outcome of the American Revolution. Southern writers often lamented the fact that the southern campaigns seemed largely ignored in the overall narrative of the Revolutionary War, while battles fought in the North were well documented. Moore saw things differently. He believed our nation should be grateful that northern writers and historians chronicled their history and that northern antiquarians, such as Lyman Draper, saved the pioneer stories of the South for posterity. He defended Draper from accusations that he failed to deliver on promises to write a comprehensive history of the early South. Using the Blair story as an example, Moore issued a scathing rebuke to his fellow southerners:

> *We have no license to complain because other people have written our histories and our literature. To the credit and glory of New England and much of the north, they began to write their history while they were making it. As they knew but little of the truth of ours, naturally they intensified their own. King's Mountain was the turning of the tide of the Revolution. Jimmy Blair's Ride, in this crisis, of a day and a night through the wilderness, assembling the Carolinians and Wautauga boys, shot through the breast by Tories, but gamely swimming the last river and warning the fort, was a greater and more perilous ride than Paul Revere's. All Jimmy needed was a Longfellow...*
>
> *I have no patience with our people who criticize the thoughtfulness and enterprise of our northern neighbors who have done what we have failed to do. We neglect our literary men to starve or go to New York before they are appreciated. We permit the names of our magazines to adorn headstones in a potter's field of ineffectual attempt. We permit our poets to starve—even such as Sidney Lanier and Henry Timrod, and our novelists to leave their home nest of sanity and truth to write popular, sexual and erratic rot for the big magazines for big pay. We should, therefore, blame ourselves and not the Drapers of other states.[172]*

Moore later added, "To the eternal credit of the North all such incidents as these happening then, such as the ride of Paul Revere, have been embodied into their literature. The South, with her wealth of them, has neglected her opportunity, forgetting that it is the literature and not the history of a country which lives."[173]

Despite Moore's claims to the contrary, expressions of literary praise for Sevier and his Overmountain Men not only existed but also thrived within the South. In a scene reminiscent of Henry Wadsworth Longfellow's poem

"Paul Revere's Ride," Tennessee author Octavia Zollicoffer Bond further mythologized the express riders and made Sevier the central hero in her 1906 book, *Old Tales Retold*. In her account she wrote:

> *Without delay each trusty courier sprang to the saddle and sped away to rally the patriots of the frontier country. There was not a cove or valley which they did not penetrate with the message. Nor was there a mountain height on which a cabin might be perched where they did not tell the news. "The Redcoats are coming!" they shouted aloud; "Rally for Chucky Jack and freedom!" And on they went through all the thinly settled region, only pausing long enough at each "clearing" to cry: "Ferguson is not far off, making his boasts that he will come and burn out our hornets' nest and hang our leaders. Rally for Chucky Jack! The Redcoats are coming!"[174]*

Once all of Sevier's men answered the summons to gather at Sycamore Shoals, Bond described the scene with even more gallant pride. The Overmountain Men, "dressed in homespun hunting shirts and leggings, with buck's tails in their hats for plumes…were remarkable for height and strength of body; and each one of them was a sure marksman with his flintlock gun, as well as skillful in the use of the knife or tomahawk in his belt."[175] She portrayed Sevier with an equally vivid and heroic description:

> *Sevier's erect figure, wherever it appeared, was the signal for hearty cheers and greetings. Every man in the ranks was his devoted friend. He had something to say to each, with special, personal kindness. To all alike he said in the quiet, magnetic voice which made his lightest word a command: "We must whip Ferguson." The cry was caught up from man to man, spreading from rank to rank, and gathering force as it went, till the Watauga hills resounded with the shout: "We must whip Ferguson!"[176]*

With that, Bond wrote, "The ardor of Sevier's own spirit was ablaze in every heart."[177]

Sevier's men then paused to hear the Reverend Samuel Doak deliver a sermon, which became another source of legendary folklore. A Presbyterian minister and pioneer, Doak was well known among the settlers of the Holston Valley. The son of Irish immigrants, Doak, a native Virginian, had studied theology at the Academy of Liberty Hall—now Washington and Lee University—before attending an academy in Maryland. Doak then entered the College of New Jersey—now Princeton University—where he graduated

Samuel Doak (1749–1830), a minister and pioneer founder of the earliest schools and many of the Presbyterian churches of East Tennessee. *Tennessee State Library and Archives.*

in 1775. He assumed his first pastorate in Abingdon, Virginia, and, by 1780, had moved to Washington County, where he founded the earliest schools and many of the Presbyterian churches in the region. There he formed Salem Church and St. Martin's Academy in 1783, the first chartered school in the region. In 1795, St. Martin's Academy became Washington College, named "in honor of the illustrious President of the United States," George Washington—the first institution to bear his name.[178]

According to tradition, Sevier asked his friend Doak to conduct religious services for the men gathered at Sycamore Shoals in advance of their march to engage the British forces at King's Mountain. On September 26, 1780, Doak stood before the Overmountain Men and delivered a sermon inspired by the biblical story of the Israelite farmer Gideon and his "Valiant Three Hundred." Gideon's small army defeated a vastly superior Midianite army by the sheer force of God's will. Doak hoped this story would stir the Overmountain Men to victory over the Tories at King's Mountain.[179]

The distinguished historian J.G.M. Ramsey knew Doak well. Ramsey attended Washington College in 1813 while Doak served as the vice-president of that institution.[180] In a letter to Draper dated July 12, 1880, nearly a century after the Battle of King's Mountain, Ramsey testified to the truth of Doak's words. He wrote:

> *It is an invariable tradition all over East Tennessee that on the point of the march of the rifleman from Sycamore Shoals on Watauga, the troops engaged in divine service and were addressed by a Presbyterian clergyman then present. This minister is said to have been Reverend Samuel Doak...The tradition has preserved this further that in his prayer or address he used the words or petition "Teach our hands to war and our fingers to fight," and also "The Sword of the Lord and of Gideon!" I have heard this tradition from my boyhood and from all my knowledge of the man I believe it substantially true.*[181]

A year later, Draper sought to validate Ramsey's claims in his book, *King's Mountain and Its Heroes*. He recorded, "'This,' writes the venerable historian, Dr. J.G.M. Ramsey, 'is the tradition of the country, and I fully believe it.'"[182]

Many years later, in 1968, Pat Alderman published perhaps the most complete account of Doak's sermon in his book *One Heroic Hour at King's Mountain*. Alderman obtained the story "through the courtesy of Mrs. Rollo H. Henley, Washington College, Tennessee...taken from the scrapbook of her father, J. Fain Anderson."[183] As a local historian, Anderson wrote several

articles on East Tennessee history for the *Knoxville Tribune* and other newspapers and maintained membership in the East Tennessee Historical Society.[184]

Within Anderson's scrapbook, Alderman found what he believed to be the very words Doak preached to the Overmountain Men on September 26, 1780. In fact, in his book, Alderman stated that he copied Doak's sermon and prayer "verbatim" from the scrapbook, though it remains unclear from this account whether the words actually came from Anderson himself. Nevertheless, Alderman treated Anderson's account of Doak's sermon as if Doak transcribed his own words on the very day he delivered them. Filled with patriotic fervor, this version of Doak's sermon contained several phrases that seemed tailor-made for Anderson's contemporaries rather than for the Overmountain Men themselves:

> *My countrymen, you are about to set out on an expedition which is full of hardships and dangers, but one in which the Almighty will attend you.*
>
> *The Mother Country has her hands upon you, these American Colonies, and takes that for which our fathers planted their homes in the wilderness—OUR LIBERTY.*
>
> *Taxation without representation and the quartering of soldiers in the homes of our people without their consent are evidence that the Crown of England would take from its American Subjects the last vestige of Freedom.*
>
> *Your brethren across the mountains are crying like Macedonia unto your help. God forbid that you shall refuse to hear and answer their call—but the call of your brethren is not all. The enemy is marking hither to destroy your homes.*
>
> *Brave men, you are not unacquainted with battle. Your hands have already been taught to war and your fingers to fight. You have wrested these beautiful valleys of the Holston and Watauga from the savage hand. Will you tarry now until the other enemy carries fire and sword to your very doors? No, it shall not be. Go forth then in the strength of your manhood to the aid of your brethren, the defense of your liberty and the protection of your homes. And may the God of Justice be with you and give you victory.*
>
> *Let us pray.*
>
> *Almighty and gracious God! Thou hast been the refuge and strength of Thy people in all ages. In time of sorest need we have learned to come to Thee—our Rock and our Fortress. Thou knowest the dangers and snares that surround us on march and in battle.*
>
> *Thou knowest the dangers that constantly threaten the humble, but well beloved homes, which Thy servants have left behind them.*

O, in Thine infinite mercy, save us from the cruel hand of the savage, and of tyrant. Save the unprotected homes while fathers and husbands and sons are far away fighting for freedom and helping the oppressed.

Thou, who promised to protect the sparrow in its flight, keep ceaseless watch, by day and by night, over our loved ones. The helpless woman and little children, we commit to Thy care. Thou wilt not leave them or forsake them in times of loneliness and anxiety and terror.

O, God of Battle, arise in Thy might. Avenge the slaughter of Thy people. Confound those who plot for our destruction. Crown this mighty effort with victory, and smite those who exalt themselves against liberty and justice and truth.

Help us as good soldiers to wield the SWORD OF THE LORD AND GIDEON. Amen.[185]

Doak's words surely stirred the hearts of the Overmountain Men on that day. The historical fact remains, however, that while Doak did speak forcefully to spur the men to action, only Ramsey's "traditions" and Anderson's word offer evidence of what exactly he said. These men based the record of Doak's sermon on recollections—not notes—of the men present for the sermon and on stories passed down through many generations of descendants. Writers committed the sermon to paper many years after the Battle of King's Mountain, at a time when the chroniclers of Tennessee history sought to canonize Sevier and his fellow Patriots, believing these great heroes had not received full credit for their roles in turning the tide of the American Revolution.

Another legend that emerged from the Battle of King's Mountain centered on a long rifle nicknamed "Sweet Lips." According to oral tradition, "Sweet Lips" drove a bullet between Patrick Ferguson's eyes with deadly accuracy and ultimately struck down the British army in the southern theater. Draper chronicled the legend of "Sweet Lips" in his book, *King's Mountain and Its Heroes.* He wrote:

One of Sevier's men, named Gilleland, who had received several wounds, and was well-nigh exhausted, seeing the advance of Ferguson and his party, attempted to arrest the career of the great leader, but his gun snapped; when he called out to Robert Young, of the same regiment— "There's Ferguson, shoot him!" "I'll try and see what Sweet-Lips can do," muttered Young, as he drew a sharp sight, discharging his rifle, when Ferguson fell from his horse, and his associates were either killed or

driven back. Several rifle bullets had taken effect on Ferguson, apparently about the same time, and a number claimed the honor of having shot the fallen chief—among them, one Kusick, another of Sevier's sharpshooters. Certain it is, that Ferguson received six or eight wounds, one of them through the head. He was unconscious when he fell, and did not long survive. It was in the region of Sevier's column that he received his fatal shots; and not very far, it would seem, from where Colonel Shelby had posted Ensing [sic] Robert Campbell to watch the motions of the enemy so strongly ensconced behind the range of rocks.[186]

From Draper's account, it cannot be determined with absolute certainty which gun felled Ferguson on that day. Other descriptions of the scene named Darling Jones as the man who fired the fatal shot, although pension records seem to contradict those accounts. Nevertheless, as time passed, the indelible story of "Sweet Lips" captured the imagination of the chroniclers of the Battle of King's Mountain. One account published in the *Johnson City Press* declared, "When Sweet Lips' metallic lips so spoke on that day of patriotic struggle, its voice was heard throughout the entire British armies and turned the tide of the revolution."[187]

Even country music performer Louis Marshall Jones, better known as "Grandpa Jones," celebrated the legend of "Sweet Lips" in song. Accompanied by his famous banjo, Grandpa Jones immortalized "Sweet Lips" and the Battle of King's Mountain in 1973 with a musical tribute. Throughout the song's creative lyrics, Jones wove a tale describing the moments leading up to the Battle of King's Mountain and the battle itself. In the chorus, Jones credited a Tennessee girl with inspiring the name of the rifle that struck the decisive blow for freedom:

Sweet Lips was a rifle named for a girl in Tennessee.
When Sweet Lips spoke,
The chains that bound us broke.
She's gone and did her part for liberty.[188]

Another larger-than-life story entered into the King's Mountain narrative—a particularly tall tale involving a giant of a man named Joseph Greer. Sevier chose Greer to carry the message of victory over the British Loyalists at the Battle of King's Mountain to Philadelphia, where members of the Continental Congress gathered to govern the new nation. Historians, genealogists and descendants of Greer have all noted Greer's towering

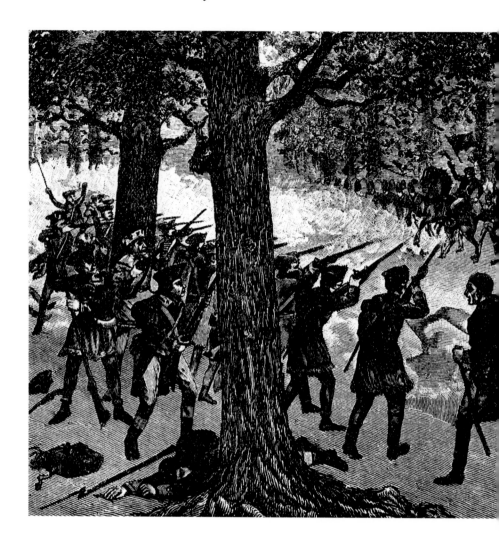

height. Throughout their narratives, some writers proposed that Greer stood at six feet, seven inches tall, while other accounts had him reaching heights of more than seven feet.[189] They further described his great skill in dealing with the Indians. According to various accounts of his journey to Philadelphia, however, Greer did not always fare so well in these encounters. At one point, Indians shot Greer's horse out from underneath him, and on another occasion, he hid inside a hollow log while Indians sat on it.[190] One wonders how a man of this stature managed to hide himself inside a log without detection, but nevertheless, Greer made his treacherous journey through hostile territory with only a compass and a blinding determination

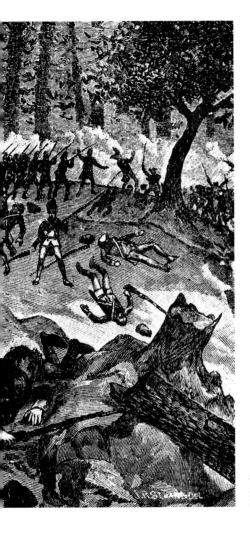

Battle of King's Mountain—Ferguson's Death Charge.
From Lyman Draper's King's Mountain and Its
Heroes, *1881.*

to spread the news of this great victory to guide him, earning him the nickname the "King's Mountain Messenger."[191]

The Continental Congress received Greer's message in November 1780, one month following the victory at King's Mountain. No one within the halls of government knew about the battle until Greer's arrival, but news of this victory over the British Loyalists quickly spread throughout the former colonies, reviving hope that the nation would emerge from this brutal war victorious.[192] Thus, the Battle of King's Mountain ensured its place in historical memory as the turning point of the American Revolution in the South, due in no small measure to the message that Greer carried

Thomas Greer, photographed at the grave site of his father, Joseph Greer, the "King's Mountain Messenger." *Tennessee State Library and Archives.*

along his incredible journey. That message also helped establish Sevier as a Revolutionary War hero, placing him on a path to future greatness.

Throughout various accounts of the "King's Mountain Messenger" story, one finds Greer's stature paramount to telling the tale. Take, for instance, the following biographical sketch found within the Joseph Greer Family Papers held at the Tennessee State Library and Archives. Written in July 1929, "A Tennessee Hero: The King's Mountain Messenger" not only opened a window into Greer's trek following the Battle of King's Mountain but also, more importantly, provided readers with a glimpse into the thinking of those who endeavored to chronicle his journey many years later:

> *The First battle which broke the opposition of the British in the war for American Independence was fought at King's Mountain, South Carolina—on October 7ᵗʰ 1780, under the command of John Sevier, Tennessee's first Governor, aided by Virginians, Kentuckians, Carolinians, and Tennesseans.*

These hardy liberty loving Americans drove Ferguson and his red coats to defeat, and from that event British aggression begun [sic] to crumble and American Independence was assured. The very beginning of the birth of this Nation.

Among the volunteers who came from Watauga, was a physical giant, seven feet tall; in the making of this man nature exhausted her ability; only twenty-six years old, full of vigor and inheriting through his Irish Ancestry, and indomitable will, for some good reason, not shown in history, presumably a knowledge of his fearlessness, determination, or perhaps some outstanding feat of bravery in battle, this young giant, Joseph Greer, was selected by those in command to advise President George Washington and the Congress then in session at Philadelphia, that the heroic frontiersmen in coon skin caps and with flint lock guns had reaped the first American Victory in the Revolutionary War, by defeating the British at King's Mountain.

A signal honor—an outstanding incident in this Nation's history—A Tennessean selected to bear the good news to the Nation.

Alone Joseph Greer, began his long trip walking over the mountains and valleys, guided by his compass from Watauga to Philadelphia, slung across his shoulder his musket and food. His experience as a surveyor, his knowledge of Indians, enabled him to safely reach Philadelphia; on arrival, he inquired the way to American headquarters; brushing past the doorkeeper without a word, strode into the midst of the assembled Congress and delivered the message, which fanned the flame of patriotism into an all consuming soul fire, from which resulted the American Victory, the origin of the United States of America.

The great size, the physical bearing of this twenty-six year old American, bedecked with a coon skin cap and his long overcoat, his trusty musket and brass compass as a pilot, amazed the people of Philadelphia.[193]

Other writers took creative license with historical accounts of Greer's journey. In *The Overmountain Men*, Alderman described, "Young Greer, twenty years old and over seven feet tall." Alderman repeated another tradition handed down through the generations by recalling George Washington's supposed words following Greer's arrival in Philadelphia. He wrote, "It is said that General Washington commented, 'With soldiers like him, no wonder the frontiersmen won.'"[194]

In yet another account of the "King's Mountain Messenger" legend, author James Ewing created a tall tale even larger than Alderman's story. "For sheer drama, few happenings of early times can match the sight of seven-foot, two-inch

Speeding the News to the Continental Congress. This illustration from a Tennessee National Guard advertisement portrays Joseph Greer's dramatic arrival in Philadelphia. *Prominent Tennesseans Photographs, Tennessee State Library and Archives.*

Joseph Greer," Ewing wrote. Describing Greer as "a Tennessee backwoodsman," Ewing further added that Greer arrived in Philadelphia "walking boldly into the chambers of the Continental Congress and informing the startled members that the battle of King's Mountain had been won."[195]

The Patriots' victory at the Battle of King's Mountain in itself proved an impressive feat, yet the folk tales that emerged in the years that followed elevated the battle to a mythological realm. The "Ride of the Rebel," Doak's sermon, "Sweet Lips" and the "King's Mountain Messenger" legends all served to bolster the desires of Sevier's admirers by connecting these extraordinary events with Sevier's great victory. Thus, these traditions cemented Sevier's role as a hero, ensuring that his victory in the Carolina backcountry would thereafter be acclaimed "the turning point in the American Revolution."

A SUITABLE MONUMENT TO COMMEMORATE THEIR DEEDS

The recollections of the crowded hours of this glorious action of our fathers speak to the heart, and make us feel, more than all the rest, that we are one people.
George Bancroft, 1855

In the immediate aftermath of the Battle of King's Mountain, carnage and devastation covered the once quiet forest. On October 8, 1780, soldiers deposited among the rocks and ravines of the rugged landscape the bodies of the 28 Patriots and the 225 British Loyalists who died in the battle. John Sevier's Overmountain Men wrapped Patrick Ferguson's body in raw beef hide and hastily buried him in a shallow grave, as fears circulated that the British might be on the way with belated reinforcements.[196] Further, as word came that the Cherokees prepared to assault their abandoned dwellings, Sevier and his men raced home as fast as their horses could carry them.[197] Circumstances allowed no time to pause for memorials.

In the days that followed, wolves and vultures, attracted by the smell of blood, feasted on the remains of these fallen soldiers, scattering their bones throughout the mountainside. For several decades thereafter, the land on which these men fought remained a hunting ground. No monument stood to honor them. Nothing remained for the survivors and their families to return to in solemn remembrance. King's Mountain yielded to nature's design.[198]

Thirty-four years later, on July 4, 1815, a surgeon and veteran of King's Mountain named Dr. William McLean returned to the scene of the battle to pay his respects. He brought with him friends, family members and several

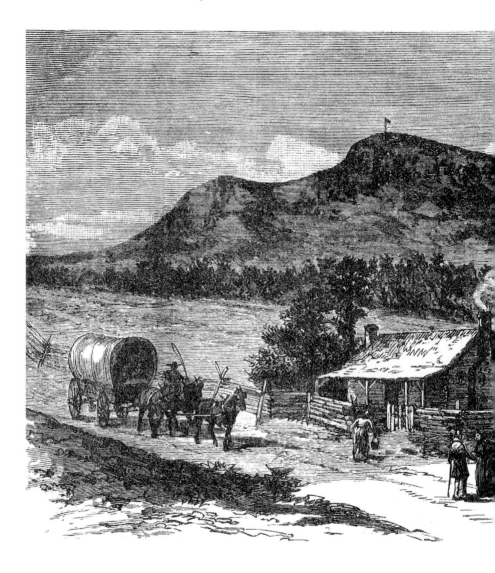

relatives of the men who had died at King's Mountain to gather up the
scattered bones of the fallen and to commemorate their victory.[199] At his own
expense, McLean erected a dark slate rock marker in honor of his comrades.
On the marker were inscribed these words:

> *Sacred to the memory of Major William Chronicle, Capt. John
> Mattocks, William Rabb and John Boyd, who were killed at this place
> on the 7th of October, 1780, fighting in defense of America.*

A View of King's Mountain. From Lyman Draper's King's Mountain and Its Heroes, *1881.*

On the opposite side of the marker, McLean paid tribute to the British foe that the Overmountain Men vanquished on that battlefield:

> *Colonel Ferguson, an officer of his Britannic majesty, was defeated and killed at this place on the 7th of October, 1780.* [200]

The solemnity of this occasion provided a striking contrast to celebrations that took place throughout the country on that Independence Day. In 1815, citizens of the United States triumphed in the glory of their most recent

victory over the British in the War of 1812. Meanwhile, the veterans of King's Mountain gathered in quiet reverence to remember their fallen comrades and to somberly acknowledge a common enemy.[201]

For several years, McLean's marker stood as the only battlefield reminder of the events that took place on King's Mountain. No ceremonies honored the dead or their accomplishment in turning the tide of the American Revolution. Over time, McLean's marker suffered from neglect and vandalism. Weathered and worn, the lettering became obscured just as memories of what happened on King's Mountain faded. Seventy-five years after the battle, however, on October 7, 1855, a flood of memories returned to that sacred spot as nearly fifty-five thousand people gathered in the Carolina wilderness to remember William Campbell, Isaac Shelby, John Sevier and their army of Overmountain Men.[202]

Prior to the seventy-fifth anniversary commemoration, companies of militia from North Carolina and Virginia encamped on the battleground for several days. On the anniversary of the day of the battle, two grandsons of Colonel Campbell—Honorable William Campbell Preston and General John S. Preston—attended the ceremony.[203] William Preston gave a particularly rousing speech that "was received with a perfect storm of applause," according to one reporter's account.[204] The keynote speaker followed a review of the military complete with celebratory cannon fire. The venerated historian and statesman George Bancroft held the attention of the assembled crowd for two hours. With an eloquent address that spoke to the events of seventy-five years ago, he also raised the concerns of the day.

In 1855, the United States found itself divided over the issue of slavery. A year earlier, Congress passed the Kansas-Nebraska Act, which sparked a violent conflict between proslavery activists and antislavery Free Staters in what would become a bloody prelude to the nation's Civil War.[205] North and South, bitterly divided, sought unity briefly in the remote wilderness of King's Mountain. In his speech, Bancroft played to the emotions of his southern audience, acknowledging the South and its important role in the outcome of the Revolutionary War, but Bancroft also used this moment to proclaim the Battle of King's Mountain a unifying force. Bancroft aimed his words to strike at the heart of the southern people, evoking a spirit of patriotism and a call for national unity. In his speech, Bancroft called northern interest in this seventy-fifth anniversary celebration "an act of reciprocity" and stated his belief that "the South cherishes the memory of every noble action in behalf of liberty without regard to place." He further added:

There is still stronger reason why the North should give you its sympathy on this occasion. She sent you no aid in the hour of your greatest need. It is a blessed thing to give even a cup of cold water in a right spirit: it was not then possible to give even that. All honor must be awarded to the South, since she was left to herself alone in the hour of her utmost distress. The romance of the American Revolution has its scenes for the most part in the South; and the Battle of King's Mountain of which we celebrate the seventy-fifth anniversary today, was the most romantic of all.[206]

Bancroft declared, "The States are bound together by commerce, and dovetailed by canals and rivers and railroads; but the recollections of the crowded hours of this glorious action of our fathers speak to the heart, and make us feel, more than all the rest, that we are one people."[207]

Bancroft concluded his remarks by calling for officials to preserve the battlefield on which these brave men fought. "Let the battleground before us be left no longer as private property; let it be made the inheritance of the people, that is, of all who are heirs to the benefits that were gained on the day which we commemorate," Bancroft said. He added, "Let a monument rise upon its peak as a memorial of the heroism of our fathers—as evidence of the piety of their sons."[208]

Despite Bancroft's emotional call for national unity, expressions of regional pride for the South and seething disdain for the North marked the seventy-fifth anniversary celebration. During the ceremonies, attendees toasted the South with the wish that Virginia and the Carolinas would continue to guard "their constitutional rights and liberties against a common foe."[209] This veiled reference to the smoldering controversy over the institution of slavery characterized the mood present during the entire ceremony. Not even the esteemed Bancroft united spirits on this day of celebration.

In the years that followed, the divided nation declared war on itself. On April 12, 1861, the firing on Fort Sumter launched the Civil War, which nearly erased all memory of what Sevier and his compatriots had accomplished on King's Mountain. By the time of the centennial anniversary of the battle in 1880, the North had conquered the South and Reconstruction left bitter wounds unhealed. As the nation once again sought unity on the slopes of King's Mountain, regional divisions still cast a long shadow over remembrance ceremonies.

Months of preparation preceded the centennial celebration in 1880. On Saturday, May 24, 1879, citizens of King's Mountain and the nearby vicinity met "to take initiatory steps towards the celebration of the centennial of the

battle of King's Mountain."[210] A committee organized whose members promptly drafted a resolution inviting "all citizens of whatever county or State, who are friendly to the object in view, to meet with us and participate in the proceedings."[211] The committee further resolved to publish its invitation in the local press, and in response, delegates from North Carolina, South Carolina and Georgia assembled on King's Mountain on July 25, 1879, to organize the King's Mountain Centennial Association (KMCA).[212] In the first order of business, this new association adopted a resolution that noted that it was "the custom of the nations of the earth from time immemorial to commemorate, by their celebrations, the cardinal and illustrious events of their history." The resolution further stated that as a nation "we would celebrate the ever memorable period when, under a common flag and with a common hope and a common destiny, our forefathers gained one of the glorious victories that gave us liberty."[213]

Although not initially involved in the centennial celebration, as word spread about the planning and activities taking place in South Carolina, Tennessee's government officials sought inclusion. On December 24, 1879, the Tennessee General Assembly passed a joint resolution acknowledging the 100th anniversary of the Battle of King's Mountain "in which the gallant soldiers of Tennessee…participated."[214] The resolution added, "It is proper that we should commemorate their gallant deeds, and show to the world that we appreciate and cherish the great blessings of civil and religious liberty for which our forefathers so nobly struggled."[215]

Tennesseans took great pride in the fact that Sevier, their first governor, with Shelby organized the expedition, marching their Overmountain Men from Sycamore Shoals to engage the British enemy at King's Mountain.[216] It did not matter that Tennessee was not yet a state at that time nor that Sevier served as a colonel in the North Carolina militia. For Tennesseans, King's Mountain represented a tangible link to the American victory in the Revolutionary War. Once torn apart by Civil War, the state's citizens again united over the accomplishments of their "first hero."

On January 4, 1880, Tennessee governor Albert Marks delivered the joint resolution to Governor T.J. Jarvis of North Carolina, and in reply, Jarvis expressed his gratitude for Tennessee's desire to take part in the festivities. In his letter of January 26, 1880, Jarvis spoke of North Carolina's kinship with the citizens of Tennessee and their common desire to commemorate King's Mountain alongside their southern neighbors:

> *It gives me great pleasure, I beg leave to assure your Excellency, to see the interest manifested by yourself and the General Assembly of Tennessee in*

the proposed celebration. One hundred years ago the Territory, whose people now so justly take pride in the name of Tennessee, was fully as much a part of North Carolina as that which still bears the name. We were all North Carolinians then, and it is gratifying to know that though no longer one in name, and no longer one in territory, we are still one in affection, and one in admiration for the great achievements of our common ancestors, and in our determination, on suitable occasions, to make that admiration known to the world.[217]

Jarvis emphasized that southern men provided this pivotal victory in the American Revolution. This is an important point to consider, particularly at a time when the nation struggled to heal from the near fatal wounds of the Civil War. Jarvis expressed the importance of the South in securing freedom for the entire nation when he wrote:

The success that befell the American arms on King's Mountain, a success achieved by Southern troops under Southern leaders, upon Southern soil, was the turning point in the war of the revolution. But for King's Mountain, there would have been no Guilford Court House, and without Guilford Court House, there could have been no Yorktown. It was the morning of the day that was to bring forth assured success, success that meant the vindication and establishment of the right of self-government, after a long night of despotism, despair and defeat. And that our forefathers bore so conspicuous a part in an achievement, so conspicuous for the brilliant genius of its conception and the grand daring of its execution, no less than for its magnificent and momentous consequences, we may well be proud, whether we call ourselves Tennesseans or North Carolinians.[218]

Shortly thereafter, the legislatures of North and South Carolina, Tennessee and Virginia proceeded to raise funds for the proposed celebration. The South Carolina legislature passed a bill on February 20, 1880, appropriating $1,000 toward the construction of a monument to honor the memory of those who fought and died on King's Mountain.[219] The State of North Carolina also agreed to provide "a sum not exceeding fifteen hundred dollars, to aid in the erection of a suitable monument on the battle ground." The North Carolina resolution of support stated, "It is proper that we…show to the world that we appreciate the gallant deeds of our forefathers, and cherish the great blessings of civil and religious liberty for which they so nobly struggled and so heroically won,

by erecting a suitable monument to mark the spot where, in the arms of victory, many of our patriot forefathers sacrificed their lives in defense of our Commonwealth."[220]

On June 23, 1880, the South Carolinian Grand Lodge of the Masonic Order laid the cornerstone for a grand monument. Inside the cornerstone, the Masons placed a copper box filled with documents describing the King's Mountain celebrations of the past and present.[221] Around the same time, the KMCA purchased from private owners thirty-nine and a half acres of land composing the battleground.[222]

As the centennial celebration approached, officials representing North and South Carolina, Virginia, West Virginia, Tennessee, Georgia and Kentucky received invitations to participate in the festivities. Invitations also extended to the governors of the thirteen original states. An entire week of celebration leading up to the dedication of the monument

James H. Moser's illustration of the King's Mountain centennial celebration was featured on the cover of *Leslie's Illustrated Newspaper* on October 13, 1880. *Tennessee State Library and Archives.*

commenced. Many visitors pitched their tents and camped for several days on the battleground. Chinese lanterns and state and national flags decorated the spot where Sevier and his determined Overmountain Men defeated Ferguson and his British Loyalists.[223]

Speeches marked "Reunion Day." Dignitaries reminded their audience of the British tyranny that led to the battle and urged remembrance for those states that fought the American Revolution. The U.S. Post Band played music most of the afternoon and ended the day with "Yankee Doodle" as the crowd dispersed. "Military Day" followed and attracted around ten thousand people. Initially, planners advertised a King's Mountain battle reenactment for the commemoration, but this changed to a military parade. Organizers encouraged the crowd to roam the battlefields and search for relics. A relic house on the site also displayed weapons and personal mementos from those who fought in the battle.[224]

October 7, "Centennial Day," dawned bright and clear, as a procession of dignitaries and honored guests, led by militia, marched to the grandstand decorated with one hundred U.S. flags and flags representing the thirteen original colonies.[225] Around twelve thousand attendees made their way to the grandstand to hear an opening prayer before the choir, and the artillery band commenced to perform "The King's Mountain Lyric," a song composed by Mrs. Clara Dargan McLean of Yorksville, South Carolina:

Here upon this lonely height,
Born in storm, and bred in strife,
Nursed by Nature's secret might,
Freedom won the boon of life.

Song of bird and call of kine,
Fluttering life on every tree,
Every murmur of the wind,
Impulse gave to Liberty!

Then she blew a bugle blast,
Summoned all her yeomen leal,
"Friends, the despot's hour is past—
Let him now our vengeance feel!"

Rose they in heroic might,
Bondsmen fated to be free,
Drew the sword of Justice bright,
Struck for God and Liberty!

Come, ye sons of patriotic sires,
Who the tyrant's power o'erthrew,
Here where burned their beacon fires,
Light your torches all anew.

'Til this mountain's glowing crest,
Signaling from sea to sea,
Shall proclaim from East to West,
Union, Peace and Liberty!"[226]

After the reading of a poem, several dignitaries spoke. Following the speeches, a procession formed and marched toward the monument. Four young ladies representing Virginia, South Carolina, North Carolina and Tennessee unveiled the monument with assistance from the governors of North Carolina, Virginia and South Carolina and General Campbell of Tennessee. Ancient Egyptian architecture, a popular motif during the nineteenth century, inspired the design of the twenty-eight-foot high, four-sided granite pylon.[227] The pylon rested atop five gradating steps composed of granite blocks. Above the base, the shaft of the monument divided into three sections with the middle containing four embedded Vermont marble slabs with the following inscriptions:

Here on the 7th day of October, 1780, the British forces, commanded by Major Patrick Ferguson, were met and totally defeated by Campbell, Shelby, Williams, Cleveland, Sevier and their heroic followers from Virginia, the Carolinas, and Tennessee.

Here the tide of battle turned in favor of the American Colonies.

In memory of the patriotic Americans who participated in the Battle of King's Mountain, this monument is erected by their grateful descendants.[228]

As the day's ceremonies concluded, the audience sang hymns of praise and worship.[229] Soon the crowd dispersed, and the battlefield once again fell silent. In the years that followed, as members of the KMCA died, the battlefield suffered from neglect. Relic hunters and vandals defaced the monuments, and visitors abused the field.[230] By the turn of the twentieth century, the call for a proper memorial at King's Mountain renewed. Tennesseans, in particular, took great interest in this effort, for their own Sevier played a crucial role in the battle's outcome.

On October 7, 1897, Tennessee's Centennial Exposition in Nashville observed "King's Mountain Day" as several members of the Tennessee Historical Society, government officials and dignitaries gathered in what the *Nashville Banner* described as "an unusually cultivated and educated assembly."[231] As the renowned Bellstedt and Ballenberg Band of Cincinnati, Ohio, played patriotic music, the day's ceremonies commenced at ten o'clock in the Exposition Auditorium with an introduction by the president of the Tennessee Historical Society, Judge John M. Lea, followed by a prayer. Lea then introduced Tennessee governor Robert Love Taylor, who

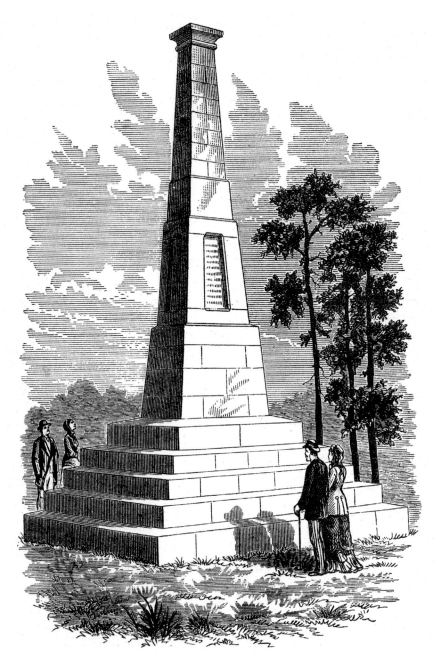

The centennial monument at King's Mountain. *From Lyman Draper's* King's Mountain and Its Heroes, *1881.*

delivered a rousing speech to the five hundred men and women assembled in the auditorium. Taylor spoke with patriotic fervor about the importance of King's Mountain and Tennessee's role in the American Revolution. He declared the day "the real birthday of American independence" and evoked Christian symbolism in a tribute to Sevier and the Overmountain Men who fought alongside him during the battle:

> *Destiny had led John Sevier and his fearless comrades through the trackless wilderness from homes and families that were beleaguered by the scalping knife and torch, to this far-away mountain top to fight a battle, the result of which changed the map of the world and heralded the dawn of a new era in the history of mankind. I thought how fate had named it King's Mountain and had placed the King's regulars on its summit, who shouted "Long live the King!" as they looked down upon the advancing mountaineers climbing up the rugged slopes to crush the hopes of the King, and I said God moves in a mysterious way his wonders to perform. He led old Moses to the mountain top to write his law on the tablets of stone; he landed the ark on a mountain top, and Christ preached his grandest sermon on the mount, the ark of his covenant rested there, and it was there that a sermon was preached which tyrants will never forget.*[232]

Taylor concluded his remarks with words of gratitude. "Thank God for the battle of King's Mountain," Taylor praised. "It made us a nation of free and independent people, where every home is the castle and palace of a prince and every citizen a sovereign."[233]

Following Taylor's speech, Judge John Allison gave an introduction. Allison's grandfather fought at King's Mountain, serving in Shelby's regiment. Known as "Captain Jack" to his regiment, Allison suffered a wound to his leg during the battle, causing him to walk lame from a stiff knee for the remainder of his life.[234] As a direct descendant of a King's Mountain veteran and a noted scholar, Allison spoke of his grandfather's service with authority. Allison edited a book entitled *Notable Men of Tennessee*, a multivolume publication filled with biographical sketches of Tennessee's most well-known historical figures. He authored *The Dropped Stitches of Tennessee*, published the same year as the Centennial Exposition. Allison dedicated the latter title to the memory of his mother, who first sparked his interest in the early history of the pioneers of his native state. In his book, Allison wrote fondly of his memories visiting "old gentlemen and aged ladies in Eastern Tennessee and a few in North Carolina" conversing with them about "old times and their

Left: Robert Love Taylor served as governor of Tennessee from 1887 to 1891 and again from 1897 to 1899. *Tennessee State Library and Archives*.

Below: *Gathering of the Overmountain Men at Sycamore Shoals, 1780*. Painting by Lloyd Branson. *Tennessee State Library and Archives*.

early lives." These conversations gave him a unique perspective on the Battle of King's Mountain.[235]

On "King's Mountain Day" at the Centennial Exposition, Allison delivered a lengthy address. He recounted in great detail the turmoil that eventually led America to war with the British Crown. His speech then focused on the events of 1780, digressing periodically into Tennessee's history of "voluntary service and voluntary action" on behalf of the entire nation. He described the scene at Sycamore Shoals, where Sevier assembled his men along with the forces of Campbell, Shelby, McDowell and Williams. He then observed:

> *This assemblage of pioneer, patriot soldiers, at Sycamore Shoals, on the banks of Watauga River, in sight of old Fort Watauga, on September 25, 1780, may properly be called the genesis of "the Volunteer State." The signal service they were entering upon was voluntary, as they were not enlisted as militia, and therefore not subject to the call of a superior officer; they had simply been requested to meet there for the purpose of crossing over the mountains to attack the British; they did not know exactly where they would find the British, nor in what force, nor were they concerned as to these questions; they were absolutely confident, as subsequent events show, that they would be the victors.*[236]

Allison again digressed, evoking the memory of Napoleon and Hannibal, whose motives for victory Allison described as "unholy ambition," "plunder" and "spoils." He then turned his attention to Sevier, Shelby, Campbell and their Overmountain Men. "When the latter ascended, camped upon and crossed over the Alleghany [*sic*] Mountains, they were not moved to do so by a desire to plunder and despoil a neighboring people, nor by a desire to form a great empire and make one of themselves emperor," Allison exclaimed. "No, no; patriotism in its purity was the motive."[237] Allison concluded his remarks by again reminding his audience of the Overmountain Men's volunteer spirit and called for a proper memorial to their sacrifice:

> *From the time our ancestors fought the battle of King's Mountain there has not been a battlefield where the soil was wet with human blood in defense of liberty, freedom and right principles that Tennesseans were not there voluntarily…The flowers of a century of springs have blossomed and faded over most of the graves of the heroes of King's Mountain, and the snows of a hundred winters have sifted gently down upon the remaining mounds that mark the spots where rest their sacred dust, and the birds have*

sung their sweetest songs in the bush and bramble that have overgrown their hallowed ashes, and yet we, their descendants and beneficiaries of their bravery in the liberties we enjoy and the magnificent and beautiful state we possess, have neglected to erect a suitable monument to commemorate their deeds, virtues and patriotism.[238]

As Allison stepped away from the podium, Bellstedt's band played "Dixie" in a triumphant conclusion to the ceremony. When the piece finished, Allison rose from his chair, turned to the bandmaster and said, "Unfortunately the heroes of the revolution had no martial band to stir their hearts. Had Bellstedt and his men been there Cornwallis would have been driven into the sea."[239]

A few short years after Allison's call for "a suitable monument to commemorate their deeds," the King's Mountain men received their tribute. In 1899, members of the King's Mountain Chapter of the Daughters of the American Revolution initiated efforts to reclaim the battlefield from neglect and launched a campaign for national recognition of the battlefield site.[240] After a long fight in Congress, Representatives D.E. Finley of South Carolina and E.Y. Webb of North Carolina realized success by obtaining an appropriation of $30,000 for a memorial at King's Mountain Battleground. In 1909, they erected a grand monument, an obelisk of white granite eighty-six feet high. The obelisk mirrored a monument at Gettysburg, and visitors declared it one of the finest in the South.[241] Bronze tablets on the four sides listed the names of those who fought in the battle, including Sevier, as well as the Americans known to have died in the battle, including Sevier's brother Captain Robert Sevier. The words cast in bronze on the south side of the monument declared, "The brilliant victory marked the turning point of the American Revolution."[242]

On October 7, 1909, the dedication day for the new government monument, campfires burned brightly once again in the valleys around the battleground as hundreds of people awaited the ceremonies. Governor Martin F. Ansel of South Carolina presided over the dedicatory exercises, and many distinguished visitors attended. A choir sang the "Centennial Lyric," and seven companies of national guards provided a demonstration of the original battle.[243] King's Mountain finally earned its national recognition, but maintaining interest in the site proved difficult. In the years that followed the 1909 commemoration, with the exception of a few periodic celebrations, the historic site, a victim of its isolated rural location, again fell silent.[244]

As the battle's sesquicentennial approached amid the backdrop of the Great Depression, a wounded nation once again sought healing at King's Mountain. The sesquicentennial celebration on October 7, 1930, overshadowed all previous celebrations of the anniversary of this famous battle. Committees worked for nearly a year on preparations and arranged for paved roads to the rural battleground, with parking space for at least twenty-five thousand automobiles.[245] Special trains operated by the Southern Railway offered reduced rates for travelers throughout the country. A "monster parade" of National Guardsmen, several prominent bands and many well-known dignitaries received invitations to attend. Invited guests included Charles Lindbergh, the celebrated aviator who crossed the Atlantic Ocean in his single-engine monoplane Spirit of St. Louis just three years earlier.[246]

As many as seventy thousand spectators attended the ceremony, including the governors of both North and South Carolina and members of the national media.[247] President Herbert Hoover, the most important attendee among the gathered masses, delivered the ceremony's keynote address. Broadcast over a nationwide network of radio stations, Hoover's opening remarks echoed the words of Lyman Draper, who several years earlier observed that history had seemingly forgotten the heroes of King's Mountain. Hoover declared King's Mountain "a place of inspiring memories" and observed, "History has done scant justice to its significance."[248]

Throughout his speech, Hoover's words conveyed a tone of resolve. At this moment in the nation's history, America languished within the grips of a Great Depression. The effects of the stock market crash of 1929 reverberated throughout the entire country. Millions of Americans suffered without work and the nation declined in a mood of despair. Hoover drew inspiration from the men who fought at the Battle of King's Mountain. He reminded his audience that America had overcome many hardships in the 150 years since the battle and expressed a "justifiable pride in the valor, the inventions, the contributions to art and literature, [and] the moral influence" of the American people. Hoover called on his fellow citizens to maintain faith in the political system inherited from the founders, and he credited the nation's "unparalleled rise" with the "ideas and ideals which have lightened the path of the whole American people."[249] He affirmed, "These ideas and these ideals were in the hearts and inspired the souls of the men who fought the Battle of King's Mountain…It is never amiss for us to review these principles, that we uphold our faith in them, that we search our fidelity to them, that by stretch of our vision over the vast pageant of our accomplishment we should gain courage to meet the difficulties of the day."[250]

The cloud of economic depression hung heavily over Hoover's speech. "The world about us is tormented with the spiritual and economic struggles that attend changing ideals and systems," he remarked. Yet Hoover looked to the Patriots of King's Mountain for inspiration during these trying times, declaring, "The forces of righteousness and wisdom work as powerfully in our generation as in theirs." Hoover concluded his remarks with words of inspiration. "The flame of freedom burns as brightly in every American heart," he proclaimed. "There need be no fear for the future of a Republic that seeks inspiration from the spirit of the men who fought at the Battle of King's Mountain."[251]

Since the sesquicentennial observance, the Battle of King's Mountain has largely faded from our nation's collective memory. The Great Depression, a global war and the threat of communism all drew attention away from the coonskin caps and long rifles of Sevier's bygone era. Although organizers planned numerous events, the 200th anniversary of the Battle of King's Mountain in 1980 delivered far less pomp and circumstance. Events included a 219-mile march beginning at Abingdon, Virginia, and ending at King's Mountain, retracing the Overmountain Men's famous trek, but only about forty marchers took part in the reenactment.[252]

Organizers also planned a drama about the battle. *Then Conquer We Must*, originally written in the early 1950s by the late Robert Osborne, presented seven performances on September 26–28 and October 3–7 at the five-hundred-seat amphitheater at Kings Mountain National Military Park. Organizers invited presidential candidates to speak—including President Jimmy Carter, who campaigned for reelection during that year—but neither Carter nor his Republican rival, Ronald Reagan, accepted their invitations to attend. Additionally, the governors of North and South Carolina arranged to meet at the state line to deliver speeches, but North Carolina governor James Hunt scheduled a luncheon in Winston-Salem on that same day, and South Carolina governor Richard Riley fell ill with "a touch of the flu."[253]

The Battle of King's Mountain received very little national attention on the 200th anniversary of the battle, although local interest remained high. Readers found newspaper coverage of the anniversary remarkably sparse, particularly in Tennessee, where one hundred years earlier that state displayed enormous pride in being part of the centennial celebration. One short article was published in Nashville's newspaper the *Tennessean* on October 7, 1980, and Knoxville's newspapers failed to acknowledge the commemoration altogether.[254]

Just as publisher Peter Thompson astutely observed in 1881 following Draper's publication of *King's Mountain and Its Heroes*, the Battle of King's

Mountain proved "too local in character." Two hundred years after the battle, this regional conflict failed to spark the public's imagination like it had in the years immediately following the carnage of the Civil War and at the beginning of the Great Depression. King's Mountain remained a source of southern pride, and Sevier endured as a figure of regional importance. Yet both the hero and the aptly named field that once humbled a king largely disconnected from the people, and over time the bold actions of patriots faded from the nation's memory.

THIRTY-FIVE BATTLES,
THIRTY-FIVE VICTORIES

Whole nations have melted away in our presence like balls of snow before the
sun, and have scarcely left their names behind, except as imperfectly recorded by
their enemies and destroyers.
Dragging Canoe, 1775

While the Battle of King's Mountain made John Sevier, for a time, a national hero, his successful military campaigns against the Cherokees secured his standing for posterity as an idol of the frontier. During the eighteenth century, the Watauga settlement on which Sevier made his mark grew rapidly as white settlers arrived from Pennsylvania, North and South Carolina and Virginia seeking a better life for themselves and their families. As early as the 1760s, settlers began moving into the southwest frontier, and by 1772, these first pioneers had built about seventy homesteads in the Watauga Valley.[255]

Throughout these formative years of white settlement, the Cherokees offered little resistance to the flood of migrants pouring into the region. Great Britain's Royal Proclamation of 1763 and subsequent treaties and land cessions provided temporary periods of negotiated peace between the Wataugans and the Native American tribes of the region. Yet settlers continued their encroachments.[256] A war with their Chickasaw rivals to the west also distracted the Cherokees for a time, having the added effect of weakening their influence in the region.[257]

In short order, the Wataugans sought more land and more opportunity. The frontier settlers formed their own government outside the authority of

British rule and negotiated land leases with their Cherokee neighbors. The rapid influx of white settlers in the region, however, made leasing the land impractical. The loss of Cherokee sovereignty over the region created periods of tension between the settlers and their Cherokee counterparts, often resulting in violent conflict.[258] The Wataugans wanted to create a buffer between themselves and the Cherokees, and that motivation compelled them to purchase the land outright.

In 1775, land speculator Richard Henderson offered to purchase 20 million acres of land from the Cherokees in return for much-needed supplies. Bounded by the "Kaintucke and Tennessee rivers," the proposed land deal included nearly all of present-day Kentucky and a portion of northeastern Tennessee.[259] By late January, more than two thousand Cherokees assembled at Sycamore Shoals, near present-day Elizabethton, Tennessee, to begin the negotiations. The tribe elders—Attakullakulla, Oconostota and Old Tassel—attended the talks, as well as a defiant young Cherokee warrior named Tsiyugunsini, known to the white settlers as Dragging Canoe.[260] Henderson's associates included Daniel Boone, whose earlier accounts of his travels through the Watauga region inspired frontiersmen like Sevier to settle the area. Sevier also gathered for this meeting, along with his fellow Wataugans, and met face to face with the Cherokee leadership during the negotiations.[261] By early March, all the principals arrived at Sycamore Shoals to consummate the deal.

Henderson's offer of guns, ammunition, clothing, blankets, beads, mirrors, bells, tomahawks and hunting knives proved to be a tempting cache for the battle-weary Cherokees.[262] While the elder statesmen of the tribe saw their treaty with the white settlers as a way to replenish their supplies, Dragging Canoe believed that any agreement with the white man placed the Cherokee on a path toward extinction. In an emotional speech before the Cherokee council, Dragging Canoe rose up in opposition to the treaty and offered these prophetic words, later chronicled by traditional accounts:

> *Whole nations have melted away in our presence like balls of snow before the sun, and have scarcely left their names behind, except as imperfectly recorded by their enemies and destroyers. It was once hoped that your people would not be willing to travel beyond the mountains, so far from the ocean, on which your commerce was carried, and your connections maintained with the nations of Europe. But now that fallacious hope has vanished; you have passed the mountains and settled upon the Cherokee lands, and wish to have your usurpations sanctioned by the confirmation of a treaty.*

When that should be obtained, the same encroaching spirit will lead you upon other lands of the Cherokees. New cessions will be applied for, and finally the country which the Cherokees and our forefathers have so long occupied will be called for; and a small remnant of this nation once so great and formidable, will be compelled to seek a retreat in some far distant wilderness, there we will dwell but a short space of time before we will again behold the advancing banners of the same greedy host; who, not being able to point out any farther retreat for the miserable Cherokees, would then proclaim the extinction of the whole race. Should we not therefore run all risks and incur all consequences, rather than to submit to further laceration of our country? Such treaties may be all right for men who are too old to hunt or fight. As for me, I have my young warriors about me. We will have our land. A-waninski, I have spoken.[263]

Despite Dragging Canoe's protests, Henderson secured his agreement to buy this "little spot of ground" with the signing of the Treaty of Sycamore Shoals on March 17, 1775.[264] Dragging Canoe left the meeting in disgust and later vowed to turn the land "dark and bloody" in his fight against further settlement.[265] In the years that followed, Dragging Canoe led his separatist Chickamauga Cherokees in several attacks on white settlements throughout the region and became one of Sevier's most bitter rivals during a series of conflicts lasting for a decade after the Revolutionary War.

History recorded this bloody and violent rivalry on the white man's terms. John Haywood described Dragging Canoe as "an obscure warrior of the Overhills" and his speech as "very animated and pathetic."[266] J.G.M. Ramsey called the Chickamaugas "an association of lawless Cherokees and Creeks, implacable, revengeful, bloodthirsty…allies in war and malcontents in peace." He further added, "They observed no treaty stipulations; they were freebooters and desperadoes."[267] The authors of early Tennessee history labeled Dragging Canoe and his tribe of Chickamauga warriors as "savages"—a description often repeated in subsequent narratives.

Meanwhile, Sevier's chroniclers eagerly cast him in the role of hero and savior of the white settlers and described him in almost reverential terms. Haywood observed that Sevier "was endowed by nature with those rare qualities which make the possessor in all places and with all people an object of attention and a depository of their confidence."[268] Ramsey noted that Sevier "was the idol of the soldiery, and his orders were obeyed cheerfully and executed with precision."[269] Francis Marion Turner recorded that Sevier's "bravery and presence of mind at Watauga… had endeared him

Tsiyugunsini, known to white settlers as Dragging Canoe, led the Chickamauga Cherokees in attacks on white settlements throughout the American Southeast. *Drawing by Bernie Sanders. Courtesy of the Tennessee State Library and Archives.*

to all the community."[270] Sevier's biographer Carl Driver concluded, "No other Tennessean contributed as much to the peace and safety of the old southwestern frontiers as 'Chucky Jack,' the Cherokee nemesis."[271]

In 1889, Theodore Roosevelt provided one notable exception to this expression of universal adoration with the publication of his multivolume work, *The Winning of the West*. Part narrative history and part tribute to Manifest Destiny, *The Winning of the West* celebrated the spread of western civilization. "During the past three centuries," Roosevelt wrote, "the spread of the English-speaking peoples over the world's waste spaces has been not only the most striking feature in the world's history, but also the event of all others most far-reaching in its importance."[272]

Roosevelt biographer Edmund Morris described *The Winning of the West* as "muscular" in its "bellicose expansionism."[273] In his book, Roosevelt called the early settlers of the land west of the Appalachians "a sturdy race, enterprising and intelligent, fond of the strong excitement inherent in the adventurous frontier life." He evidently saw within them a kindred spirit. He wrote, "Their untamed and turbulent passions, and the lawless freedom of their lives, made them a population very productive of wild, headstrong characters."[274] Roosevelt especially admired and identified with Sevier and his fellow frontier leaders. In a letter to Judge John M. Lea, president of the Tennessee Historical Society, Roosevelt wrote:

> *I am very nearly as much of a Dakota man as New Yorker; I like pioneer life; and the part of our history for which I most care is that dealing with the expansion of our frontier and the building up of the nation.* [John] *Sevier,* [Isaac] *Shelby,* [William] *Clarke,* [Daniel] *Boone,* [David] *Crockett,* [Sam] *Houston, are all figures that excite my interest and sympathy far more than do the Eastern leaders of the same time—proud though I am of some of the latter.*[275]

While he admired Sevier and his compatriots, Roosevelt believed these men should be held to a higher standard of behavior than their Cherokee counterparts. Roosevelt cast a particularly critical eye toward Sevier's military tactics and evoked the founding fathers in his narrative to scorn Sevier's treatment of Native American prisoners. In *The Winning of the West*, Roosevelt documented an incident that occurred in 1788 during Sevier's campaign against the Overhill Cherokee, when militiamen took the Cherokee chiefs Old Abraham and Old Tassel prisoner. Sevier assigned John Kirk, a man whose family had been slaughtered by the Cherokees in an earlier skirmish, to guard the prisoners.

According to Roosevelt's account, Sevier put the captured Cherokees in a hut and then left the scene. Roosevelt asserted that Sevier knew that Kirk and the rest of the troops stood eager to take justice into their own hands. Kirk entered the hut and attacked the Cherokee chiefs with a tomahawk while his comrades looked on without interfering. Roosevelt called this incident "a horrible deed of infamy" and said it constituted "criminal negligence" on Sevier's part for leaving his prisoners to the mercy of the "blood lust of his followers."[276] The incident led to calls of condemnation from the Continental Congress and even diminished Sevier's reputation with President George Washington. Washington later claimed that Sevier "never was celebrated

for anything except the murder of Indians."[277] Roosevelt forcefully argued that Sevier "must be judged by another standard. He was a member of the Cincinnati, a correspondent of Franklin, a follower of Washington. He sinned against the light, and must be condemned accordingly."[278]

Though not a trained historian, Roosevelt always carefully documented his sources. While researching *The Winning of the West*, he traveled throughout the country in a meticulous quest to chronicle "the great deeds of the border people."[279] Of his visits to Tennessee, Roosevelt wrote, "At Nashville, Tennessee, I had access to a mass of original matter in the shape of files of old newspapers, of unpublished letters, diaries, reports, and other manuscripts. I was given every opportunity to examine these at my leisure, and indeed to take such as were most valuable to my own home." Roosevelt consulted the Campbell Manuscripts containing documents and correspondences detailing Sevier's role in the Cherokee wars, the Battle of King's Mountain and land speculations. He also referenced information contained in the Sevier and Jackson papers located in the library of the Tennessee Historical Society.[280]

While Roosevelt acknowledged drawing information from secondary sources, he observed them critically, believing these narratives overused oral "tradition." Of the venerated Haywood, Roosevelt wrote, "The old Tennessee historians, headed by Haywood, base their accounts of the actions on statements made by the pioneers, or some of the pioneers, forty or fifty years after the event; and they do a great deal of bragging about the prowess of the old Indian fighters. The latter did most certainly perform mighty deeds; but often in an entirely different way from that generally recorded; for they faced a foe who on his own ground was infinitely more to be dreaded than the best trained European regulars."[281] He further observed, "Haywood commits so many blunders concerning the early Indian wars that it is only safe to regard his accounts as true in outline; and even for this outline it is to be wished we had additional authority."[282]

Roosevelt acknowledged "a debt of gratitude" to Haywood for his work to preserve the oral traditions that "would otherwise have been lost."[283] He believed it critically important, however, to utilize original source material in his writings rather than to rely exclusively on these oral traditions. So with a force equal to his personality, he charged headlong through the letters, diaries and newspaper accounts of the period, unearthing many previously unpublished documents along the way.[284] He eagerly scoured the archives of the Tennessee Historical Society for documentary evidence. In his preface, Roosevelt graciously acknowledged Lea, to whom he felt indebted for "the unfailing courtesy" shown to him.[285]

A prolific author, Theodore Roosevelt (1858–1919) wrote twenty-six books, over one thousand magazine articles and thousands of speeches and letters. *Library of Congress*.

Roosevelt's research at the Tennessee State Library and Archives and his examination of records belonging to the Tennessee Historical Society proved particularly noteworthy. Despite his acknowledgement of unfettered access to original material, Roosevelt encountered some difficulty in locating the historical evidence he needed to complete his work. The State's Archives

Division—a separate entity from the State Library—only began organizing its records following Roosevelt's visit. In fact, the establishment of the State's Archives Division in 1889 launched when director Robert Thomas Quarles acknowledged an "inability to supply Colonel Roosevelt with data for his *Winning of the West*." That deficiency led to the cataloging and the arranging of the present State Archives.[286] Nonetheless, Roosevelt soldiered on with his research.

After its publication, *The Winning of the West* quickly became a bestseller. The first edition of Roosevelt's book sold out in little more than a month. He also garnered high praise from frontier scholars such as Frederick Jackson Turner, who called *The Winning of the West* "a wonderful story, most entertainingly told." Turner commended Roosevelt for his "breadth of view, capacity for studying local history in the light of world history, and in knowledge of the critical use of material."[287]

Roosevelt, however, encountered critics. Dr. William Frederick Poole, a librarian and scholar who served as the president of the American Library Association and the American Historical Association in the mid-1880s, praised Roosevelt for his prose. He nonetheless challenged him to devote more of his time and energy to examining the original source material at his disposal. Dr. Poole wrote, "It is evident from these volumes that Mr. Roosevelt is a man of ability and of great industry. He has struck out fresh and original thoughts, has opened new lines of investigation, and has written paragraphs, and some chapters, of singular felicity…Mr. Roosevelt, in writing so good a work, has clearly shown that he could make a better one, if he would take more time in doing it."[288]

Another critic, James Roberts Gilmore—a novelist and author of a popular trilogy of books chronicling the history of the trans-Appalachian frontier—went further, accusing Roosevelt of fraud and plagiarism. Evidently, Roosevelt provoked Gilmore with a footnote within his text challenging Gilmore's account of Sevier's life. In his criticism of Gilmore's 1887 book, *John Sevier as a Commonwealth-Builder*, Roosevelt referenced Gilmore's use of "traditions gathered a century and a quarter after the event" as evidence that his accounts consisted of "mere fable."[289]

One of the more fantastic tales chronicled in Gilmore's book involved an incident that allegedly occurred in Sevier's youth. Gilmore recorded that when Sevier struck out on his own, opening a dry goods and grocery store in the village of New Market, Virginia, he resisted a fierce attack by Indians with "only [a] half-dozen men with him." Gilmore noted that the following morning, Sevier gathered "a score of his friends together" and "followed in

pursuit of the marauders." As Sevier caught up to his attackers, Gilmore asserted that he "made so furious assault upon them that they speedily fled in all directions. Their village was reduced to ashes, and a number of their braves were left unburied among the cinders."[290]

Roosevelt took a particularly critical stance toward Gilmore's claim that Sevier accomplished all of this "when a youth of scarcely eighteen…often defeating bodies of five times his own numbers."[291] Roosevelt dismissed this statement, writing that "Mr. Gilmore forgets that we have numerous histories of the war in which Sevier is supposed to have distinguished himself, and that in not one of them is there a syllable hinting at what he says." When Sevier arrived at Watauga, Roosevelt wrote, "his life had been as uneventful as that of any other spirited young borderer; his business had been that of a frontier Indian trader; he had taken part in one or two unimportant Indian skirmishes."[292]

Roosevelt accused Gilmore of embellishing Sevier's battles with the Indian tribes of the region and added:

Sevier was neither leader nor participant in any such marvelous feats as Mr. Gilmore describes; on the contrary, the skirmishes in which he may have been engaged were of such small importance that no record remains concerning them. Had Sevier done any such deeds all the colonies would have rung with his exploits, instead of their remaining utterly unknown for a hundred and twenty-five years. It is extraordinary that any author should be willing to put his name to such reckless misstatements, in what purports to be a history and not a book of fiction.[293]

Roosevelt detailed with great enthusiasm the historical errors rife throughout Gilmore's work. In a veiled reference to Gilmore's prior work as a novelist, Roosevelt called Gilmore out by his fictional pseudonym, Edmund Kirke, and continued his criticism with a scathing critique of his research methods, which relied heavily on second-hand accounts of stories told by Sevier's aging comrades. He wrote:

Mr. Kirke puts in an account of the battle on Lookout Mountain, wherein Sevier and his two hundred men defeat "five hundred Tories and savages." He does not even hint at his authority for this, unless in a sentence of the preface where he says, "A large part of my material I have derived from what may be termed 'original sources'—old settlers." Of course the statement of an old settler is worthless when it relates to an alleged

important event which took place a hundred and five years before, and yet escaped the notice of all contemporary and subsequent historians. In plain truth unless Mr. Kirke can produce something like contemporary— or approximately contemporary—documentary evidence for this mythical battle, it must be set down as pure invention. He has done good service in popularizing the study of early western history, and especially in calling attention to the wonderful careers of Sevier and Robertson. Had he laid no claim to historic accuracy I should have been tempted to let his books pass unnoticed; but in the preface to his "John Sevier" he especially asserts that his writings "may be safely accepted as authentic history." On first reading his book I was surprised and pleased at the information it contained; when I came to the study of the subject I was still more surprised and much less pleased at discovering such wholesale inaccuracy—to be perfectly just I should be obliged to use a stronger term. Even a popular history ought to pay at least some little regard to truth. [294]

Gilmore fired back in a letter to the editor, published in the September 22, 1889 edition of the *New York Sun* and signed under the pen name of "Cumberland." He asserted that Roosevelt could have never written *The Winning of the West* alone, stating that "it would have been simply impossible for him to do what he claims to have done in the time that was at his disposal."[295] Gilmore added:

The truth is that of the manuscripts and documents which he [Mr. Roosevelt] enumerates as unpublished there is not one that has not been repeatedly examined by historians, and no fact of any historical importance is contained in any one of them which has not been already published. A claim made at this late date to the discovery or use of any valuable original document relating to early Tennessee or Kentucky is, on the face of it, too absurd for serious refutation. [296]

In response, Roosevelt identified the pseudonymous writer—calling Gilmore out by name—and challenged him to produce evidence that he did not write *The Winning of the West* alone or that he based his book largely on the work of other scholars rather than on original sources. Roosevelt offered $1,000 to anyone who could prove that he had not written the book himself and dared Gilmore to confront him directly with his accusations. "I challenge Cumberland to come out over his own name and substantiate his charge," Roosevelt wrote, "a charge all the meaner because it is as much innuendo as

direct assertion; and until he does thus substantiate it I brand him as a coward who dares not sign his name to the lying slander he has penned."[297]

Gilmore failed to respond sufficiently to Roosevelt's challenge and only countered with an accusation that Roosevelt had plagiarized certain "facts" previously published. Roosevelt quickly dismissed Gilmore's claims, stating, "It makes one almost ashamed to be in a controversy with him. There is a half-pleasurable excitement in facing an equal foe; but there is none whatever in trampling on a weakling."[298]

In an earlier time, Gilmore indeed proved himself to be no weakling. Born in Boston, Massachusetts, on September 10, 1823, Gilmore's early career began as a businessman. By the age of twenty-five, he had worked his way up the corporate ladder, becoming the head of a cotton and shipping firm in New York City. His frequent business trips to the South provided Gilmore with the inspiration to become a writer, and by the time the Civil War broke out in 1861, Gilmore retired from his shipping business to focus his attention on becoming an author.[299]

During the Civil War, Gilmore's writings gained widespread attention for their realistic portrayals of Southern life and graphic accounts of slavery. Written under the pen name Edmund Kirke, Gilmore's novels—*Among the Pines* (1862), *My Southern Friends* (1862), *Down in Tennessee* (1863), *Among the Guerillas* (1863), *Adrift in Dixie* (1863), *On the Border* (1864) and *Patriot Boys* (1864)—resonated with his audience and inspired many in the North to take up the Union cause of emancipation.[300]

In 1862, Gilmore founded the *Continental Monthly* magazine to advocate for emancipation as a political necessity. By July 1864, Gilmore summoned such high regard that President Abraham Lincoln entrusted him to conduct an unofficial mission to Richmond seeking a peaceful settlement to the Civil War. Gilmore's efforts, however, failed. Confederate president Jefferson Davis refused to agree to any peace proposal that did not include a declaration of independence for the Confederate States.[301]

By the end of the Civil War, the Union had won, but Gilmore had lost the fortune he amassed as a businessman prior to the conflict. He decided to enter into business again in 1873, but the desire to write never left him. In 1880, he published a book entitled *The Life of Jesus, According to His Original Biographers*. In the same year, Gilmore wrote *The Life of James A. Garfield*. This title sold eighty thousand copies during the presidential campaign and immediately afterward.[302]

Gilmore thus built a reputation as a writer of history and soon embarked on a quest to chronicle Sevier's life. In 1886, he published *The Rear-Guard*

of the Revolution, an account of the early settlement of Tennessee. He later published two companion volumes entitled *John Sevier as a Commonwealth-Builder* (1887) and *The Advance-Guard of Western Civilization* (1888).

In *The Advance-Guard of Western Civilization*, Gilmore described his goal for writing this three-volume history of the early American frontier:

> *The three volumes cover a neglected period of American history, and they disclose facts well worthy the attention of historians—namely, that these Western men turned the tide of the American Revolution, and subsequently saved the newly-formed Union from disruption, and thereby made possible our present great republic. This should be enough to secure for their story an attentive hearing, had it not the added charm of presenting to view three characters—John Sevier, James Robertson, and Isaac Shelby—who are as worthy of the imitation of our American youth as any in their country's history...*
>
> *...In this and my two preceding volumes I have endeavored to rescue from oblivion her earliest and greatest heroes; and, if I have done my work as faithfully as I ought, historians will no longer ignore their existence, but be swift to assign to them the exalted places to which they are entitled in American History.*[303]

Gilmore described Sevier, Robertson and Shelby as men of "boundless courage, a constant fortitude, a self-devoted patriotism, worthy of the most heroic ages" and singled out Sevier as "a gentleman born and bred." By Gilmore's estimation, history ignored these men. Of Sevier, Gilmore lamented, "No other man of equal talents and equal achievements has been so little noticed in American history."[304]

In an effort to rescue Sevier from oblivion, Gilmore constructed his narrative on the foundation of others, relying heavily on Ramsey's work for historical background. Gilmore used Ramsey's *Annals of Tennessee* "somewhat in the manner of a textbook" to provide historical background.[305] Gilmore also claimed that Ramsey knew Sevier intimately "from early childhood till he was of the age of eighteen, when Sevier died." According to Gilmore, "Dr. Ramsey informed me that Sevier was very fond of young people, and that it was his custom in his old age to gather them about him and tell to them the story of his campaigns by the hour together. It was thus that Ramsey imbibed that fondness for pioneer history which bore fruit in his *Annals of Tennessee*."[306]

Gilmore further relied upon "traditions" gathered from nearly fifty descendants, whom he met sometime between 1880 and 1884. Gilmore

declared that these direct descendants "had personally known John Sevier and many of his compatriots" and furnished him with letters from Sevier himself, all of which Gilmore claimed, "Helped to make the present volume more full and accurate." According to Gilmore, "I have conversed with a number of aged men who knew Sevier well in their boyhood, and they all agree in describing him as possessed of a personal magnetism that was nothing less than wonderful."[307]

For those who questioned Gilmore's research methods, he maintained, "Among many there is a prejudice against tradition as a foundation for historical writing; but it should be borne in mind that most history is, and was, originally tradition." He defended his source selection with a sacrilegious comparison:

> *By tradition I do not mean rumor, but those carefully treasured accounts of striking events and heroic exploits, in the lives of our forefathers, which are handed down with religious care from father to son in all families having proper pride in their ancestry. Upon some such traditions were undoubtedly based all but one of the biographies we have of the greatest character in history; and my investigations into the present subject have given me a singular light upon the manner in which at least two of those histories, and the introductory portion of another, must have been constructed. The three synoptic gospels accord wonderfully in their reports of the spoken words of Christ, but they differ considerably as to the circumstances attending some of the important events which they relate. In a similar manner, striking speeches, which in this and the previous volume I have put into the mouths of Sevier, Shelby, and Robertson, have been repeated to me alike, word for word, by half a dozen separate narrators, while the same persons have differed widely in their narrative of events—in some instances so widely that the accounts cannot be reconciled, and I have been obliged to discard them all.*[308]

Gilmore truly believed that he had compiled an "authentic history" of Sevier's life and based his conviction on the stories and anecdotes told to him by his aged contemporaries.[309] In contrast to Roosevelt's approach to his subject, Gilmore's reliance on oral tradition amplified Sevier's reputation as an Indian fighter. In *The Advance-Guard of Western Civilization*, Gilmore wrote that Sevier carried "fire and sword to the Cherokee towns among the Smoky Mountains…leaving a trail of blackened ruin behind him."[310] Gilmore claimed that the Cherokees held a "superstitious dread" for Sevier,

who they called "the Great Eagle of the pale-faces" and regarded "as well-nigh invincible."[311]

Sevier engaged in no less than thirty-five battles with the Cherokees, some of them "hardly contested and decisive." Yet in all of these, Sevier's chroniclers viewed the outcome as victorious.[312] In a quick and effective method of combat, Sevier employed a small army of close confidants and loyal followers to swiftly attack the enemy with violent precision. Using guerrilla tactics and the element of surprise to his advantage, Sevier "was the first to introduce the Indian war-whoop in his battles." He often deceived his enemies into thinking that he led an entire regiment.[313] Gilmore noted that "with the 'Tennessee yell' they had learned of Sevier," his militiamen "would swoop like a whirlwind upon the enemy, never asking or expecting quarter."[314] Sevier relentlessly pursued the Cherokees at every opportunity and destroyed every town in his path, burning villages, pillaging supplies and massacring entire Indian families.[315]

The writers of early Tennessee history justified Sevier's savagery in battle by asserting that the Cherokees also employed these brutal tactics. In his book *History of Tennessee,* James Phelan wrote:

> *If his mode of warfare was barbarous, he was waging war against barbarians, brave, cruel, relentless, and treacherous, without any of the things which civilization gave except its engines of destruction. Sevier was not the man to trifle with his task. Indian incursions could only be stopped by exterminating the Indians. Hence he tried to exterminate them. General Sheridan in the valley of Virginia was not more thorough. Every grain of corn was destroyed. Everything which could be used was burned, broken, or carried away. Every wigwam received the torch. Every boat was sunk. Nothing was spared except a few helpless human lives.*[316]

Tales of Sevier's bravery in combat often swelled to mythic proportions. At the Battle of Boyd's Creek, for example, on December 16, 1780, Sevier engaged the Cherokees in hand-to-hand combat. By Ramsey's account, he displayed unflinching courage under the most extreme circumstances:

> *In the charge, Sevier was in close pursuit of a warrior who, finding that he would be overtaken, turned and fired at him. The bullet cut the hair of his temple without doing further injury. Sevier then spurred his horse forward and attempted to kill the Indian with his sword, having emptied his pistols in the first moment of the charge. The warrior parried the licks*

from the sword with his empty gun. The conflict was becoming doubtful between the two combatants thus engaged, when one of the soldiers, rather ungallantly, came up, shot the warrior, and decided the combat in favour of his commander.[317]

Sevier's war against the Cherokees' resistance movement eventually carried his militia to Lookout Mountain, near present-day Chattanooga, Tennessee. This set the stage for yet another military campaign shrouded in myth and mystery. On July 23, 1782, North Carolina governor Alexander Martin ordered Charles McDowell, a North Carolina militia general, to raise five hundred men for a campaign against the Chickamauga Cherokees. Following the expedition, Martin directed McDowell to work with Sevier to arrange a treaty with the Cherokees that included substantial land cessions.[318]

By the autumn of 1782, nearly one year after British general Charles Cornwallis formally surrendered to General George Washington at Yorktown, Sevier once again set out to break the spirit of his Cherokee enemies. Haywood and Ramsey recorded the details of this campaign and relied heavily on stories told to them by elderly veterans of the expedition. Years later, Gilmore embellished these second-hand accounts. In *The Rear-Guard of the Revolution*, Gilmore boldly asserted that Sevier's campaign took place "on the identical spot where, eighty years later, Hooker fought his famous 'battle above the clouds,'" a claim Gilmore never substantiated with primary sources.[319]

By connecting Sevier's movements on Lookout Mountain with those of Major General Joseph Hooker during the Civil War, Gilmore created a narrative that subsequent writers and local historians embraced. By the mid-1880s, Civil War veterans' conventions infused significant dollars into local economies. Thus, keen competition existed among southern cities to host these reunions. Realizing this, real estate speculators supplied Chattanooga with a competitive advantage over other cities in the South desiring to host conventions by marketing Chattanooga's importance as both a Civil War and Revolutionary War site.[320]

Years later, during America's bicentennial celebration, Chattanoogans still accepted claims that Sevier fought the "last battle of the Revolution" at Lookout Mountain. George Little, a prominent local artist, painted an imagined scene from the battle. "Confederama," a local Civil War tourist attraction, added a small exhibit devoted to Sevier's campaign. Another popular tourist site, Reflection Riding, hosted a dramatic reenactment of the engagement that later became an annual event.[321]

The John Sevier Chapter of the Sons of the American Revolution placed this marker on the slopes of Lookout Mountain on September 22, 2007. *Photograph courtesy of James W. Belt.*

James Sevier, who served as a militia captain under his father, provided the only contemporary account of the campaign. In a letter dated August 19, 1839, he recalled:

> *We set out for the Indian country in the month of September, 1782. On the Highwassee [sic] river and Chickamauga creek we destroyed all their towns, stock, corn & everything they had to support on. We then crossed a small range of mountains to the Coosa river, where we found and destroyed several towns, with all their stock, corn & provisions of every kind. The Indians eluded our march and kept out of our way in the general, although a few men, women and children were surprised and taken. We left the Coosa river for home about the last of October...Thus ended the war of 1782. We all set out for our homes without the loss of a single man.*[322]

By military measures, Sevier's Lookout Mountain campaign proved futile. Letters from key participants revealed that Sevier's guide, a man by the

name of John Watts, a known British Loyalist, led Sevier's men away from hostility.[323] Even Governor Martin declared, "The expedition against the Chickamaugas hath not answered our expectations. The Indians fled on the approach of our Militia and were not to be found. Their huts were destroyed and some trifling plunder taken."[324] Still, the mere fact that the governor of North Carolina sanctioned Sevier's activities gave many steadfast believers in Sevier's legend cause to recognize this campaign as the "Last Overmountain Battle of the American Revolution."

Sevier forged his reputation as a fearless Indian fighter. He led a tenacious assault upon the Cherokees, rapidly moving from village to village destroying everything in sight.[325] His actions were forceful and decisive, and the men under his direction regarded him as their unquestioned leader. Driver noted that Sevier's "personal magnetism was contagious, and his discipline voluntary. The soldiers respected him and had confidence in his judgment."[326] Those soldierly skills served him well in the years that followed as Sevier entered the next phase of his life when he faced new and unexpected dangers as a skilled and cunning politician and statesman.

PART III

STATESMAN

8
GOD SAVE THE STATE!

We shall continue to act as independent, and would rather suffer death in all its various and frightful shapes than conform to anything that is disgraceful.
John Sevier, 1787

Writers first carved John Sevier's reputation as an iconic regional political figure out of the hills and valleys of Watauga, but his standing as a statesman of the Early Republic fully emerged from the smoldering ruins of the state of Franklin. Established in 1784, local leaders formed the state of Franklin from territory that the State of North Carolina offered to Congress as a cession to help pay off its war debts following the Revolutionary War.[327] As Franklin's first and only governor, Sevier suffered his greatest political defeat in his failure to gain congressional approval for Franklin's statehood movement. Yet posterity presents a different story.

Preceding Franklin's declaration of independence, the North Carolina legislature passed a law known as the "Land Grab Act," which opened all of that state's western lands for sale. Between October 1783 and May 1787, for only ten dollars per 100 acres, buyers claimed nearly 4 million acres under this new law.[328] Members of the legislature and their business partners claimed 3 million of those acres for themselves, creating vast opportunities for corruption and fraud. As part of the agreement to cede its western lands to Congress, legislators included a provision ensuring the legitimacy of all land warrants issued under North Carolina law.[329] The cession not only resulted in unprecedented speculation by wealthy landowners but also left the poor

settlers of Watauga and the surrounding area effectively abandoned by their state government and unprotected from attacks by the Cherokees inhabiting the region.

Disillusioned with North Carolina's governance of the territory, the settlers in North Carolina's western counties formed their own government, creating a separate, independent state of Franklin on August 23, 1784.[330] Originally named Frankland in honor of Benjamin Franklin, delegates selected political leaders, including Sevier, who served as Franklin's governor.[331] Meanwhile, fearing Congress would not honor North Carolina's land warrants, state legislators voted to rescind its cession and reasserted North Carolina's claim to the region.[332] This set of circumstances set up a violent rivalry between two factions led by the region's most dynamic leaders—Sevier and John Tipton. Through an amazing twist of fate, Sevier's political fortunes in Franklin rose and fell amid the backdrop of his bitter dispute with Tipton. The turmoil between these two men during Franklin's fight for statehood provided authors and historians an opportunity to once again cast Sevier in the role of hero.

Born in Baltimore County, Maryland, in 1732, Tipton arrived in Washington County in 1784 at the very moment when the movement to create a separate state of Franklin took shape.[333] Prior to his settlement in the region, Tipton moved to Virginia's Shenandoah County

Mouths of the Missis

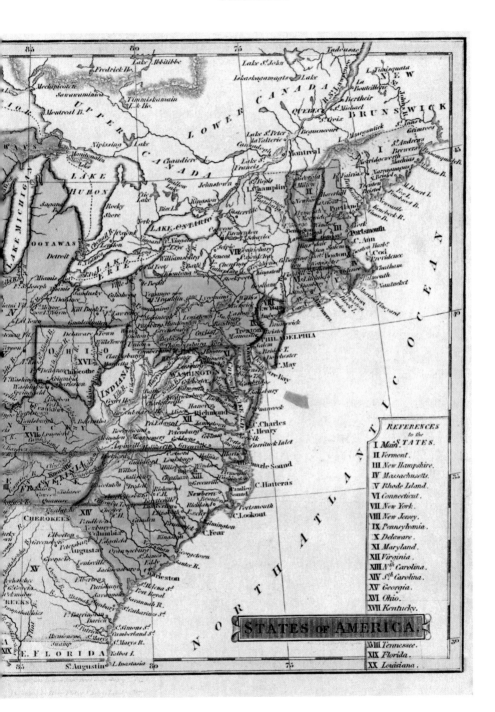

Map of twenty "States of America" with East Tennessee depicted as "Franklinia." *Tennessee Virtual Archive (TeVA), Tennessee State Library and Archives.*

and served as a member of the Virginia House of Burgesses during its 1776 Constitutional Convention. Though he never fought in the Revolutionary War, Tipton worked as a recruiting officer for the Continental army. Six of Tipton's sons served in the army during the Revolution, and his brother, Jonathan, fought with Sevier at the Battle of King's Mountain.[334]

Confusion surrounding the names of two of the Tipton brothers—John and Jonathan—led some Tennessee historians to make incorrect statements about the nature and depth of the feud between Sevier and Tipton.[335] In his 1938 book, *Old Frontiers*, John P. Brown incorrectly identified John as having fought with Sevier in the December 1780 Battle of Boyd's Creek, when, in truth, Jonathan participated in the battle. Brown misinterpreted an account by Sevier's sons James and George Washington Sevier recorded in Lyman Draper's notes. In Brown's version of the events surrounding this battle, John, not Jonathan, failed to follow Sevier's orders to march his men toward the left flank in a maneuver designed to surround and surprise the Cherokee attackers. According to Brown, Tipton's men questioned the maneuver, but Tipton angrily replied, "Mind your own business and be damned—I know my orders!" Brown later characterized the incident as "the beginning of Tipton's hatred for Sevier, a hatred which was in time to become almost fanatical."[336]

Brown again incorrectly recorded that, in 1781, John—rather than his brother, Jonathan—disobeyed a direct order from Sevier to return to the militia after accompanying an injured soldier back to his home. In his account of this incident Brown wrote, "Tipton, instead of returning to the army, continued on to his own home, for which breach of orders Sevier revoked his Major's commission; a link in the chain of circumstances that was to make hatred of John Sevier the ruling passion of Tipton's life."[337] Adding to the confusion, John named one of his sons John, who, like his father, held a long and distinguished career in public service as a legislator in Tennessee. Tipton also had a nephew named John, who served as a United States senator from Indiana. Even J.G.M. Ramsey confused this point in his *Annals of Tennessee*.[338] Although John Tipton certainly held Sevier in contempt, Jonathan actually suffered under Sevier's wrath in these early confrontations.

As a delegate during Franklin's 1784 convention in Jonesborough on August 23, John Tipton led the opposition against Franklin's declaration of independence from the state of North Carolina. Controversy existed among historians and chroniclers over whether or not Tipton originally favored Franklin's statehood. James Gilmore stated that Tipton initially sided with

the Franklinites as an advocate for secession. "When the decision came to be made," Gilmore wrote, Tipton "gave his vote in the affirmative!"[339] Historians Will Thomas Hale and Dixon Lanier Merritt, however, disagreed and pointed to the writings of Tennessee's earliest historians as evidence that Tipton never favored the separation. John Haywood, in particular, knew these pioneers intimately, and, according to Hale and Merritt, he would never "discredit Colonel John Tipton's espousal of North Carolina's cause" with such a statement.[340] Ultimately, history recorded that Tipton joined another brother, Joseph, and thirteen other men in opposition to the proposed separation. The vote, however, did not go in Tipton's favor, and the delegates moved to declare North Carolina's three western counties united as one free and independent state.[341]

By the autumn of that same year, delegates adopted a constitution. Meanwhile, Tipton continued to serve as a member of the county court of Washington County. The North Carolina legislature also elected Tipton as colonel of the Washington County militia. Tipton later served as a legislator in the North Carolina Senate following his election in 1786. Deeply committed to North Carolina's sovereignty over its western counties, Tipton's position placed him in direct opposition to Sevier, who favored the separation.[342]

Sevier entered his role as protagonist in this rivalry reluctantly. He served as clerk of the court of Washington County, and the North Carolina Assembly appointed him as brigadier general of the militia of the district of Washington.[343] Like Tipton, Sevier remained loyal to his home state, at least in the initial days of rebellion. Following the repeal of North Carolina's cession of its western lands, Sevier recommended that secessionists "proceed no farther in their design to separate from North Carolina."[344] As the political currents shifted, however, Sevier found himself caught up in the surge for statehood. In a private meeting with Sevier, William Cocke, a proponent of Franklin's independence and one of Sevier's closest allies, "erased the favorable impression that he had received toward the government of North Carolina."[345] Sevier joined the Franklinites, and following the first official meeting of the Franklin Assembly in March 1785, delegates elected him governor.[346]

In response to Franklin's declaration of independence, North Carolina governor Alexander Martin became infuriated with Sevier and his insurrection. On April 25, 1785, he issued a manifesto. He warned the citizens of Franklin to "return to their duty and allegiance" to the state of North Carolina, or "consider the consequences that may attend such a dangerous and unwarrantable procedure, that far less causes have deluged

states and kingdoms with blood." Martin then aimed a warning directly at Sevier, reminding him of the cause of freedom won during the Battle of King's Mountain and calling his statehood movement a "black and traitorous revolt."[347]

Sevier defiantly reacted to Martin's manifesto. He issued a proclamation accusing Martin of stirring up thoughts of sedition among the citizens of Franklin and ordered his people "to be obedient" to the laws of the newly formed state. Sevier scolded North Carolina, stating, "Their own acts declare to the world that they first invited us to the separation." Sevier used the rhetoric of the American Revolution, recalling how his citizens "saved their State out of the hands of the enemy, and saved her from impending ruin." Sevier closed his proclamation with the plea, "God Save The State!"[348]

Tipton, on the other hand, viewed Franklin's secession as a treasonous act and pledged his allegiance to North Carolina. In response to Martin's manifesto, Tipton wrote, "I think myself in duty bound to obey your Excellency's commands in all points required, both from the zeal I bear the old state and the respect I bear toward your Excellency."[349]

Following the election of Richard Caswell as North Carolina's governor in 1785, Sevier saw an opportunity to mend the wounds that existed between the Franklinites and their mother state. Sevier argued passionately for Franklin's cause, using the rhetoric and ideology of the American Revolution and his reputation as a Revolutionary War hero to inspire followers and to solicit outside support.[350] In a 1786 letter to Caswell, Sevier expressed his hope that the state would "cheerfully consent to the separation," stating so many of Franklin's citizens "fought and bled in behalf [of] the parent state, and are still ready to do so again, should there be an occasion."[351] Following up with a more forceful missive, Sevier again wrote to Caswell, stating, "We shall continue to act as independent, and would rather suffer death in all its various and frightful shapes than conform to anything that is disgraceful."[352]

By 1788, Sevier grew weary of North Carolina's intractable position with regard to the state of Franklin. In an October 30, 1788 letter to both houses of the General Assembly of North Carolina, Sevier again evoked the memory of the American Revolution. He recalled:

> *You are sensible and sufficiently acquainted how recently we were all employed and deeply engaged to keep off the British yoke of slavery and tyranny, and in the days of your greatest extremity, the people who are now suffering for differing in political sentiments were those who gave you the first relief, at the expense of their blood and loss of their dearest relations...Has North*

Carolina forgot that for such acts America took up arms against the British nation? Has she also forgot that the man and party that now suffers was her zealous defenders in the days of her greatest extremity?[353]

Sevier reminded the legislature of his own personal sacrifice. "I assure the State of North Carolina I have always wished her prosperity," Sevier wrote. He continued, "I have fought and suffered in her cause. It is consistent with my own honor, secret pride and satisfaction that she, as well as the whole of the Union, may always flourish and become great."[354]

Meanwhile, Tipton embarked on a strategy to undermine Sevier's authority in the region. He conspired with Caswell to form a parallel government within the three counties composing the state of Franklin. After gaining election as North Carolina's official representative for Washington County, Tipton offered pardons to residents of Franklin who swore their allegiance to North Carolina, created a wholly new county of Hawkins and appointed Evan Shelby to replace Sevier as brigadier general of the Washington District.[355] Tipton then appointed his own judges and clerks to serve in the Washington County courts while Franklinites appointed Sevier's son James as county court clerk. Tipton presided over Washington County courts "under the authority of North Carolina" while James Sevier held sessions as a representative of the state of Franklin.[356] The competing court systems led to confusion among the citizens of the region and open hostility among supporters of both men. In August 1787, Tipton and fifty armed men charged into James Sevier's courtroom, removed court papers and tossed judges from their chambers.[357] Franklinites retaliated by raiding Tipton's courtroom, reclaiming the Franklin court documents and stealing North Carolina court papers.[358] These "courthouse wars" continued, eventually leading to a physical altercation between Tipton and Sevier. Haywood chronicled the confrontation in his book, *The Civil and Political History of the State of Tennessee:*

> [Sevier] *and Tipton met in Jonesborough, where as usual a violent verbal altercation was maintained between them for some time, when Sevier, no longer able to bear the provocations which were given to him, struck Tipton with a cane. Instantly the latter began to annoy him with his hands clinched. Each exchanged blows for some time in the same way with great violence and in convulsions of rage. Those who happened to be present interposed and parted them before victory had declared for either.*[359]

Haywood further noted that the violent nature of the feud between these two men spilled over into other venues, as members of their respective families

"frequently and with varying success took lessons in pugilism from each other at public meetings."[360] As these repeated scenes of courthouse chaos unfolded, public opinion swayed against Sevier. On April 9, 1787, Sevier desperately appealed to his government's namesake, Benjamin Franklin, and once again used the language of patriotism in his letter to solicit support.[361] Following a recitation of his government's plight, Sevier pleaded:

> *From your known patriotic and benevolent disposition as also your great experience and wisdom, I am, by and with the advice of our Council of State, induced to make this application, that should you from this simple statement of the occurrences think our cause so laudable as to give us your approbation, you would be pleased to condescend to write on the subject. And any advice, instruction or encouragement, you may think we shall deserve, will be acknowledged in the most grateful manner.*[362]

Franklin responded by instructing Sevier to resolve his "misunderstanding with the government of North Carolina by amicable means" and to avoid "an Indian war by preventing encroachments on their land."[363] These words did nothing to relieve Sevier from his troubles. His dispute with Tipton and the North Carolina government that he represented had escalated beyond repair. Furthermore, Sevier believed his skirmishes with the Cherokees served to bolster his standing as a strong military leader among his people. Sevier's political standing, however, proved to be weak. Ramsey noted, "Vestige after vestige of Franklin was obliterated; its judiciary gone; its legislature reduced to a skeleton; its council effete, defunct, powerless; its military disorganized, if not discordant, and its masses confused and distracted, with no concert, and unanimity among themselves."[364]

Sevier's vulnerable state provided Tipton the opportunity to strike. Using his authority as Washington County court clerk, Tipton ordered the county sheriff to seize property belonging to Sevier as payment for unpaid taxes owed to the state.[365] In early 1788, Sheriff Jonathan Pugh raided Sevier's Plum Grove plantation, took the governor's slaves and livestock and placed them in "safe-keeping" at Tipton's estate.[366] While preparing his militia for a spring attack on Dragging Canoe's Chickamauga Cherokees, Sevier received word of Tipton's raid. He quickly ordered about one hundred of his men to surround Tipton's home and, upon his arrival, demanded Tipton and his loyalists "surrender themselves to the discretion of the people of Franklin."[367] Tipton refused, and, as legend recorded, cursed Sevier, daring him to "fire and be damned!" On February 27, 1788, Sevier's men obliged Tipton and opened fire on his home.[368]

Jonesborough served as the first capital of the state of Franklin. Following the summer of 1785, the government moved to this log cabin home in Greeneville. *From John Allison's* Dropped Stitches in Tennessee History. *Department of Conservation Collection, Tennessee State Library and Archives.*

In the chaos that ensued, one of the Tiptonites fled under the cover of darkness and made his way east toward North Carolina seeking reinforcements. Caught in the line of fire, a woman received a wound to her shoulder after attempting an escape. The following morning, Sevier sent another offer of truce, but Tipton remained defiant. By that evening, Washington County's militia received word of Tipton's distress and quickly dispatched troops to his aid.[369]

As a heavy blanket of snow enveloped the scene, a full-scale assault commenced. Both sides exchanged volleys, and over the course of the battle, confusion beset Sevier's forces. Soon, Sullivan County's militia joined the fray, and Sevier's Franklinites found themselves surrounded. The sudden attack by Tipton's men forced Sevier into retreat. During the battle, Pugh—a man whom Tipton considered one of his closest friends—was mortally wounded.[370] Meanwhile, Tipton's militia captured two of Sevier's sons, John

and James, and his nephew John, all of whom had left the battle momentarily to run reconnaissance. Tipton threatened to hang both of Sevier's sons in retaliation for Sevier's attack, but cooler heads prevailed.[371] Upon receiving word that Tipton held his sons in captivity, and acknowledging his Franklin militia's defeat, Sevier eventually agreed to surrender to Tipton, "asking [for] his life [and that] of his parties" agreeing to "submit to the Laws of the State" of North Carolina.[372]

In the immediate aftermath of the Battle of Franklin and prior to his detainment, a demoralized and defeated Sevier made one last attempt to secure independence for his struggling state. In March 1788, Sevier launched another military campaign against the Cherokees in the hope that he could restore his popularity and prestige in the region.[373] He then pursued negotiations with representatives from Spain, hoping to forge an alliance that would secure Franklin's independence once and for all.[374]

At this time, Spain controlled access to the Mississippi River and claimed lands east of the river toward the Ohio and Tennessee Rivers. Spain also negotiated treaties with the Indians living in the region, providing them with gunpowder and supplies in exchange for their armed resistance against American encroachment. Peace talks between representatives of the U.S. government and Spain broke down amid the sectional discord in Franklin. Thus, Sevier found an opportunity to fill the void.[375]

In April 1788, Dr. James White, superintendent of Indian affairs and congressional delegate from North Carolina, delivered a message from the Spanish charge d'affaires Don Diego de Gardoqui to Sevier and his government. If Franklin's leadership "wished to put themselves under the protection of Spain and favor her interests," de Gardoqui required that two conditions must be met. Franklinites must take an oath of allegiance to Spain, and they must renounce all allegiances to any other sovereign power.[376]

In July 1788, and again on September 12, 1788, Sevier's son James delivered letters from his father in reply to de Gardoqui's proposal. In the correspondences, Sevier requested "the Minister's interposition" with the Cherokees. Sevier wrote, "I hope…that his Catholic Majesty will be graciously disposed to reconcile the minds and keep in peace with us, all the Tribes of Indians that come immediately under the Notice, and Dominion of Spain."[377] Sevier then declared Franklin's citizens "unanimous in their vehement desire to form an alliance and treaty of commerce with Spain, and put themselves under her protection."[378] The alliance with Spain held potential not only to end Franklin's violent war with the Cherokees but also to open up more land to speculation by Sevier and his allies.

Engraved portrait of James Phelan Jr. (1856–1891), lawyer, politician and author of *History of Tennessee: The Making of a State*. *Tennessee Historical Society Collection, Tennessee State Library and Archives.*

Dr. Archibald Henderson, an early twentieth-century mathematician, biographer and historian whose chief historical works included *The Conquest of the Old Southwest*, called Sevier's efforts to forge an alliance with Spain "calculating and desperate."[379] Another scholar declared, "John Sevier

in his desperate disgrace was ready to grasp at any chance to better his fortunes."[380] Lacking access to the correspondence between Sevier and White, however, most early Tennessee historians chose to ignore Sevier's overtures in their writings. Others surmised that Sevier's engagement with the Spaniards served a greater purpose—to protect the frontier settlements from attack and to open Franklin's commerce to the west.[381] Some early Tennessee historians denied the existence of an alliance altogether. In his *History of Tennessee*, James Phelan flatly stated, "The attempt to form the State of Franklin was one expression of the prevailing discontent with the existing order of things. But there is not one scintilla of evidence for the belief that it ever verged towards Spain."[382] Phelan argued, instead, that Sevier actually sought to protect Franklin, and the nation, from Spain's territorial ambitions. He observed:

> *Sevier, bearing up against the world in arms, cast about for some refuge, and there are reasons for believing that at this time he entertained an idea of utilizing the enthusiasm of his troops by a campaign against the Spanish possessions in the valley of the Mississippi, in order to frustrate the negotiations then pending...It was in keeping with the boldness and brilliant decisiveness of his character to regard as neither chimerical nor audacious an enterprise so full of danger, and so wide-reaching in its results.*[383]

Gilmore concurred. As Spain "spread her sheltering wings over the entire Mississippi Valley," Gilmore wrote that Sevier, "that proscribed and outlawed man, who had lost all that most men value, and was at that very moment standing with his back to the wall, sternly waiting death at the hands of uncounted enemies, stretch [*sic*] out his arm across two hundred miles of trackless wilderness...to shape for long centuries the destinies of the West." Gilmore wondered with admiration, "Is it not hard to find in all history a more magnificent spectacle?"[384]

Years later, letters detailing the clandestine communication between Sevier and White surfaced as researchers began looking into the papers of the Spanish Archives for evidence related to Tennessee's earliest history. Beginning in 1937, D.C. Corbitt and his wife, Roberta Corbitt, published transcripts of these letters in *The East Tennessee Historical Society's Publications* journal.[385] The letters proved unequivocal—Sevier certainly engaged in an attempt to forge an alliance with Spain in Franklin's waning moments of existence. From this discovery, scholars began to question previously held beliefs, though patriotic feelings toward the state of Franklin persisted.

On July 29, 1788, North Carolina governor Samuel Johnston issued a warrant for Sevier's arrest on charges of high treason, but finding a judge willing to serve the papers to the popular Sevier proved challenging. Despite his diminished standing following the Battle of Franklin, Sevier maintained close alliances within the judicial system.[386] Sevier proceeded to conduct business as if he still governed the state of Franklin. Throughout the spring and summer months, Sevier continued his military campaign against the Cherokees and engaged in the secret alliance with Spain. All the while, North Carolina sought justice, and Tipton pursued vengeance.[387]

Eventually, the scales of justice tilted against Sevier. By early October, Judge Samuel Spencer issued the required writ, and Tipton eagerly carried the arrest warrant to Sevier. Meanwhile, on the day before his arrest, Sevier engaged in a heated confrontation with a merchant named David Deaderick. In a sworn affidavit, Deaderick testified that Sevier arrived at his store demanding "Whiskey or Rum," but Deaderick refused, saying that "he had none." Sevier then called for the former Franklin sheriff Andrew Caldwell, who stepped into the argument to defend the merchant. Sevier became enraged, ransacked the store and harassed its inhabitants. During the exchange, Sevier called Deaderick "a son of a Bitch." Deaderick replied by calling Sevier "a dead son of a Bitch." He then "stepped close to Sevier, who immediately drew out his pistol, or pistols." Caldwell attempted to negotiate a truce between the two men, but his efforts proved unsuccessful. The argument escalated into a challenge to a duel. As Deaderick gathered his pistols to confront Sevier, Caldwell got into his own heated altercation with the outlaw governor. According to Deaderick's sworn testimony, Sevier raised his pistol and fired, wounding another man in the process. Sevier then fled the scene. Tipton and several others arrived shortly thereafter and followed in pursuit.[388]

The next morning, Tipton detained Sevier at the home of the widow of one of his former captains, Jacob Brown. Following the arrest, Tipton ordered Sevier bound in iron handcuffs and delivered to Morganton, North Carolina, to face trial for the charge of treason.[389] The road to Morganton, however, led Sevier to a path of freedom instead of captivity, and the myths surrounding his journey colored the narrative of this event for many years afterward.

By most historical accounts, a small party of Sevier's closest family, friends and supporters, including his brother Joseph and son John, set out to rescue Sevier from his captors. They crossed the mountains into Morganton and, upon arrival, entered a tavern, where, much to their surprise, "they found Sevier in company with Major Joseph McDowell." McDowell and

his brother Charles fought alongside Sevier in many campaigns during the Revolutionary War. Without hesitation, the two brothers posted bail for their good friend so Sevier could await trial as a free man. Sevier loitered in the tavern for an hour or two before riding out of town toward the mountains.[390]

In the years that followed, writers embellished the details surrounding Sevier's "escape." Haywood wrote of a fantastic rescue at the Morganton courthouse engineered by Sevier's would-be liberators.[391] Ramsey repeated Haywood's account in his *Annals of Tennessee*, adding further details, which Ramsey stated he "derived from one conversant with all the actors." According to Ramsey, one of Sevier's rescuers, James Cozby, distracted the presiding judge in a "quick and energetic tone," as Sevier, "taking advantage of the confusion," made a hasty retreat for the door, and on his horse rode to safety.[392] Ramsey's conversant did little to hide his anger over Sevier's capture or his esteem for the exiled governor of Franklin:

> *Had the destroying angel passed through the land, and destroyed the first born in every section, the feelings of the hardy frontiersmen would not have been more incensed; had the chiefs and warriors of the whole Cherokee nation fallen upon, and butchered the defenseless settlers, the feeling of retaliation and revenge would not have been more deeply awakened in their bosoms. They had suffered with him; they had fought under him; with them, he had shared the hungers and privations of a frontier life, and a savage warfare and they were not the spirits to remain inactive, when their friend was in danger. The chivalry of the country gathered together; a number of men were selected to fly to the rescue; armed to the teeth, these dauntless sons of the woods crossed the mountains, determined to rescue their beloved commander, or leave their bones to bleach upon the sand-hills of North-Carolina, a proud memento of the children of the West.*[393]

The noted late nineteenth- and early twentieth-century Tennessee jurist Samuel Cole Williams attempted to correct this embellishment in a footnote to his *History of the Lost State of Franklin*. "While picturesque," Williams noted, Ramsey's account "is not authentic."[394] In spite of William's correction, however, writers continued to take artistic license with the facts surrounding Sevier's "escape." Newspaper accounts repeated the Haywood and Ramsey version of events with dramatic effect. Even Sevier's biographer Carl Driver mentioned the story, albeit with more brevity, simply stating, "While one of [the rescuers] questioned the judge, Sevier dashed from the building, mounted his horse, and rode away with his associates."[395]

Following his "escape," Sevier returned to his home, where on October 30, 1788, he wrote to the North Carolina General Assembly in an attempt to persuade the state government to drop its charge of treason. In the letter, Sevier called Tipton "an obscure and worthless individual" whose "ambition & malice" became the only driving force behind his persecution. Sevier implored:

> *Can it be possible that North Carolina is so void of understanding as to think she is so permanently fixed as not to be shaken; has she not discovered, that there is formidable and inveterate enemies around her watching to take the advantage of our divisions, which I am sorry to say are too numerous? Have you not discovered that those people have it in their power to do as much at least, if not a great deal more, for the Western Americans, than you can yourselves? Have you not seen the most affectionate child become sour & inveterate against the parent, when the parental and tender ties of humanity have been refused?*[396]

Ultimately, realizing the political futility in prosecuting its case, the State of North Carolina dropped the charge against Sevier. The legislature then restored his citizenship. Francis Marion Turner later recorded that Tipton so vehemently opposed this action that a "personal encounter" with one of Sevier's legislative supporters "would have resulted had it not been for the intervention of friends."[397]

As time passed, authors, scholars, antiquarians and amateur historians attempted to place Sevier's state of Franklin within greater historical context. In his analysis of the historiography of the state of Franklin, Kevin Barksdale detailed two divergent historical interpretations of Sevier's statehood movement. First, Barksdale observed that following the state of Franklin's dissolution in 1788, "descendants and celebrants of the Franklinites recast the historical legacy and meaning of the trans-Appalachian separatist movement...as a patriotic extension of the American Revolution."[398] In their letters to Tennessee's earliest historians, Barksdale maintained that the children of Franklin reshaped the legacy of Sevier's lost state "in an attempt to secure their own families' claims to regional preeminence."[399]

An example of this rhetoric survived in a letter to Draper, written by Sevier's son George Washington Sevier. George Sevier criticized Haywood's *Civil and Political History of Tennessee*, arguing that the historian gathered his information "from the statements of a few old men" who held

"strong prejudices" against his father. Sevier offered his own biographical sketch of his father to correct Haywood's "imperfect" history. Sevier's devoted son acknowledged his father as "the Governor of the small State of Franklin" and credited him with providing "internal improvements" within his state, though his sketch provided very little detail about the failed statehood movement.[400]

Sevier's admirers embellished these descendants' accounts with effusive praise and attempted to frame Sevier's failed attempt at statehood as a triumph rather than a tragedy. In 1851, attorney, businessman, historian and author Albigence Waldo Putnam[401] wrote a thirteen-page biographical sketch of the "life of Gen. John Sevier" for the Nashville newspaper the *True Whig*. In his account, Putnam described the state of Franklin as "an anomalous state," full of "stirring scenes and strangely commingled events." Sevier "feared not, faltered not, and failed not" in Putnam's vision of Franklin. Throughout the "emotion and commotion, contention and strife" of the Franklin ordeal, Putnam believed that Sevier did "more to defend the people and promote their peace and prosperity than any other man in all the country." Putnam even used biblical symbolism to further his point, comparing Sevier to Moses as a man who would rather suffer than submit to North Carolina's rule. "But out of it all," Putnam wrote, "the Lord delivered him—and the people finally shouted Jesus and amen!"[402]

Williams came, perhaps, closer than any of these early chroniclers to documenting the history of Sevier's state of Franklin accurately. As a respected jurist, Williams laid his case before the court of public opinion in his 1924 book, *History of the Lost State of Franklin*. In the preface to the first edition of his book, Williams gave credit to the antiquarians who came before him. Of Haywood and Ramsey, Williams wrote, "Anyone who attempts to write of the early history of Tennessee will find himself debtor to both." Williams then traced the history of scholarship on the state of Franklin, noting that Ramsey "borrowed heavily from Haywood" but had the added benefit of access to "documents handed down by his father, Francis A. Ramsey, Sevier, and other Franklin leaders." Williams also acknowledged Theodore Roosevelt, who in his book *The Winning of the West* drew upon "such ampler stores of information" made available in the archives of Virginia, North Carolina and Georgia.[403]

Through his work, Williams desired "to extend the research, to correct errors and supplement the work of these earlier writers." Williams believed that vital source materials remained unchecked in the archives of Tennessee and in other states, and he endeavored to document "in text, notes or

appendices" these "essential parts of the story of The Lost State."[404] While Williams carefully documented his sources, even he could not contain his admiration for Sevier. He observed, "Only Sevier's moderation, in the face of danger threatening from a common foe, the Indians, prevented the prompt adoption of repressive measures" from the North Carolina government.[405]

Tipton's story, on the other hand, mustered few allies among Franklin's literary advocates. In his zeal to deify Sevier, Gilmore characterized Tipton in the harshest terms. He called Tipton a "born demagogue" with a "violent and reckless" spirit. "Profane, foul-mouthed, turbulent, and of an irascible, domineering temper," Gilmore believed Tipton "lacked every quality of a gentleman except personal courage." Gilmore demeaned Tipton's intellect as a legislator and statesman. As the men of Franklin debated secession, Tipton, according to Gilmore, "sat in his place as dumb as an oyster." In matters of politics, Gilmore used even more forceful language. He described Tipton as a man "greedy for office" who "had the natural jealousy of Sevier that men of low and yet ambitious minds feel for their moral and intellectual superiors." Gilmore even compared Tipton to the devil himself, declaring him to be "a man of Belial, whose name was Sheba, the son of Bichri."[406]

Tipton's admirers and descendants sought redemption and, in their writings, cast him in the role of a loyal patriot. In his 1929 sketch of "The Tipton Family of Tennessee," Selden Nelson lamented, "No historian has yet given this noble man's true record." In a revisionist look back at Tipton's life, Nelson wrote:

> *He was far-sighted and knew the time would come when this part of North Carolina, then known as Washington County, would some day peacefully and without violating the laws of the land be made a separate State, and he lived to see that time come and himself an important factor in the formation of the Constitution and laws of the State. He, in the course during the troublesome times of the State of Franklin, represented the opposite of a principle that caused the greatest civil war ever known. He held to the Alexander Hamilton idea of a strong central government and put the state's rights in the back ground.*[407]

Nelson also paid tribute to Tipton's descendants, who he called "a noble race" who "occupied many positions of honor and trust" within government.[408] "The archives of our state and nation are full of deeds of valor and patriotism of the Tipton family," Nelson wrote. Meanwhile,

future generations of Tiptons inherited their ancestor's seething hatred of Sevier. Tipton's grandson proudly proclaimed that during the Battle of Franklin, "a skirmish took place in which the Sevier party was routed with the loss of 6 or 7 killed and wounded."[409] In an oral history "gathered from old men and women who distinctly remembered all the facts they detailed," another descendant, Tipton's maternal great-grandson Dr. Abraham Jobe, described the Battle of Franklin as "the War of the Rebellion in epitome." Jobe declared Sevier to be a man *without authority* from either the State of North Carolina or the United States" who "raised an army and commenced marching on Tipton to coerce him into obedience." Tipton's "little brave band" of men held off Sevier's forces, and according to Jobe, "So ended the State of Franklin."[410] Another Tipton family chronicler even accused Sevier family loyalists of arranging the death of Tipton's nephew Joshua on April 16, 1798, at the hands of "a marauding band of Cherokee Indians."[411]

Nelson believed that the Tipton family deserved recognition and that Tipton himself had earned a special place of honor to commemorate his legacy. "No marble shaft marks the last resting place of Colonel John Tipton," Nelson complained. "The Daughters of the American Revolution of Washington County should at least place a tablet over his grave, so as to show the future generations where the man, who broke up the State of Franklin, sleeps his last sleep. Within a few years those that know that John Tipton was buried on his farm near Johnson City will be gone and no one be able to locate his grave."[412]

By the early 1930s, a second phase of Franklin's historical interpretation ensued. Barksdale noted that in this period of economic depression, historians challenged the "romanticized vision of Franklin's murky past,"[413] as progressive writers and historians explored the achievement of wealth through land ownership as a motive for Franklin independence.[414] The work of Thomas Perkins Abernethy held particular influence over the historical thinking of this period. In his 1932 book, *From Frontier to Plantation in Tennessee: A Study in Frontier Democracy*, Abernethy characterized the Franklin statehood movement as "a game played between two rival groups of land speculators." He called into question the mythology and patriotic devotion previously associated with leaders like Sevier.[415]

Amid the social tumult of the 1960s, historians expanded upon these works, drawing even stronger connections between land speculation and the Franklinite's separatist movement. Barksdale quoted Tennessee historians Stanley J. Folmsbee, Robert E. Corlew and Enoch L. Mitchell in their four-

volume *History of Tennessee*, stating the authors argued "that 'Sevier assumed leadership' of the Franklin government 'apparently in the hope that…[it] might be used as a means of reviving and advancing' a lucrative Tennessee River land deal."[416] Barksdale also cited Tennessee scholar Wilma Dykeman, who "believed that 'money was a deep though often obscure motive behind the movement for the new state.'"[417]

Throughout these interpretive shifts within the scholarly community, however, local authors, novelists and amateur writers continued to record the history of the state of Franklin in wistfully nationalistic terms. In his 1968 book, *Franklin: America's Lost State*, author and novelist Noel B. Gerson declared, "Franklin may have been impractical, a wild venture, but she laid the foundations for the establishment of Tennessee, and her sons, from John Sevier to the most humble frontiersman, together made a major contribution to America's rich heritage of freedom."[418] Years later, in his slim volume *Franklin: The Stillborn State*, Dave Foster credited the rivalry between Sevier and Tipton with the creation of America's two-party political system. Foster wrote:

> *The Franklin feud between Sevier and Tipton ushered a new type of rivalry on America's western political landscape. For more than two centuries now, political parties have vied for the spin-offs and spoils when their friends are elected to high office. Truly, Sevier and Tipton were authentic pioneers of the southwestern frontier, but as midwives at Franklin's stillborn birth, they also served as political pioneers.*[419]

Although the Franklin statehood movement ended in political embarrassment for Sevier, his popularity in the region only briefly waned. Sevier had previously earned the respect and admiration of his fellow settlers through his fearless engagements with the Cherokees. His personal charisma and effective use of the language of patriotism to remind citizens of his personal sacrifice during the Revolutionary War allowed Sevier to maintain favor in the eyes of his contemporaries in spite of Tipton's undermining efforts. Sevier parlayed his popularity, political alliances and business relationships into a solid base of support. In 1789, voters elected Sevier to a seat on the North Carolina State Senate. In that chamber, Sevier registered a vote in favor of a second cession. Through the legislative process, Sevier finally realized his dream of a separate state with Tennessee's admission into the Union in 1796.[420] Sevier won election as Tennessee's first governor and served in that capacity for six two-year

"Key to the State of Franklin Capitol," displayed at the East Tennessee History Museum. *Author's collection.*

terms. As governor, Sevier galvanized his political support and solidified his legacy as a statesman.

In the years that followed, the state of Franklin rebellion led to the inclusion of Article IV, Section III of the U.S. Constitution, which specifically addressed the formation of new states from territories claimed by existing states.[421] Sevier's descendants and loyal followers chose to remember the Franklin statehood movement as a four-year triumph of local civic autonomy. Sevier's glaring missteps in the Franklin experiment—particularly his defeat and imprisonment following the Battle of Franklin and his clandestine alliance with Spain—became footnotes in history. Again, patriotism played a key role in this view of democracy on the frontier.

Tipton's legacy, on the other hand, suffered greatly. This Virginia statesman who challenged "Tennessee's first hero" assumed the role of villain in the retelling of the Franklin drama. Though he won the Battle of

Franklin, he certainly lost the war of remembrance. Following this episode, Tipton all but disappeared from public memory. Tipton's most vocal critic, Gilmore, wrote, "Of John Tipton himself all trace from this time disappears. Whether he had died, or had retired, like Cincinnatus, to his farm, I have not been able to discover."[422]

Called the "lost state" by many writers, Franklin developed into East Tennessee's "Lost Cause" in the years following the Civil War—an emotional outlet for a region consumed by the devastation of that conflict, yet not fully willing to embrace pro-Confederate narratives.[423] "To East Tennesseans," Barksdale wrote, "Franklin and its charismatic governor, John Sevier, have come to represent rugged individualism, regional exceptionalism, and civic dignity."[424] While modern historians effectively challenged the traditional view of Franklin as an extension of the patriotic ideals that sparked the American Revolution, amateur writers, authors and descendants maintained their hagiographic narrative. Economic interests certainly motivated Sevier, but the "high and noble principles"[425] ascribed by his early biographers left an enduring impression. By arousing sentimental feelings toward the American Revolution, Franklin remained a safe place for chroniclers, admirers and descendants to express their regional pride in this "virtuous and patriotic people."[426]

HIS EXCELLENCY GOVERNOR JOHN SEVIER

We have had no real State hero since the pioneer days. The list began with John Sevier and ended with Andrew Jackson.
E.E. Miller, 1922

In 1796, John Sevier's dream of forging a state from the western lands of North Carolina finally became reality. After Congress authorized Tennessee's application for statehood, members of both houses of the state's new legislature gathered in Knoxville to establish a government. The legislature immediately undertook the important task of inaugurating a governor. The settled counties held elections, and Sevier won a decisive victory. Despite the turmoil of the failed state of Franklin experiment, Sevier's popularity among the frontier people remained strong. He was their unquestioned leader. At the noon hour of March 30, 1796, Judge Joseph Anderson administered the oath of office to Sevier who afterward addressed the General Assembly:

> *Gentlemen of the Senate and House of Representatives:—The high and honourable appointment conferred upon me by the free suffrage of my countrymen, fills my breast with gratitude, which, I trust, my future life will manifest. I take this early opportunity to express, through you, my thanks in the strongest terms of acknowledgment. I shall labour to discharge with fidelity the trust reposed in me; and if such my exertions should prove satisfactory, the first wish of my heart will be gratified.*

Gentlemen—accept of my best wishes for your individual and public happiness; and, relying upon your wisdom and patriotism, I have no doubt but the result of your deliberations will give permanency and success to our new system of government, so wisely calculated to secure the liberty, and advance the happiness and prosperity of our fellow citizens.[427]

Success would not come easy. Tennessee's geography presented unique challenges to the new governor. The newly formed state stretched from the Appalachian Mountains to the Mississippi River, and around two-thirds of that territory remained under the control of the Native American population. While Sevier negotiated a series of treaties to clear Indian claims to territory in Tennessee, the federal government's strict policy of enforcement of these treaties infuriated many settlers, who believed the terms of the treaties often favored the Indian tribes.[428] Managing diplomatic relations and negotiating territorial disputes between white settlers and the tribes of the region consumed much of Sevier's time and attention during his first series of administrations as governor. He balanced his concerns for his fellow statesmen with an adherence to the laws of the federal government. Yet in many cases, conflict proved unavoidable, and sometimes settlers took matters of justice into their own hands, often through violent means.[429]

The new governor faced another challenge—the administration of military appointments. At this time, the law subjected all free men between the ages of eighteen and fifty to military duty. The governor issued military commissions and adjudicated disputes over the election of officers. Men in the militia sought every opportunity for higher office, and often fraud and partisanship provided the means by which these men achieved their rank. By most accounts, it appears that Sevier attempted to settle these matters fairly. Nevertheless, his political opponents frequently accused him of favoritism.[430]

By the time that Tennessee achieved statehood, a young and ambitious politician named Andrew Jackson served in Congress as a U.S. senator. Jackson longed to leave Philadelphia to serve his home state in some other capacity. Therefore, he offered himself as a candidate for major general of the state militia. Sevier, however, favored another man for the position, George Conway, and helped to secure Conway's election to that post. Jackson became infuriated, but Sevier brushed Jackson aside, claiming that he cared little about the "scurrilous expressions of a poor, pitiful, petty-fogging lawyer."[431]

Over time, Sevier's relationship with Jackson worsened. Following Jackson's return to Philadelphia in 1797, the two men exchanged angry

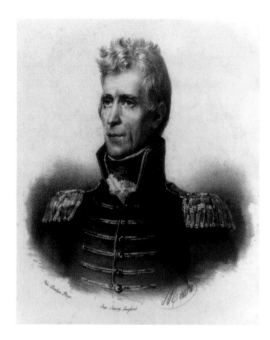

Portrait of Andrew Jackson (1767–1845) painted by John Vanderlyn in 1823. *Library of Congress.*

letters with each other. Seeing no real political benefit to either man for their continued animosity, however, mutual friend James Robertson urged Sevier and Jackson to put aside their differences. Eventually, Sevier relented, writing to Jackson, "I never was nor am I yet, either your private or political enemy." Jackson replied cordially, "I now remark to you that I think you had no malicious design to injure my reputation."[432]

The following year, Jackson resigned his seat as a U.S. senator and accepted an appointment as a judge of the Superior Court of Tennessee. Upon learning of Jackson's desire for the appointment, Sevier offered his unequivocal endorsement. In a letter dated August 29, 1798, Sevier wrote, "This information is truly satisfactory to the executive…I will do myself the honor of informing you that in case the office of judge of the Superior Court of Law and Equity meets your approbation, you will please consider yourself as already appointed."[433] The Tennessee General Assembly subsequently elected Jackson to that office, and he remained on the bench until 1804. While the two men behaved cordially, bitterness and jealousy simmered beneath the surface.

The state constitution prohibited Sevier from seeking a fourth consecutive term following his three successive two-year terms as governor. In 1801, Archibald Roane, another political rival of Sevier, became governor of Tennessee. During Roane's term as governor, Sevier solicited the same position in the state militia that Jackson earlier sought. This time, Roane selected his friend and ally Jackson for the position. With this political maneuver, the rivalry between these two men not only renewed but also escalated.[434]

Sevier used this political defeat as motivation to mount a campaign against Roane for another term as governor of Tennessee, but during the campaign, Sevier encountered charges of bribery and scandal. Jackson produced

documents claiming Sevier had engaged in a massive land fraud. He asserted that Sevier conspired to destroy original records of land ownership, replacing them with forged claims. He further alleged that Sevier resorted to bribery to keep the replacement quiet.[435] Despite these claims, Sevier won election for a fourth term as governor but remained chafed under the humiliation of Jackson's accusations. So when the two men encountered each other on the courthouse steps in Knoxville, Tennessee, on October 1, 1803, an inevitable confrontation ensued.

As Jackson arrived in Knoxville to hold court, he encountered Sevier in the public square. Both men exchanged a barrage of angry words. Sevier sneered at Jackson, alluded to his lack of military experience before becoming major general and dared him to draw arms. Jackson—still recovering from a severe illness and fever and carrying only a cane against Sevier's sword—declined. Instead, Jackson defended himself by citing his considerable services to the state and to the nation. "Services?" Sevier laughed in derision. "I know of no great service you rendered the country, except taking a trip to Natchez with another man's wife."[436]

With that insult, Sevier crossed a line from which he could not retreat. Stunned silence filled the air, but soon afterward, Jackson exclaimed, "Great God! Do you mention her sacred name?" Jackson then lunged at Sevier. As the governor brandished his sword, Jackson raised his cane in defense of his wife's honor. Friends of both parties drew pistols, and shots rang out as a bullet grazed at least one bystander.[437] For a moment, a bloody confrontation loomed. Fortunately, cooler heads prevailed, and the crowd quickly separated the two men, preventing a fight that could have altered the course of history.[438]

While they avoided a physical altercation, a war of words between the governor and the judge quickly commenced. The following day, Jackson launched into a written tirade against Sevier. In a letter dated October 2, 1803, Jackson wrote:

> *The ungentlemanly expression and gasconading conduct of yours, relative to me yesterday, was in true character of yourself, and unmasked you to the world, and plainly shows that they were the ebullitions of a base mind, goaded with stubborn proofs of fraud, and flowing from a source devoid of any refined sentiment or delicate sensation.*
>
> *But, sir, the voice of the people has made you a Governor. This alone makes you worthy of any notice, or the notice of any Gentleman. For the Office I have respect, and as such I only deign to notice you and call upon*

you for that satisfaction and explanation that your ungentlemanly conduct and expression require. For this purpose I request an interview, *and my friend, who will hand you this, will point out the time and place, when & where I shall expect to see you with your friend and no other person. My friend and myself will be armed with Pistols,—you cannot mistake me or my meaning.*[439]

Indeed, Jackson clearly stated his intentions. His demand for an "interview" veiled a call to meet in a duel. Honor and reputation were paramount to gentlemen of the late eighteenth and early nineteenth centuries, and the duel offered a method to settle disputes that had escalated into an insult of character.[440] Before a duel, both parties needed to agree to terms for the meeting. Here, Jackson's challenge to Sevier met with resistance. Sevier responded to Jackson in a letter of his own filled with words of equal vitriol, matching Jackson's letter almost word for word in a mocking rebuke:

Your ungentlemanly and Gasconading conduct of yesterday, and indeed at all other times, heretofore, have unmasked yourself to me and to the world. The voice of the Assembly has made you a Judge, and this alone has made you worthy of my notice or any other gentleman; to the office I have respect, and this alone makes you worthy of my notice.

I shall wait on you with pleasure at any time and place not within the State of Tennessee, attended by my friend with pistols, presuming you know nothing about the use of any other arms. Georgia, Virginia, and North Carolina are in our vicinity, and we can easily repair to either of those places, and conveniently retire into the inoffending Government. You cannot mistake me or my meaning.[441]

The two men continued to trade barbs in several letters over the next few days. Jackson wanted to fight Sevier in the town where the insult took place, while Sevier refused to duel on Tennessee soil. On October 3, 1803, Jackson wrote, "Your attack was in the town of Knoxville; in the town of Knoxville did you take the name of a Lady into your polluted lips; in the town of Knoxville did you challenge me to draw, when you were armed with a cutlass and I with a cane—and now sir in the Neighborhood of Knoxville you shall atone for it or I will publish you as a coward and a poltroon."[442]

Knowing Sevier had no intention of meeting on these terms, Jackson accused him of evasion and proposed to meet him in Indian territory, saying, "If it will obviate your squeamish fears, I will set out immediately to

the nearest part of the Indian boundary line…you must meet me between this and four o'clock this afternoon, or I will publish you as a coward and poltroon."[443] Sevier tersely replied, "Your letter of this day is before me and I am happy to find you so accommodating. My friend will agree upon the time and place of rendezvous."[444]

The stage set, a duel seemed inevitable, but Sevier claimed he had further business to conduct at the Knoxville Courthouse and could not meet Jackson until after his business concluded. Was this a delay tactic, or a sincere devotion to the duties of public office? Jackson believed he knew the answer to this question. On October 9, 1803, he wrote a lengthy letter to Sevier, recalling their confrontation. Like an attorney arguing before a jury, Jackson laid out his case for retribution in great detail. He then accused the governor of avoiding his challenge and threatened to denounce him in the press. Jackson wrote:

> *The delays I thought were intended as a mere subterfuge for your cowardice. You will recollect that you on the 1st inst. in the public streets of Knoxville appeared to pant for the combat. You Ransacked the Vocabulary of Vulgarity for insulting and blackguard expressions; you without provocation made the attack, and in an ungentlemanly manner took the sacred name of a Lady in your polluted lips, and dared me publicly to challenge you, and now, since you gave the insult, you have cowardly evaded an interview. On that day you appeared at Court. You ought, at least before you make a premeditated attack, to be ready to repair the injury of the call of the injured. I have waited your time. I have named the Indian boundary line, to prevent you from having any subterfuge, to which you agreed,—and all in vain. Cowardice is now your only chance of safety; to that you have resorted; and as you will not give that redress in the field that the injury you have done requires, and as your old age protects you from that chastisement you merit, the justice I owe myself and country urges me to unmask you to the world in your true colors.[445]*

Jackson's patience exhausted, he requested that Sevier meet him within two hours of receiving his note. He defiantly remarked, "I hope it will not be stated, that I ran away for fear of you, and your friends."[446] Sevier's reaction to Jackson's latest missive demonstrated his disdain for the young attorney:

> *As to answering your long detail of paper gasconading, I shall not give myself the trouble. You need not be uneasy about an interview, for you*

shall be favored with a hearty concurrence, but I shall not neglect the public business I am bound to attend to, nor my own private business now before the House, that you and several other poltroons are aiming at to my prejudice.

An interview within the State you know I have denied. Any where outside, you have nothing further to do but name the place and I will the time. I have some regard for the laws of the State over which I have the honor to preside, although you, a Judge, appear to have none. It is to be hoped that if by any strange and unexpected event you should ever be metamorphosed into an upright and virtuous Judge, you will feel the propriety of being Governed and Guided by the laws of the State you are sacredly bound to obey and regard. As you answering all your jargon of pretend bravery, I assure you it is perfectly beneath my character, having never heard of any you ever exhibited.[447]

Apparently, believing the previous letter not emphatic enough, Sevier wrote another letter to Jackson reiterating what he had penned earlier, again berating Jackson for his "gasconading conduct."[448] The exchange of letters continued. On October 10, 1803, Jackson replied, naming a time and place for their long-awaited interview. "You may yet retrieve your character, by seeing me in this neighborhood, this evening or early to-morrow morning. If at South west point, to-morrow evening, or on Wednesday next, any time before 12 o'clock of that day. If you incline to this meeting, I will expect to be notified by you."[449]

Later that same evening, an exasperated Sevier replied:

I have constantly informed you I would cheerfully wait on you in any other quarter, and that you had nothing to do but name the place and you should be accommodated. I am now constrained to tell you that your conduct during the whole of your pretended bravery, shows you to be a pitiful poltroon and coward, for your propositions are such as you and every other person of common understanding do well know is out of my power to accede to, especially you a Judge!! Therefore the whole tenor of your pretend readiness is intended for making nothing more than a cowardly evasion. Now, Sir, if you wish the interview accept the proposal I made you and let us prepare for the campaign.[450]

Sevier's reply enraged Jackson. Jackson concluded that Sevier intended to avoid a confrontation. On the evening of October 11, 1803, he finally grew weary of the literary exchange. "I have just to remark that it is high

time the thing should be put an end to," Jackson wrote. "Time is precious with me; nothing detains me from my family but waiting on you for an accommodation of this business, and I have instructed my friend to have such an answer as will be final."[451] A friend, Captain White, carried Jackson's letter. White reported that Sevier refused to open it, saying he would not read it and "would have nothing to do with the Judge or any of his notes." According to White, Sevier "utterly refused" Jackson's invitation.[452]

With this letter, the correspondence between Jackson and Sevier ended, but Jackson refused to set aside his pen. He published his "advertisement" as threatened, publicly accusing Sevier of cowardice and demanding retribution for the insults leveled just days earlier. He declared:

> *To all whom shall see these presents Greeting—Know ye that I, Andrew Jackson, do pronounce, Publish, and declare to the world, that his Excellency John Sevier, Esq., Governor, Captain-General, and Commander-in-chief of the Land and Naval forces of the State of Tennessee, is a base coward and poltroon—he will basely insult but has not the courage to repair the Wound.*[453]

After receiving no satisfactory response from Sevier, Jackson set out for Fort South West Point with his friend and ally, Dr. Thomas Vandyke, a surgeon's assistant with the U.S. Army.[454] Jackson maintained hope that Sevier would honor his challenge and meet him at that location. The governor, however, inaugurated to a fourth term less than three weeks earlier, left Knoxville to attend a conference with the Cherokees. To Sevier, duty to the affairs of state took precedence over assuaging Jackson's demand for a duel.

Jackson waited on Sevier at South West Point for two days, but the governor did not arrive. Jackson left in disgust, but upon his return to Knoxville, his opportunity for vengeance finally presented itself. After an overnight stay at a house near Kingston, Tennessee, Sevier, accompanied by three other men—Sevier's son James, Andrew Greer and John Hunter—left the home on Sunday morning, October 16, 1803. On the road departing Kingston, Sevier and his traveling companions encountered Jackson.[455] The long-awaited interview between these two men seemed imminent.

Loyalists to both parties colored the various accounts and details surrounding the chaotic events of that day. Sworn affidavits signed by witnesses to the encounter painted conflicting portraits of the scene. In one version of events, after seeing Sevier and his party on the Kingston Road,

Jackson dismounted his horse, drew his pistols, and advanced toward Sevier. "Scurrility ensued," Vandyke observed, adding:

> *General Sevier was standing near a tree. General Jackson remarked that if he was a soldier, and as they both had pistols in their hand, to unmark himself and fire. General Sevier replied that he would not fire, and that he did not wish to be assassinated, that he had been informed we had the preceding evening traveled up the road as far as Captain Stones with the intention to meet and assassinate him. I observed the information was false, and his informant a rascal, that I never had or would be accessory to the assassination of any man.*[456]

As the two men exchanged unpleasantries, Vandyke requested that Jackson and Sevier deliver their pistols to him, and "meet in a proper manner on the field of honor." According to Vandyke, "General Jackson agreed to the proposition. General Sevier positively refused."[457]

Sevier's allies, however, told a slightly different version of the events of this day. Greer, one of Sevier's three traveling companions, testified in his own sworn affidavit that he witnessed Jackson draw his pistols and advance toward the governor. Sevier then dismounted his horse and drew his own pistols until both men stood within twenty steps of one another. Greer stated he "heard the Governor damn him to fire away," but after some heated exchange of words, the two men holstered their pistols. According to Greer, Jackson then advanced toward Sevier and drew his sword. This frightened the governor's horse, which ran away, carrying Sevier's pistols into the woods far removed from the chaotic scene. Sevier quickly took cover behind a tree, cursing Jackson for attempting "to fire on a naked man." At that moment, according to Greer, Sevier's son James drew his pistol and advanced toward his father to protect him from Jackson's onslaught. Vandyke then joined the fray, drawing his pistol on young James Sevier. The two men traded more insults until, at some point, both Jackson and Sevier returned to their horses. "Judge Jackson damned the Governor for a coward," Greer testified, while Sevier responded that he knew Jackson "would not fight him in the State" after "he had made it a point to send him so many challenges."[458]

Both Jackson and Sevier chronicled their versions of the events of that day in partisan newspapers representing both sides of the dispute. Sevier called the incident the "Kingston attempt to assassinate" and reminded voters that a governor's time should not be squandered on a private feud.[459] Jackson's accusations in the press outraged Sevier's defenders. One particular

ally of the governor, a man who identified himself only as "a citizen of Knox county," wrote a lengthy defense of Sevier's character and challenged Jackson's assertion that Sevier behaved in a cowardly manner. In the editorial published in the *Knoxville Gazette*, and reprinted in the *Tennessee Gazette and Mero-District Advertiser*, this "citizen" disputed Jackson's characterization of Sevier, calling the charges "abusive and scurrilous" in a scathing rebuke:

> *Now, let us ask, how many hundreds of respectable characters, are in this, and several other states, who have been eye witnesses of the governor's courage; where he displayed as much as was necessary to be found in the most tried and experienced veteran? Who is it that have fought the battles of this country, and drove from its borders its numerous and desperate enemies? Who are the people beholden to for the settlement of the fame? Is he not the man, whose exercions [sic] have taken from the numerous hords [sic] of the savage wilds, and placed thereon a rising, growing and respectable republic, in which thousands of families are rearing up their children in peace, opulence and security? Strange indeed, that after so many battles and engagements the governor has encountered, that such a thing as cowardice should be imputed to him!!!—The judge, at the very time of his buffoonery and pretended heroism, calling the governor to an interview, this evening, to-morrow morning, was busied in publishing his piece of scurrility and vagary, well knowing that it would, as it very justly did, occasion the governor to forbid any further correspondence on the subject; from the foregoing circumstances, and particularly that of fending challenges to a person in the governors situation, who (except he had been madman) could not accept, is a ample & satisfactory a proof of a coward and poltroon, as any that ever did or ever will exist; the judge, shark like, intending to grasp the prey into his voracious jaws, has unfortunately darted himself out of the water flat on his own back, upon a dirty beach, from where it will be impossible for him with all his serpetile [sic] windings, to make his retreat with credit into the clear and pure channel, that prescribes laws and rules by which he has taken so solemn an oath to preserve, be ruled, and ought in conscience to be governed and guided thereby; and has effected no other purpose, but to expose his own grinning, and the carnivorous teeth of that fealy [sic], finny, & ill looking monster.*[460]

The "citizen" then questioned why Sevier, a man "on the verge of three score"[461] in age, with sixteen children to support and governing as the chief magistrate of the state, should even engage in a duel. Under these circumstances

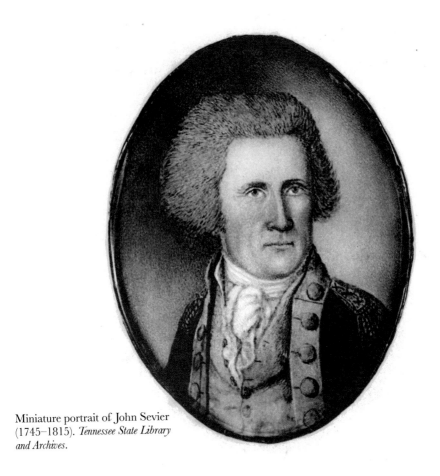

Miniature portrait of John Sevier
(1745–1815). *Tennessee State Library
and Archives.*

the "citizen" wondered, "Could the governor have imagined, that the judge or
any other person was, or had been lurking about for the abominable purpose
and most abhorrent of all crimes, that of assassination."[462]

Jackson's allies did not remain silent on the matter. In a letter published
in the *Tennessee Gazette* on December 14, 1803, a pseudonymous writer
named "Veritas" called out the "citizen of Knox county." Veritas accused
Sevier of authoring the letter and described his "vulgar and ungentlemanly
expressions" as evidence of his cowardice. "The dread of punishment
appears to have had a pretty sudden operation on his Excellency's morals,"
Jackson's advocate wrote. Veritas further added:

> *If then the Citizen of Knox county and his Excellency do not think the general
> an upright and virtuous judge, they must certainly admit that he is successful*

as a preacher, his Excellency has no doubt heard many good sermons in the course of his life, and still remained a hardened offender, both against the laws of God and man, and yet, thro' the persuasive eloquence of the generals lectures, in the course of a few days we find him converted to Christianity, and a rigid adherence to legal precepts; the question is not whether the general was acting in obedience to the law in seeking redress from his Excellency, but whether the facts justified the conclusion, that his Excellency acted the part of a coward and poltroon, and of this there cannot remain a single doubt; all his shifts and devices to evade this conclusion fail. [463]

Despite Jackson's vocal accusations in the press, Sevier's popularity among the voters of Tennessee never waned. Privately, however, Sevier suffered from the affair. In a letter to his old friend, James Robertson, Sevier wrote:

I make no doubt but you have heard many ill-natured things respecting me and my conduct, of my being a rogue, a coward, and a thousand other things...if I have been a rogue, I suppose there must those come forward that I have wronged and make it known wherein I have injured them. As to cowardice, there is [sic] thousands that have witnessed my transactions as a soldier and it is for them to say on that point. I have to observe to you that in the whole course and experience of my life, I have never been as much insulted, and the many little practices made use of, for the purposes to trapan & deceive, as have been made use of by Jackson to injure me...I am sorry I am bound to view him Judge Jackson, as one of the most abandoned rascals in principle my eyes ever beheld. [464]

In the decades that followed, writers and scholars played an important role in the casting of this episode. James Gilmore portrayed Sevier as both a hero and gentleman. In his account of the duel, Gilmore embellished the details with the flourish of a novelist's pen, comparing the confrontation to a medieval jousting match:

Both were mounted, and Sevier was surrounded by about twenty horsemen. Jackson was much more thinly attended, and armed only with a cane and a brace of pistols; but, putting his cane in rest, like the lance of a plumed knight, he charged down upon Sevier most furiously. The latter dismounted to meet the assault; but a collision was prevented by the attending gentlemen, who soon pacified Jackson, and induced him to give his hand to the Governor. [465]

Francis Marion Turner more vigorously defended Sevier. In 1910, Turner published *Life of General John Sevier*, which contained prose rife with respect and admiration for his subject. Turner downplayed Sevier's insult toward Rachel Jackson and elevated the governor's temperament to that of a statesman:

> *Although Sevier was elected by the popular vote, there were those who, jealous of his popularity, tried to destroy his political favor by circulating false reports about him. They accused him of speculation in land-warrants and even of forgery...Sevier's popularity seems not to have been affected by these efforts to injure his reputation. But his indignation was aroused against Andrew Jackson, whom he had appointed Judge of the Superior Court. Jackson was of a very different temper from Sevier. Sevier's temper was fiery, but he was ever ready and eager to atone for any wrong he had done, while, on the other hand, Jackson rarely forgave an enemy.* [466]

Turner described the dueling tradition and the correspondence between Jackson and Sevier leading up to their confrontation. He downplayed the whole event, however, giving the reader the distinct impression that Sevier charmed Jackson into submission. "It seemed that a duel was inevitable," Turner wrote, "but, through negotiations of friends on both sides, matters were finally adjusted, and the two heroes were induced to join hands in friendship." [467]

In 1932, Sevier biographer Carl Driver provided a more scholarly approach to his subject but still left room for admiration. In *John Sevier: Pioneer of the Old Southwest*, Driver stated that Sevier "cleverly sidestepped his opponent and left Jackson with an injured reputation" immediately following their encounter. [468] While Gilmore and Turner glossed over Sevier's feud with Jackson, Driver acknowledged that Sevier "could not forget what he considered an unprovoked attack upon his reputation and popularity." According to Sevier's own diary, Jackson disturbed his thoughts and haunted his dreams:

> *Curious dream. I dreamed my Father came descending in the air in what appeared at first like a cloud...I asked him if there was any news where he had been. He answered that nothing existed there but the utmost peace and friendship, that he had heard much conversation respecting the Quarrel between Judge Jackson & myself, I then asked him if it was possible that*

affair had reached so far? He then replied that long before he had arrived the news was there and also every other transaction that had taken place in Tennessee—I then asked him what was said? He told me that Jackson was viewed by all as a very wicked base man, and a very improper person for a judge, and said I have it in charge to intimate you either by dream or some other mode, that you have nothing to fear provided you act a prudent part for they are all your friends—on his saying by a dream I began to think I was dreaming & immediately awaked.[469]

During his years as governor of Tennessee, Sevier's charismatic personality delivered him through six terms, virtually unchallenged, and his popularity in the state led many potential opponents to avoid challenging him all together.[470] James Phelan noted that Sevier "possessed perhaps every qualification which could contribute to an essential degree to the success of a politician."[471] He observed that Sevier enjoyed engaging with the public, opened his home to total strangers and through charm and reputation as a leader of men could turn the opinion of even his most staunch opponents.[472]

Yet as his final term as governor ended, Sevier's political rivals saw an opportunity to fill the void of leadership within the state. Most historians agree that the feud between Sevier and Jackson during Sevier's final years as governor marked the beginning of political sectionalism between East and West Tennessee.[473] Sevier's political power resided in East Tennessee, while Jackson forged his political identity in the middle and western portions of the state. As the center of population moved west, political power consolidated with Jackson. While East Tennessee still revered Sevier, the settlers living in the Cumberland settlements and further west held little regard for the governor. They committed their political loyalties to Jackson. As a result, in the twilight of his political career, Sevier failed to develop a political organization capable of carrying on his legacy.

The historian John Spencer Bassett observed that Sevier "gave way to his opponents, who then took a continuous control of the affairs of the state."[474] Thomas Perkins Abernethy went one step further in describing Sevier's lack of political acumen during his final years in office. "He was a frontier Indian fighter rather than a politician," Abernathy wrote, "and he never came to understand the methods by which a democracy is governed. For all its enthusiasm, his following was mere personal clique, with no coherence and no directive leadership. There was no organization, there were no policies, and there was no real politics."[475] Years later, the political legacies

of both men moved farther apart. After the Tennessee legislature requested sculptures of Sevier and Jackson for Congress's National Statuary Hall, Samuel Cole Williams remarked, "Having regard to the bitter enmity that marked their careers, the sculptor may achieve a master-stroke by causing the two marble effigies to look in opposite directions."[476]

The writer E.E. Miller proposed that Tennesseans "have had no real State hero since the pioneer days. The list began with John Sevier and ended with Andrew Jackson."[477] Years following the two men's dispute, loyal advocates of Sevier and Jackson continued to extol the virtues of these great political rivals. The rivalry between Sevier and Jackson, however, encompassed more than a mere bitter dispute between two sworn enemies. This conflict shaped the course of politics in the state of Tennessee for generations to come.

YOUR MOST OBEDIENT HUMBLE SERVANT

I have labored to merit the esteem and confidence of my Countrymen, and the great object of my political life, has been to promote the Welfare of this part of the Western country; now the State of Tennessee. How far I have succeeded is not for me to determine.
John Sevier, 1797

John Sevier's final term as governor of Tennessee ended in 1809. He concluded his service as the state's chief executive after six two-year terms.[478] In his final address to the Tennessee General Assembly on September 19, 1809, Sevier bid farewell to his fellow statesmen. "Permit me, in taking leave of your august body," Sevier remarked, "to express a hope that a benign providence will ever guard therewith and promote the well-being and happiness of my fellow citizens of the state of Tennessee."[479] Sevier's popularity among the citizenry in East Tennessee remained high, and his political career was far from over.

Sevier refused an earlier call by the people to run for Congress, stating that the affairs of the state prevented him from mounting a campaign. Yet following his last term as governor, he served his constituency in another capacity. On August 4, 1809, Sevier won election without opposition to the state senate representing Knox County.[480] Shortly after Sevier took office, John Cocke delivered an impassioned speech before the General Assembly

expressing the state's appreciation for Sevier's service to Tennessee and to the nation. He stated, "Permit us to express the grateful sense, which, in common with our constituents, we entertain of the various and important services you have rendered to your country, both in your civil and military capacity. These services have evinced an extent and a purity of patriotism which have justly secured to you the confidence of your fellow citizens."[481]

Sevier later campaigned for a seat in the U.S. House of Representatives. Victorious, he served the remainder of his political career as a congressman from March 4, 1811, until his death in 1815.[482] Though certainly an effective administrator as governor and a popular politician in Tennessee, Sevier never experienced the same level of success as a statesman in Washington, D.C. While he served on several committees, Sevier at no time held a leadership role and rarely voiced his opinion on the House floor. The journalist and historian Richard Hildreth noted that Sevier arrived at Congress "stiff and grim as an Indian arrow, not speaking, but looking daggers."[483] Carl Driver observed, "No speech is recorded, and no letters or documents are available which would indicate that he took part in a single debate." Driver further remarked, "Practically nothing exists which would give his attitude upon the public questions confronting the government except a record of his votes in the *Annals of Congress*. Only a few letters supplement the record."[484]

Sevier openly expressed his views, however, on one issue. In 1812, members of Congress debated the prospect of military intervention against Great Britain. This occurred in response to the British navy's interference with trade and the impressment of sailors on American ships, as well as British military support of Indian tribes eager to halt American territorial expansion. On June 4, 1812, Sevier joined seventy-eight of his congressional colleagues and voted for a formal declaration of war.[485] In a letter written to Tennessee governor Willie Blount following the vote, Sevier conveyed his feelings on the matter. He declared, "We have at length passed the Rubicon. War is finally declared against Britain and her dependencies."[486] Sevier's letter burned with hatred toward the enemy, especially the Creek Indians, whom he believed the British supported. "Fire and sword must be carried into that country before those wretches will be reduced to reason or become peaceable neighbors," Sevier raged. He continued, "There can be no reliance or trust placed in them. No doubt British emissaries are among them."[487]

Anti-British sentiment ran high in Tennessee, and rumors of a growing Creek presence along Tennessee's borders armed with British weaponry only served to fan the flames of war even higher.[488] Ironically, Sevier's old

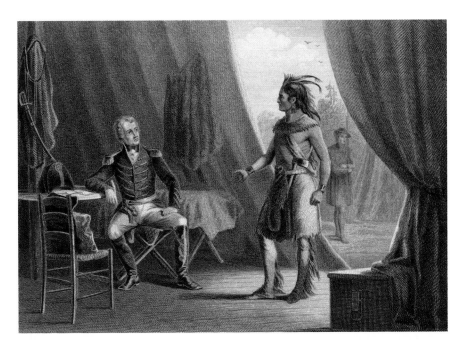

Creek chief William "Red Eagle" Weatherford surrenders to Andrew Jackson on August 9, 1814, ending the Creek War. *Tennessee Historical Society Collection, Tennessee State Library and Archives.*

nemesis Andrew Jackson played a pivotal role in the outcome of the war. On August 30, 1813, a faction of the Creek Nation known as the Red Sticks, under the command of its chief William Weatherford massacred some 250 men, women and children at Fort Mims, Alabama. The attack spread panic throughout the frontier, and settlers demanded action from their government. In response, Blount called up 2,500 volunteers and placed them under the command of General Jackson with orders to engage the enemy. Jackson's militia laid waste to the Red Sticks, and his eventual victory at the Battle of Horseshoe Bend on March 27, 1814, completely destroyed Creek military power in the region.[489] As news of Jackson's victory spread across the frontier and throughout the rest of the nation, his popularity soared. Meanwhile, Sevier stood relegated to the role of a mere bystander. Nonetheless, as an elder statesman, Sevier had one last task to perform in the service of his country.

Following Jackson's conquest of the Creeks and the resulting Treaty of Fort Jackson, which effectively ended the Creek War, President James Madison appointed Sevier as a commissioner to run the boundary line of

the new Creek Nation. In agreeing to the terms of the treaty, the Creek Nation ceded more than 20 million acres of territory in southern Georgia and central Alabama to their nation's conquerors.[490] Despite his lingering bitterness toward Jackson over their previous encounters, Sevier accepted the appointment and departed his plantation home near Knoxville on June 10, 1815, to begin what would be his final mission.[491]

Sevier made several entries in his diary following his departure. Although these consisted mostly of mundane observations about the weather and provisions, by August, the summer heat and the arduous journey began to take its toll on his aged body. On August 26, 1815, Sevier noted, "Some unwell with pain in my back." By September 9, he observed that one of his traveling companions, a man named Dicky Brown, became "very sick."[492] In the days that followed, Sevier himself contracted a fever. A few days later, he breathed his last breath. On September 24, 1815, Sevier died in his tent on the Creek boundary, ironically as duty called him to survey territory conquered by his most bitter rival.[493]

On March 29, 1889, years after his death, the *Daily Picayune* newspaper of New Orleans printed the legend that emerged from that dark day:

> *There is a pretty story still told around the firesides in this country of how Governor Sevier came to his death. He was attending a feast of the Indians known as the "Green Corn Dance," and although nearly 72 years of age, was there participating in the festivities of the evening. The next day, while on his return to Fort Decatur, he was taken suddenly sick, and while being carried across the Tallapoosa river, and feeling that he was dying, he said to his attendants that if they would carry him to a big spring about a mile away and let him get a drink of the water he thought he would get well. But he died while crossing the river, and his body was buried on top of the hill overlooking the big spring to which he had referred, and whose waters still sing a constant requiem near his grave.[494]*

Sevier's companions buried him with military honors on a spot of land not far from where he fell ill, on the east bank of the Tallapoosa River near Fort Decatur, Alabama.[495] A simple two-foot-long oak stump charred at its end marked his grave.[496] Unaware of Sevier's illness, Tennesseans had reelected him to Congress without opposition a few weeks prior. News of his death, however, quickly spread to the state capitol where members of the Tennessee General Assembly mourned their fallen hero.[497] On October 26, 1815, state senator Adam R. Huntsman offered a resolution that each member of the

legislature wear a crepe on the left arm for thirty days "in honor to the memory of that distinguished fellow citizen, statesman, and patriot."[498]

Following this monthlong period of mourning, Sevier's remains lay buried beneath that charred oak stump for several decades before any effort commenced to resurrect his memory from the Alabama soil. Years of weathering and decay removed most outward signs of Sevier's final resting place. By the summer of 1834, a man who helped bury Sevier's body, Captain William Walker, returned with his nephew, John Harbinson, to locate the grave. In a letter penned on December 5, 1874, a native Tennessean living in Alabama named Littleberry Strange recalled Captain Walker's visit:

> We went to the place where [Harbinson] stated Gov. Sevier was buried; we commenced and continued digging until we struck a hard substance in the surface.
>
> We dug up the substance, and found it to be the charred end of a post oak log or stump, some two or two and a half feet long. Mr. Harbinson identified that as the place where lay the remains of Gov. Sevier.
>
> Capt. Walker took a light wood knot, some two feet long, placed it in the hole from which we had taken the charred end of the post oak log and said that there he intended to place a marble slab.
>
> In 1836 Capt. Walker went with Gen'l Jessup to Florida, to the Seminole War, where he died without carrying out his noble purpose of placing the marble slab at the head of the grave of John Sevier.
>
> Capt. Walker was a noble man; he was a patriot; he loved his country; he loved the noble dead, and for these qualities I esteem him.
>
> And that his noble purpose might be carried out—he and Harbinson both being dead—I—for the purpose of carrying out his intention, and for the further purpose of assuring posterity of the location of the last resting place of a noble man—I, in 1841, procured marble slab and stone and placed them at the head and foot of the grave of Gov. John Sevier, and I have no doubt that these stones mark the true spot.[499]

The small white marble headstone that Littleberry Strange placed on that site measured two feet wide by two inches thick and bore the simple inscription:

J. Sevier, died September 24th, 1815.

Posterity neither erected a statue in his honor nor embellished his epitaph with details. Years later, Sevier's grandson George Washington Sevier

The original tombstones of Governor John Sevier and "Bonny Kate" Sevier, brought from Alabama and presented to Knox County on October 2, 1922. *Author's collection.*

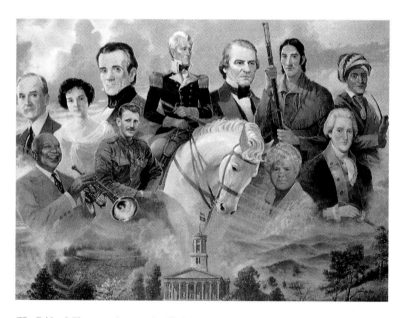

The Pride of Tennessee, the state's official bicentennial portrait depicts eleven people who played a prominent role in Tennessee's history, including John Sevier. *Tennessee State Library and Archives.*

lamented, "That arm that so often drew the sword in defense of his country has long mouldered [*sic*] in the soil of a sister State and Tennessee does not now know where the mortal remains of Gen. John Sevier lies."[500] While no monument yet stood in Sevier's memory, in his *Annals of Tennessee*, J.G.M. Ramsey delivered a poetic tribute which offered mourners some solace:

> *How died that hero in the field, with banners o'er him thrown*
> *With trumpets in his falling ear by charging squadrons blown*
> *With scattered foemen flying fast and fearfully before him*
> *With shouts of triumph swelling round, and brave men bending o'er him*
> *He died not thus; no war note round him rang;*
>
> *No warriors underneath his eyes in harness'd squadrons sprang;*
> *Alone he perished in the land he sav'd,*
> *And where in war the victor stood, in peace he found a grave.*
> *Ah, let the tear flow freely now, it will not awake the sleeper.*
> *And higher as ye pile his tomb, his slumber shall be deeper.*
>
> *Freemen may sound the solemn dirge—the funeral chant be spoken;*
> *The quiet of the dead is not by idle mockeries broken!*
> *Yet, let Tennessee's banner droop above the fallen chief.*
> *And let the mountaineer's dark eye be dim with earnest grief;*
> *For who will stand as he has stood, with willing heart and hand,*
> *To wrestle well with freedom's foes,—defender of his land!*[501]

The branches of "Old Hickory" cast a long shadow over Sevier's grave. He died a few months following Jackson's decisive victories in both the Creek War and the Battle of New Orleans. With the end of the War of 1812, Jackson, now a war hero, soared in popularity in the Volunteer State and nationwide. His light eclipsed that of his rival Sevier. Not until the end of Reconstruction following the Civil War did Sevier's remains and memory finally receive honor in a manner befitting of "Tennessee's first hero."

A CENOTAPH WORTHY OF HIM

John Sevier will live so long as history shall last.
Tennessee governor Robert Love Taylor, 1889

As time passed and memories grew distant, John Sevier's body remained buried in the Alabama soil. Over time, his humble grave deteriorated as the legend of "Nolichucky Jack" faded. His frontier exploits vanished from the public consciousness. In fact, Tennessee no longer constituted the frontier. The pioneers moved to land farther west, across the Mississippi River and into the plains and deserts of unconquered territory. New heroes emerged, and more costly wars than those fought by Sevier and his comrades unfolded. The Civil War, in particular, left an indelible mark on the memories of the people of this nation. Following its bloody conclusion, Americans sought to heal their broken country by paying tribute to the heroes of their past.

In his book, *Mystic Chords of Memory*, Michael Kammen noted that in the period between the end of the Civil War and the early twentieth century, American memory began to take form as a "self-conscious phenomenon."[502] During this time period, Americans expressed a desire to honor the memory of those who lost their lives during the Civil War and to canonize the heroes of prior wars who helped to secure the nation's Manifest Destiny. At the same time, photography developed as a new technology used to chronicle significant events in the present for future generations.[503] An intense hunger for tradition coupled with advances in human ingenuity led to a great release of emotion expressed in the form of memorials and statues

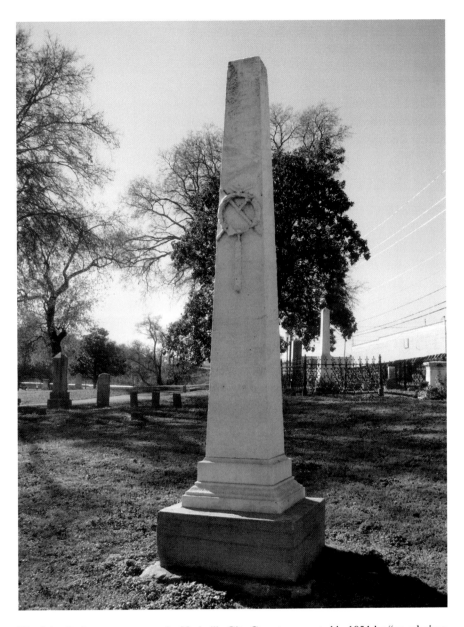

The John Sevier monument at the Nashville City Cemetery erected in 1851 by "an admirer of patriotism and merit unrequited." *Author's collection.*

honoring the great historical figures of the past. Some of the most intense battles of the Civil War took place in Tennessee, making this especially true for citizens of the Volunteer State. Though Sevier lived in a different time and era, his participation in the Revolutionary War provided Tennesseans with a connection to their past. The tales of his exploits on the frontier as a conquering hero further served as inspiration uniting a region once divided and still healing from the wounds of the Civil War.

Although Nashville's City Cemetery erected a monument to Sevier in 1851, his body lay elsewhere, leading some to question the location of his remains and why Knoxville lacked a memorial.[504] After all, Knoxville once served as the capital of Tennessee during Governor Sevier's administration, and the citizens of East Tennessee claimed him as their favorite son. As knowledge of Sevier's modest grave in Alabama spread, citizens throughout the Volunteer State felt compelled to honor him with a grand monument and to give their frontier hero a proper burial in the city of Knoxville.

The Tennessee Historical Society proved instrumental in gathering support for the reinterment of Sevier's remains in Knoxville. Arthur St. Clair Colyar, a member of the society, became a key figure in this effort and with good reason. Colyar's father, Alexander, fought in the Battle of King's Mountain, and his mother, Katherine Sevier Sherrill Colyar, was the niece and namesake of Sevier's second wife, Catherine "Bonny Kate" Sherrill. Colyar had a vested interest in preserving the memory of his ancestor.

As an attorney, political leader, newspaper editor and industrialist, Colyar stood as an influential figure in Tennessee politics. Known mainly for his ardent support for the Confederacy during the Civil War and for his leadership of the Tennessee Coal, Iron and Railroad Company, Colyar also possessed literary talents. In 1904, he published a two-volume book entitled *Life and Times of Andrew Jackson*. In his book, Colyar admitted to being conflicted about Sevier's feud with Jackson. "I was connected by family ties with the Sevier side of the controversy," Colyar wrote, "and all my training and feeling and family influence had been on the side of Sevier instead of Jackson." Colyar, however, troubled by what he perceived as an "astounding prejudice" brought against Jackson by "sectional partisan writers," vowed "that justice must be done and that the truth must be told."[505] He held Sevier in high regard, yet still admired Jackson. Behind the scenes, Colyar worked tirelessly to ensure that Sevier's body returned to his home state of Tennessee.[506]

The society's president, J.G.M. Ramsey, also expressed his desire for a fitting tribute to Sevier, stating, "He needs no monument, but it is a great satisfaction

Arthur St. Clair Colyar (1818–1907) described John Sevier as "courageous, beloved, and a great soldier." *Tennessee State Library and Archives.*

to know the place which grateful and admiring countrymen from Tennessee and elsewhere may visit and recognize as our Mecca, and to which hereafter our pilgrimage may be made."[507] In his *Annals of Tennessee*, Ramsey wrote in a near state of desperation of his desire to build a memorial to Sevier:

> *Let one of the historic places within old Knoxville, or in its environs, be chosen, on which a cenotaph shall be erected, commemorative of the achievements, military and civil, of the pioneer on Watauga, the hero of King's Mountain, the Governor of Franklin and of Tennessee. May the writer suggest respectfully, though earnestly, to the able and enlightened press of his State, to appeal—as he does himself here appeal—to the public spirit and liberality of his countrymen, thus to perpetuate the fame of these worthies in the places already consecrated by their noble and patriotic services.*[508]

The press obliged Ramsey's request. An editorial published in the *Nashville True Whig* bemoaned the lack of a proper memorial to Sevier:

> *History has been strangely neglectful of the memory of this, one of the most distinguished pioneers of our State, whose early annals are adorned by the records of his prowess in arms and his wisdom as a civilian. His remains lie buried in a neighboring State, where he died more than thirty years ago in the service of his country, without a stone to mark the place of their repose or an enclosure to protect them from unhallowed intrusion…When we review the deeds of this man's life, and ask for the evidences of due appreciation, we wonder and are sad that a people intelligent, so rich, so prosperous, so proud, so honorable—a people ready to applaud the spirit of patriotism and independence, and to glory in deeds of daring, and to give hearty expressions of praise to a devoted public servant—should build up no beautiful and durable monument or proud cenotaph to teach their children and the world that such a one deserved this, and more than this, and shall not be forgotten, but ever honored—highly honored. What is the sentiment of East Tennessee? What of the County of Sevier, and of Hawkins, with her beautiful marble?—Of Sevier and Hawkins—hewed out of the Indian quarry, chiseled and fashioned and adopted and organized under the State of Franklin; one honored by and honoring the name of the Governor of that interesting State, the other rejoicing in the name of her who was the honored and honoring first wife of that model architect and statesman, hero and civilian! Consult, combine, contribute; construct a cenotaph worthy of him—worthy of yourselves!*[509]

Calls for the construction of a monument to Sevier even echoed outside the state of Tennessee. On August 22, 1887, the *St. Louis Daily Globe-Democrat* delivered a scathing rebuke of posterity's oversight, asking rhetorically, "Is it not a great shame that the grand State of Tennessee does not know where to find the bones of such a patriot? Is it not a great shame that she has never erected a suitable cenotaph to his memory? If Tennessee will not come and dig up his ashes and do the proper honor to them, let Alabama hunt the spot and mark it with a monument."[510] Another newspaper editorial published in the *Daily Picayune* of New Orleans observed, "A small white marble headstone is all that marks the last resting place of the first governor of Tennessee, and one of the greatest soldiers who ever held his own in a hand-to-hand fight or led a band of warriors against the hostile

Indians. There is no record there to tell of his lofty patriotism or his gallant service to his country."[511]

With public support for a memorial mounting, efforts began in earnest to bring Sevier's remains back to Tennessee in what Ramsey described as a "labor of love."[512] On March 25, 1889, the Tennessee General Assembly passed a joint resolution appropriating $500 for the removal of the mortal remains of Sevier from his grave in Alabama to the Soldiers' Cemetery at Knoxville.[513] Legislators also directed a committee to solicit private donations to be used "in the erection of a monument on the Capitol grounds at Nashville to his memory," but this effort failed.[514] Sevier's remains were ultimately reinterred in the courthouse yard in Knoxville, not the Soldiers' Cemetery. By the summer of that same year, Sevier returned home.

Officials organized a grand celebration along the route from Decatur, Alabama, to Knoxville, Tennessee, where Sevier's remains traveled. On June 17, 1889, several dignitaries gathered at Sevier's grave site of over seven decades, including the governors of Alabama and Tennessee, along with many of Sevier's descendants. A number of citizens of Montgomery, Alabama, also assembled for the ceremony, eager to be a part of the historic occasion. Alabama governor Thomas Seay delivered a speech on that scorching summer day that evoked the memory of Tennessee's frontier past and its most celebrated hero:

> *From 1745 to 1815 John Sevier gave his life to the republic, and here on this spot seventy-four years ago he was laid to rest. Imagine the scene. A soldier's funeral! The war whoop of the Indians had hardly died away. By the open grave stood the few surviving soldiers and here and there the stalwart and silent form a friendly savage. The startled hare and the frightened squirrel, perhaps, stared at the strange cortege which brought him to his rest. Silent and kindly nature has kept him since. Seventy-four years of this guardianship has not been broken, for Alabama has adopted for his grave the benediction of Prentiss for that of Lafayette: "Let no cunning sculpture or monumental marble deface with its mock dignity the patriot's grave, but rather let the unpruned vine, the wild flowers, the free song of the uncaged bird and all that speaks of freedom and peace be gathered about it."*
>
> *But now, very justly, but not for Sevier's sake, nor for his fame, but for the sake of the republic, for the education and inspiration of her sons, Alabama surrenders these relics to Tennessee. Take all that is left of him.*

Convey it gently and kindly to his own dear mountains of Tennessee, and under their protecting shadows, beside the Holston, let your monument lift its proud head, that men may know that loyalty to man's best interest is never unrewarded.[515]

Tennessee governor Robert Love Taylor thanked Governor Seay for his kindness, cordiality and generosity. He then briefly recounted Sevier's accomplishments, stating, "We receive the dust from your Excellency the governor and friends, and will take it back to the state where his great

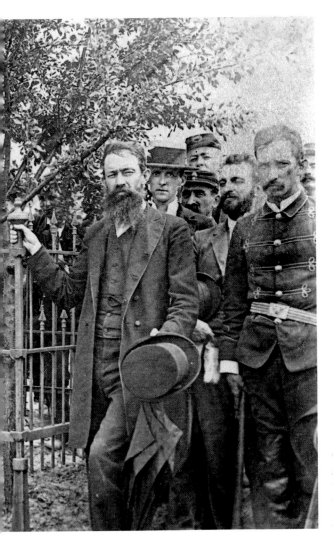

On June 17, 1889, dignitaries gathered around the grave site of John Sevier near Decatur, Alabama. *Tennessee Historical Society Collection, Tennessee State Library and Archives.*

life's work was done and will erect a monument cut from the mountains to his memory. His body is dust, but his memory is alive. Sleep on, Sevier, sleep on!"[516]

The dignitaries assembled following the ceremony for a photograph. Taylor proudly leaned against the iron fence surrounding Sevier's grave, while others gathered to witness the occasion crowded around the gate. Souvenir hunters, eager to collect a memento of the occasion, cut down a plum tree that had grown over the grave site. Not a single twig remained of the tree, which had once provided shade to Sevier's grave.[517]

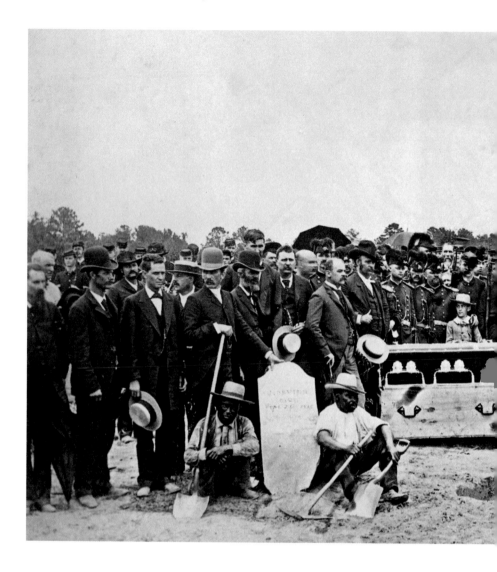

Gravediggers removed Sevier's body from the earth as Taylor sat on a pine stump at the foot of the grave, and Seay rested on a seat nearby, watching the progress with interest. Many speculated that Sevier's companions had simply wrapped his body in an army blanket before placing him in the shallow grave. The crowd soon learned differently. After toiling in the hot Alabama sun for an hour, the exhumers discovered a hollow place in the earth. This revealed a vault dug in clay and shaped exactly in the style of a homemade coffin. Two pieces of a thigh bone, half a dozen teeth, and many smaller bone fragments rested in that spot along

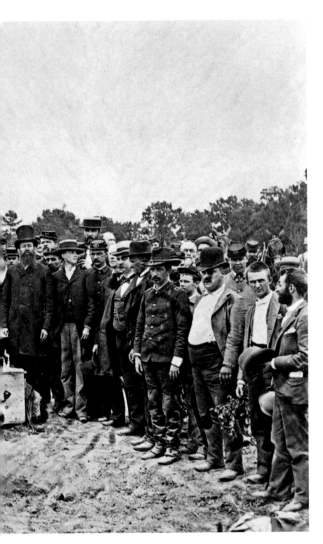

On June 17, 1889, a crowd assembled around John Sevier's casket for a photograph before his reinterment in Knoxville, Tennessee. *Tennessee Historical Society Collection, Tennessee State Library and Archives.*

with about a dozen nails. Workers then carefully placed Sevier's remains in an ornate metal casket brought to the site, and presented the nails to Dr. J.M. Boyd of Taylor's staff, who later delivered them to the Tennessee Historical Society.[518]

The two governors and their staffs and committee members congregated for one last photograph to commemorate the solemn occasion before departing for Knoxville. Officials loaded the coffin onto a wagon, and the Second Regiment of Alabama military band played the funeral march. A small battalion of state troops then led the procession, followed by the

wagon and casket and then by the governors, their respective staff members and invited guests. That evening, Taylor and his party boarded the special train provided by the Western Railway of Alabama. Seay and his staff accompanied them as far as Birmingham. As the train departed, the Alabama artillery fired a cannon salute.[519] Sevier finally began his journey home to a hero's welcome.

After an overnight stop in Chattanooga, Tennessee, the train departed the Union depot amid a heavy rainstorm. Two of the passenger cars on the train, draped in black and white and the national colors, carried the governor, his staff and Sevier family descendants. Another car contained detachments from three military companies of Chattanooga who served as the honor guard. The June 20, 1889 edition of the *Knoxville Journal* captured the events that unfolded on the day before in vivid detail. The paper recorded:

> *As the train swept along through Cleveland, Charleston, Athens and other towns along the route, hundreds of people stood in silent reverence and in many instances with uncovered heads. The funeral drapery that hung limp and wet on the sides of the cars attracted the attention of the curious and made a sign to the knowing ones that the revered dust of John Sevier was speeding to its final resting place.[520]*

At 1:15 in the afternoon, the funeral train made its final stop along the journey. As the train pulled into Knoxville's Union Station, thousands of people gathered to greet their departed hero despite the inclement weather that day. By some estimates, as many as thirty thousand people lined the streets, which organizers had decorated with thousands of patriotic flags. The special train from Chattanooga brought in hundreds more. Within the hour, "the streets were alive with soldiers and civilians in carriages, on horseback and afoot," the *Knoxville Journal* reported. "From a window halfway down Gay Street the pageant could be seen at its best. It was magnificent in every respect. The street was teeming with thousands of sight-seers. Every window and other point of vantage was occupied."[521]

By three o'clock, the ceremony commenced. Elaborate floral arrangements draped Sevier's elegant casket, wrapped in a silken banner and surrounded by even more floral offerings. A wreath with the figures of a sword and tomahawk made of small dark flowers lay at the center of the beautiful display. Dignitaries placed the flower-laden casket into position and gave the order to proceed toward the Knox County Courthouse, Sevier's final resting place.[522]

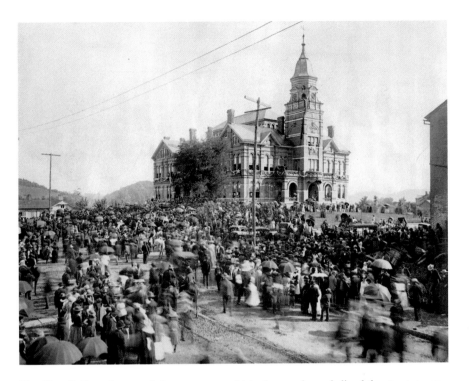

The *Knoxville Journal* reported that as many as thirty thousand people lined the streets to pay tribute to John Sevier during reinterment ceremonies at the Knox County Courthouse on June 19, 1889. *Tennessee Historical Society Collection, Tennessee State Library and Archives.*

At least ten thousand onlookers greeted the procession at the courthouse. According to the *Knoxville Journal's* account of the ceremony, "As far as eye could reach it was one human mass. The big platform erected immediately in front of the east steps of the courthouse was jammed with people. Even the roof over the east courthouse was covered, and many occupied seats on the parapet of the same."[523]

Taylor, his staff, several dignitaries and Sevier descendants all assembled on the speakers' platform. Members of the Tennessee Historical Society placed two items from its collection near the grave as a tribute—a life-sized oil portrait of Sevier and an engraved sword once given to Sevier by the State of North Carolina for his service during the Battle of King's Mountain.[524] Following speeches by several dignitaries, the Reverend Dr. James Park delivered a prayer as workers lowered Sevier's casket into the ground and placed a marble slab over his grave. Park remarked:

Inscribed on the grand obelisk marking John Sevier's final resting place are the words, "Pioneer, Soldier, Statesman, and one of the Founders of the Republic." *Author's collection.*

Here, with patriotic pride in his heroic days in the time of war, and profound veneration for his high service in time of peace, we commit his mortal remains to the grave, "earth to earth, ashes to ashes, and dust to dust." And may the people of this great State who owe so much to John Sevier for his unselfish service in times that tried men's souls, do him justice, and yourselves and the commonwealth honor by erecting such a monument as shall keep his name and fame an illustrious example in everlasting memory.[525]

Work immediately began to erect a monument. In a few short years, on October 7, 1893, citizens dedicated a large obelisk on the old Knox County Courthouse lawn, thus bestowing an enormous tribute that towered much higher than the small plum tree that once cast a shadow over Sevier's former grave. Onto the stone base of this grand monument stonemasons inscribed the following words:

Pioneer, Soldier, Statesman, and one of the founders of the Republic, Governor of the State of Franklin, six times Governor of Tennessee, four times elected to Congress, a typical pioneer who conquered the Wilderness and fashioned the State, a projector and hero of King's Mountain, fought thirty-five battles, won thirty-five victories, his Indian War Cry: "Here they are! Come on boys!"[526]

Oliver Perry Temple, an attorney, judge and author, penned an admiring tribute to Sevier for the dedication ceremony. His tribute chronicled Sevier's accomplishments in hagiographic terms, comparing him favorably to three other better-known men of his era: George Washington, Alexander Hamilton and Thomas Jefferson. He wrote affectionately of Sevier, declaring him "the idol" of the frontier people, and proclaimed, "We are kindled into enthusiasm by the memory of him. And enthusiasm, in its highest development, closely touches on the realms of imagination. Imagination, in turn, easily passes the borders of the real, and lingers on the outer confines of the fabulous." He further emoted, "Sevier's name is an electrical one. It flashes through the heart as does no other name of his time."[527]

At the dedication ceremony, Temple delivered a speech that harkened back to Sevier's triumph at the Battle of King's Mountain. As he concluded, he spoke of the solemn pride that all Tennesseans should feel for their founding father:

And now, on the one hundred and thirteenth anniversary of this decisive battle, we dedicate this monument to the memory of John Sevier, the father

of Tennessee and the most beloved of all her great men. That State which he, more than any other man, won and saved, suffered his remains to lie among strangers, unmarked and unhonored for seventy-five years. And even now it declines to honor in a suitable manner the little left of him, finally brought back to rest at his old home. It leaves this work of love to his East Tennessee admirers. Shame on the spirit which feels no pride in the fame of such men as John Sevier and James Robertson, and fails to perpetuate in our Capitol their memory by statues or monuments.

Let Tennessee, if it will, continue to neglect our First Governor, but the people among whom he lived, and whom he so often led to victory, will all the more glory in his memory, and in the proud share they had under him in the never-to-be-forgotten battle of the 7th of October, 1780.

After all, Sevier needs no monument of marble or bronze. King's Mountain is his true, his eternal monument, more enduring than one fashioned of hardest marble. This, which we rear with our hands, only serves to fittingly point to that.[528]

Tennessee ultimately raised "a cenotaph worthy of him." Although the first generation of antiquarians and writers who chronicled Sevier's life and exploits had already ensured his immortality, Sevier's legend, now cast in stone, forever marked him as "Tennessee's first hero." A biographical sketch published in the *Knoxville Journal* on the eve of Sevier's reinterment paid tribute to these pioneer scholars and lamented how subsequent generations had failed to remember Sevier and all that he accomplished. "The verdicts of history are often rendered with a surprising tardiness. Sometimes they are correct and stand the test of time under the glaring light of onward progress; often they are erroneous and are consequently reversed. In the case of John Sevier, the first governor of Tennessee, his contemporaries did him justice." Yet the pages of history were insufficient in recording his achievements. "The people of the present age know far less of his life than they should," the paper noted. "They know enough of it, however, to know that a narrative of the leading events in that eventful life would be read with far more interest than the most thrilling story that has or possibly could be told by those who explore the labyrinthian paths of fiction's field."[529]

POSTSCRIPT

CHUCKY JACK'S A-COMIN'

If in Shakespeare the hero of the history plays is England, then the hero of the present outdoor drama is America, and not any individual historical character.
Kermit Hunter, 1953

The early chroniclers of Tennessee's history built John Sevier's reputation as a pioneer, soldier and statesman. Beginning in the early nineteenth century, these men authored a legacy on which future writers and scholars based their own works. By the middle of the twentieth century, however, a new form of storytelling appeared as a thriving part of America's cultural landscape. The outdoor historical drama became the primary vehicle through which admirers told Sevier's story. Born out of the economic despair of the Great Depression, the outdoor drama not only created a distinctively American art form but also reflected popular regional expressions of patriotism, especially in the South.[530] Tennesseans, in particular, frustrated by the perceived neglect of their historical heroes, envisioned the outdoor drama as an entertaining way to raise awareness of the events and important figures of the past.

During the early 1950s, playwright John B. "Pat" Alderman developed a keen interest in Appalachian history and culture and used Sevier's story as inspiration to write his own outdoor drama entitled *The Overmountain Men*.[531] Alderman's hometown newspaper, the *Erwin Record*, published numerous front-page accounts of plans for a "Big Historical Pageant" that the paper claimed would "encompass one of the most rugged and dramatic

epics in the birth of this—the United States of America."[532] Written and performed almost entirely from the pioneers' perspective, *The Overmountain Men* drew its inspiration from the prevailing belief that Manifest Destiny propelled these early settlers to the mountains and valleys of East Tennessee. In Alderman's vision of the Old Southwest, Cherokees merely played a supporting part, while white settlers assumed the roles of heroes. Newspaper accounts described *The Overmountain Men* as "the thrilling story of how the pioneers came over the mountains and opened up the west for settlement and founded the Volunteer State."[533] The *Erwin Record* reported, "The pioneer pageant of bronze and white will have a most definite thread of personal human interest that treats with the individual as well as the spread of an empire."[534] According to the paper, all of these elements "added up to history interestingly portrayed, with the theme [of] freedom and how it came to the white, red and common man."[535]

As Alderman composed his script, *The Overmountain Men* developed into a massive undertaking and full-scale production. Set in a two-thousand-seat football stadium, Alderman's drama unfolded replete with "horses, Indian fights, and celebrations."[536] A number of stage props loaned to the production included authentic articles used by the pioneers of the eighteenth century. Actors used more than twenty long rifles in the pageant, one of which belonged to the family of James Robertson.[537] *The Overmountain Men* included sixteen episodes in three distinct acts with a three-hundred-person cast made up almost entirely of citizens from Erwin, Tennessee. Alderman cast fifteen major leads in the pageant, including the play's most important character, John Sevier.[538] Charter members of the drama's planning committee included descendants of the first pioneer families of Tennessee and one of Sevier's own descendants. This ensured that Sevier remained the central figure in Alderman's drama.[539]

Alderman's script cut a wide path through the Tennessee frontier, covering succeeding periods of early Tennessee history from 1760 to 1796. The scenes moved swiftly from stage to stage with the assistance of special lighting effects and background organ music.[540] The play opened in an Indian village. The Boy Scouts of Erwin had gathered cane from Plum Grove—Sevier's home during his first three terms as governor—to construct the tepees and houses used on the set.[541] The second act set the stage at Fort Watauga, where, in 1776, legend held that Sevier rescued Catherine "Bonny Kate" Sherrill from an attack by Cherokee warriors. Actors reenacted that dramatic scene along with other historically important events surrounding Sevier's life. In the play's final act on the opening night of the pageant, Tennessee

governor Gordon Browning portrayed Sevier in an inauguration scene that also included many Tennessee judges and political figures cast in key roles.[542] Manifest Destiny endured as a consistent theme in Alderman's dramatic portrayals of life on the early American frontier, and he cast Tennessee as "the gateway of western expansion."[543] Embraced by the community of Erwin and endorsed by officials in state government, Alderman's *The Overmountain Men* succeeded in perpetuating Sevier's image as a heroic figure of the Early Republic.

Alderman later published a series of booklets based on his drama, which he eventually compiled into a single-volume narrative also entitled *The Overmountain Men*. Alderman liked to describe his brand of storytelling as "history made interesting." He filled *The Overmountain Men* with illustrations and photographs from his dramatic reenactments, and the prose flowed with hagiography gleaned from the works of the early Tennessee writers and historians who preceded him. Although Alderman furnished a brief bibliography, he provided no footnotes to check statements of fact. Alderman acknowledged this weakness, writing that "this brief pictorial sketch of early Tennessee History is not intended as a source of research, but rather as a medium of calling attention to some of the highlights of that period."[544]

During the same decade, another successful playwright named Kermit Hunter gained attention for his dramatic portrayals of America's earliest frontier. In 1956, Hunter wrote and produced an outdoor drama entitled *Chucky Jack: The Story of the Tennessee Frontier*. Largely biographical, *Chucky Jack* told the story of Tennessee's early history through Sevier's life and experiences. The play followed Sevier's life in two acts from his arrival at Watauga to his election as Tennessee's first governor.[545] Historian Kevin Barksdale observed that "*Chucky Jack* stood as the theatrical embodiment of the mythology of John Sevier."[546]

Hunter collaborated with Gatlinburg hotel owner R.L. Maples, who fully invested in Hunter's idea for an outdoor drama written specifically for Tennessee. Maples pooled together a significant portion of his family's financial resources to build the Hunter Hills Theatre, a 2,500-seat amphitheater located just four miles outside the heart of Gatlinburg. The main stage of the amphitheater was fifty-five feet wide and equipped with two thirty-foot revolving stages that allowed speedy set changes. The play also employed ninety-two actors, some of whom had previously worked on Broadway, including college drama students and local residents.[547] Hunter even cast Sevier's descendants in parts. Mark Sevier, an accomplished actor and musician and descendant of Robert Sevier, John Sevier's brother, played the role of James Sevier in the *Chucky Jack* drama.[548]

Playwright Kermit Hunter (1910–2001) wrote over forty historical dramas, including the John Sevier–based play *Chucky Jack*. *From* Chucky Jack *program, 1958. Author's collection.*

Maples focused on Sevier's adventurous exploits as part of his marketing strategy, as evidenced by this excerpt from a 1956 *Chucky Jack* ticket order form:

> *Hero of King's Mountain—one of the first settlers to push down the green valleys to the west—member of the Continental Congress—founder of the Lost State of Franklin—first governor of Tennessee—one of the truly great American patriots…JOHN SEVIER!…called by the Indians* CHUCKY JACK *from his pioneer home on the Nolichucky River. Now*

this giant figure comes to life in a Hills Theatre at Gatlinburg in the cool shadows of the Great Smokies. Sixteen memorable scenes trace the career of this eminent statesman whose character and leadership at a crucial moment molded the very foundations of American democracy. Authentic Colonial costumes, exciting incidents, colorful dances, a magnificent musical score composed by Jack Frederick Kilpatrick...CHUCKY JACK is an experience you will always remember.[549]

Maples advertised the play as "a painless, pleasurable way to learn early Tennessee history in the coolness of pristine mountain air."[550] Maples also tapped into public feelings of nostalgia and patriotism in his advertising efforts. He described Sevier as "a man who braved the wilderness of long ago to establish a new social order, to give opportunity and scope to the people around him, to produce in the western wilderness a better way of life."[551]

While Maples focused on the business and marketing side of the *Chucky Jack* drama, Hunter developed his script. He believed that his form of storytelling served a greater purpose. For Hunter, the outdoor drama offered a solution for many of the problems and crises of the twentieth century. In an editorial published in the *Nashville Tennessean Magazine* on January 19, 1958, Hunter wrote about the fear and apprehension existing within the nation in the 1950s. Fear of the spread of communism, the growing civil rights movement and changing attitudes toward moral public behavior drove many traditionalists like Hunter to seek out examples from the past that could serve as a guide to how the nation should conduct itself in trying times.

Hunter observed that Americans had "stumbled perilously afar from the path of their patriot forefathers." As a playwright, he complained, "Books and plays seem designed to portray man as a lost soul on a simmering, dying planet in space, without hope or future." He pointed to newspaper columns that reported an increase in alcoholism and drug abuse and a decline in the culture of reading.[552] On this last point, Hunter's criticism was particularly damning:

These facts are the sign of a society being eaten down from within, a society slowly growing sick. It symbolizes a philosophy of self-seeking, of pleasure, of blind racing toward some illusive phantom that will never be realized, a philosophy totally at odds with the heritage that we received from Jackson, Adams, Webster, Washington, Jefferson, and the men who dreamed up this democracy and then gave it shape.[553]

A postcard view of Kermit Hunter's outdoor drama *Chucky Jack: The Story of the Tennessee Frontier. Author's collection.*

Hunter believed that Sevier's name deserved mention among these great heroes of the Early Republic. He singled out Sevier and James Robertson as "men motivated by a totally different purpose from what we seem to respect today." He concluded that their lives and careers exemplified three major beliefs: a belief in the existence and the power of God, a belief in rugged individualism and a belief in the positive influence of democracy. "I can't imagine Andrew Jackson being afraid of communism, or losing his head completely at the sight of it," Hunter wrote. "He knew, without having to have a weekly demonstration, that communism could not and would not work as a system of government in human society. He was not afraid to have democracy and communism held up and compared, so that men could see."[554] Of course, the threat of communism never confronted Jackson in his lifetime. Nevertheless, Hunter saw society's challenges through the lens of history and believed men like Jackson and Sevier represented a toughness and firmness of character that contemporary society failed to emulate.

For a particular scene to flow, Hunter often sacrificed historical accuracy for the sake of good storytelling. He occasionally had to defend his use of artistic license to the community of antiquarians, historians and scholars who valued historical facts. In an October 10, 1953 address delivered at

the annual banquet of the East Tennessee Historical Society in Knoxville, Hunter offered a defense of the outdoor drama and its loose interpretation of history. During his speech, he revealed that patriotism—a consistent theme in many of the narratives of Sevier's life—played the role of protagonist in his work:

> *The outdoor drama of today, although it is based on historical incidents and actual historical characters, makes an effort to portray the sense of history rather than the dry fact. We seek verisimilitude not of fact but of tone and mood. Our task in the historical drama is to avoid violating the* spirit *of history. If in Shakespeare the hero of the history plays is England, then the hero of the present outdoor drama is America, and not any individual historical character.*
>
> *The shifting of minor dates, the collecting of historically separated characters into the same scene, the discarding of irrelevant material in order to emphasize the pertinent facts concerning a man or an era—these methods should be acceptable now and always, especially since the audience has been told that certain modifications in history have been made.*[555]

While some historians questioned the historical accuracy and educational value of the outdoor drama, one historian, Dr. Robert H. White, had no problem with Hunter's dramatic interpretation of Sevier's life. Tennessee's first state historian, White wrote numerous letters on Hunter's behalf to help promote his *Chucky Jack* drama and to solicit funding for his project.

In a letter dated February 29, 1956, Maples wrote White soliciting "suggestions for reaching influential circles."[556] Shortly thereafter, Maples's director of public relations contacted White with the hopes of reaching out to "various Historical groups." He sought advice on how to elicit contact with officials who could aid in promoting the *Chucky Jack* drama throughout Tennessee and neighboring states.[557] White invested a great deal of time corresponding with businessmen, community leaders and civic organizations for this purpose.

In a form letter sent out to several constituents, White wrote, "A knowledge of the hardships encountered, endured, and overcome by the pioneers of Tennessee tends to awaken the interest and deepen the appreciation of the present-day citizenry in the history of Tennessee." He added, "I have personally witnessed *Chucky Jack* four different times and I have been very much impressed with the presentation of the drama. I should like to see many more of our citizens avail themselves of the opportunity

R.L. Maples (top), president of the Great Smoky Mountains Historical Association, and Dr. Robert Hiram White (left), Tennessee's first state historian. *From* Chucky Jack *program, 1958. Author's collection.*

to see this play for we know too little about the hardships, privations, and dangers which our forefathers had to undergo in laying the foundations of statehood which has enabled us to enjoy the fine civilization of today."[558] In another letter composed for the 4-H Club, White wrote, "I am thoroughly convinced that it is really worthwhile for these boys and girls to have an opportunity to witness the play. It is historically sound, presented in a very attractive manner, and will leave lasting impressions on the youngsters that could never be attained by merely reading books and documents."[559]

White not only worked tirelessly to promote *Chucky Jack* to his network of contacts but also put his scholarly reputation behind his efforts. At Maples's urging, White wrote a three-thousand-word essay on the subject of James Robertson and the Cumberland settlements for the *Chucky Jack* souvenir program distributed to attendees.[560] Maples and White also worked together with officials in Tennessee's Department of Conservation to coordinate a reunion of Sevier family descendants in Gatlinburg on July 2, 3 and 4, 1957, with the hope of improving attendance numbers.[561]

By its third year in production, however, despite all their efforts, Maples and White failed to draw enough tourists to Hunter's *Chucky Jack* drama to support it financially. On September 15, 1957, Hunter wrote to White to fend off rumors of his production company's financial instability and the drama's lower-than-expected attendance. From the beginning, Maples completely financed the production, borrowing heavily in order to keep *Chucky Jack* in operation. In response to a local newspaper article about the drama's financial situation, Hunter was apoplectic. "In Gatlinburg there are several cliques, many of whom are jealous and narrow," he wrote, "and the play has suffered much from lack of public backing."[562]

To make up for the shortfall, Hunter and Maples called together seventy-five area businessmen to explain the financial situation and solicit support. Their reaction, however, lacked enthusiasm. "I sensed for the first time that undercurrent of opposition," Hunter wrote. "I came away quite disillusioned...Personally I doubt that the town will do anything, and it saddens me very much, because this was a fine thing for the state at large. Over 75,000 people have seen the drama and have liked it, and the closing will hurt everyone concerned."[563]

Once again, Hunter and Maples reached out to their friend in state government. As a final recourse, Hunter hoped to convince the state historian to lobby legislators and secure state funding for his *Chucky Jack* drama. Hunter believed that, at the very least, White could encourage attendance and demonstrate to the state the financial and cultural interest in promoting *Chucky*

Jack to the masses. In his solicitation for support, Hunter pointed out to White that his drama helped to draw tourists to Gatlinburg and the Great Smoky Mountains. He further noted that Virginia and North Carolina engaged in special efforts to promote and finance their own outdoor dramas. "As far as that is concerned," Hunter wrote, "I should think that <u>all</u> these state enterprise[s] in Tennessee should be advertised by the State, if the State sincerely wants tourists. What is the state advertising budget for anyway?"[564]

In response, White looked beyond the borders of his state to solicit advice and direction on how best to secure funding. On November 8, 1957, White wrote to North Carolina governor Luther Hodges inquiring whether or not his state provided any legislative appropriation for the promotion of Hunter's Cherokee-inspired outdoor drama, *Unto These Hills*. "Our people are not patronizing *Chucky Jack* to the extent that we should like to see it done," White wrote. "For that reason," he continued, "I am hoping to obtain some information from you in regard to any type of publicity or promotion that has been put forth by your State."[565] Hodges directed his state's advertising director, Charles Parker, to respond. Parker notified White that the State of North Carolina contributed $35,600 to the initial fund and between 1950 and 1951 made a loan of $25,000 for expansion of the production and associated attractions.[566]

In addition to the difficulty of securing financial support from the state, political support for Tennessee's *Chucky Jack* drama proved lukewarm at best. White lobbied state legislators to secure support for the project. In 1957, he helped draw up a resolution that urged Tennesseans to "attend the production of *Chucky Jack* and to encourage its continued performance each summer session." The resolution recognized *Chucky Jack* for its "historical significance." It encouraged the creation of "advertisements in nationally-circulating magazines and journals" as incentive "to attract out-of-state tourists to visit Tennessee" to witness a play "which interprets and displays the sterling virtues of pioneer Tennesseans who laid the foundation stones of the proud 'Volunteer State.'"[567] Despite the fact that the resolution committed no tax dollars in support of the drama, the measure failed to gain the full support of the General Assembly. In a footnote that White typed onto the draft resolution, he observed, "Due to some objections registered by one or two East Tennessee members of the Commission, the Resolution was withdrawn."[568]

It is unclear from White's notes what specific objections legislators raised to the *Chucky Jack* drama, but Hunter frequently garnered rejection from officials in state government. His North Carolina drama, *Unto These Hills*, drew

harsh criticism from the Ladies Hermitage Association and from Tennessee governor Browning for its portrayal of Andrew Jackson. Opened in 1950 in Cherokee, North Carolina, Hunter's *Unto These Hills* followed the story of the Cherokees until their removal on the Trail of Tears in 1838. After members of the Ladies Hermitage Association protested to Browning about Jackson's depiction in *Unto These Hills*, the governor screened the play for himself and seethed with anger at what he saw. He called Hunter's depiction of Jackson "a travesty on American history" and insisted that the governor of North Carolina stop production of *Unto These Hills* altogether.[569] He declared:

> *I went to see it and must admit that my sense of fairness received a rude jolt by the way they depicted one of the greatest characters of all time. To belittle a man like Andrew Jackson, as this production did that I saw, is enough to make the blood of any patriotic citizen a little warm. I care not if the purpose is to please the Cherokee Indians for whom I have a great admiration. I think it is cheap and utterly unjustified to make out a man of his strength and courage as a weak and a vacillating idiot. Personally, I resent this reflection on a man that should be held in great esteem as much in Tennessee and North Carolina as any place in the world. If it were undertaken in my state we would do everything in our power to stop what I regard as a libelous assault on the memory of one of the greatest statesmen who ever lived.[570]*

After receiving word from North Carolina's governor that Tennessee's chief executive had lodged this protest, Hunter wrote to Browning personally and offered a calm and reasoned response. Hunter defended himself against the charge that he portrayed Jackson as "a weak and a vacillating idiot," calling Jackson "a man of positive action" who moved "quickly and decisively." Hunter, however, made no apologies for writing the play from the Cherokees' perspective:

> *In all honesty, in all sincerity, we believe that we have told the truth regarding Jackson's relationship with the Cherokee Indians. There has been no attempt to belittle Jackson or to commit an "outrage," but merely to tell the truth about one part of his career, in the interest of intellectual integrity. We cannot believe that this does any real damage to the name of a great man. If it could, he would not be a great man. But I feel that Jackson will always stand, because he was truly a great man, in spite of the Indian question.[571]*

Indeed, Hunter attempted to tone down Jackson's brutality toward the Cherokees in order to make *Unto These Hills* more marketable to audiences, and he defended the play against criticism. He claimed, "There is not one Indian in America who does not literally hate the name of Andrew Jackson. They scrawl it in chalk on the walls of privies; they teach their children to despise his name." Hunter even stated that some Indians could not bring themselves to go inside the Hermitage, while others made a special trip to Nashville, just to spit on his fence.[572] He stated:

> *I have a feeling that much of the resentment of the Ladies Hermitage Association against the play rises not from what is actually said and done on the stage or in the script, but from their wanting and expecting to see Jackson as a perfect hero, and being disappointed as finding him an ordinary man like everyone else in the play...I think it is unfortunate that so many people cannot view Jackson impartially, and see him for what he was—a great and powerful man, having some faults, yet possessed of the qualities of greatness...I think most of the resentment is a matter of disappointment at not finding him the hero.*[573]

Browning issued a scathing and terse response. In a letter to one member of the Ladies Hermitage Association, Browning wrote, "Naturally, I would like to blast him again, but I do not think it would do any good."[574]

In striking contrast to his portrayal of Jackson as the antagonist, Hunter cast Sevier as the central hero in his *Chucky Jack* drama. This, however, did not earn him any friends in Tennessee's General Assembly. Three years following *Chucky Jack*'s opening to the public, the state still provided no support. The production suffered financially, and audiences waned. After a three-year run, in 1959, Hunter reluctantly closed the final curtain on his *Chucky Jack* drama.[575]

Other outdoor dramas emerged during this period of mid-twentieth century patriotic fervor. In 1951, freelance writer Robert B. Osborne wrote a play entitled *Then Conquer We Must*, based on the historic Battle of King's Mountain and set in the Carolina mountains. Osborne echoed Hunter's feelings of despair for the nation when he said the Overmountain Men endured hardships "because they believed in freedom and the dignity of man in these times." He added, "When too many people seem to have lost all belief in ideals, when youths dodge the draft and boast about it, when defeatism is so prevalent in high offices—as it was then, too—and when so many people seem to think that freedom is not worth fighting for, we

need to look back at the lessons taught at King's Mountain."[576] Another long-running outdoor drama, *Liberty! The Saga of Sycamore Shoals*, depicted life on the eighteenth-century settlement of Watauga. Originally entitled *The Wataugans*, this outdoor drama earned recognition by Tennessee's General Assembly in 2001 and again in 2009 following its renaming as *The Official Outdoor Drama of the State of Tennessee*.[577]

For Tennesseans, Sevier's story provided comfort and inspiration during uncertain times. During the height of the Red Scare and at the cusp of the civil rights movement, the outdoor drama served as a local reminder of the grit and determination exhibited by America's earliest pioneers. By capitalizing on themes of patriotism and tradition, playwrights propelled Sevier's legend beyond the written word and delivered his story to a whole new generation.

AFTERWORD

WARTS AND ALL

We would fain tread lightly on the ashes of the dead, but faithful history demands, like Cromwell of his artist, "Paint me as I am, warts and all."
John Hill Wheeler, 1884

Legend asserts that when the seventeenth-century English political and military leader Oliver Cromwell sat before the painter Sir Peter Lely for a portrait, Cromwell declared, "Paint me as I am, warts and all!" Although the actual source and exact wording of this quote remain in dispute, the sentiment is particularly relevant to the study of history.[578] Years ago, my college history professor used this anecdote in a class to describe how one should study the past with a "warts and all" approach to the subject. History unfolds full of contradictions, and those contradictions make the study of history compelling.

I consider John Sevier a compelling subject for the same reason that I find history compelling. Sevier's story is one of contradictions. On the one hand, he rose to prominence as a legend on the frontier and a hero of the American Revolution. He demonstrated political savvy, guiding Tennessee to statehood and becoming its first governor after once failing to carve the state of Franklin from the foothills of the Smoky Mountains. Even in his twilight years, Sevier felt duty bound to serve his country in the backwoods where he made his reputation as a fearless Indian fighter many years earlier. He died in relative obscurity in the woods of Alabama, only to have his legend resurrected generations later by those who believed his life's exploits worthy of honor and recognition.

On the other hand, Sevier was human, and his actions revealed a man less than perfect. He encroached on Native American lands and led armies in the slaughter of hundreds of people in his drive to claim the western edge of the Appalachians. He found himself accused of treason in his effort to create the state of Franklin against the wishes of his mother state. One could further argue that Sevier provoked Andrew Jackson into a duel by insulting his wife, then behaved cowardly in the face of threats of retaliation and actually feared Jackson to such an extent that "Old Hickory" invaded his dreams.

As I began writing about Sevier for my blog, The Posterity Project, I wanted to explore these contradictions. I aspired to understand the true character of Sevier, "warts and all." I received largely positive feedback from readers, with a few exceptions from apparent Sevier descendants. One particular reader stated that I had engaged in a "smear campaign against Sevier." Another Sevier descendant believed I focused too much on the "bad things" that Sevier did. This reader questioned my "motive for doing so" and accused me of using history to further a "particular ideological agenda." In Tennessee, passions for Sevier have transcended the generations, and these exchanges certainly proved that.

I certainly hold no personal animosity toward Sevier nor maintain any ideological agenda. In fact, even though I am not a descendant of Sevier, as a native Tennessean, I sense a kind of civic kinship to him. His history is my history. I wrote about Sevier to satisfy a curiosity about the history of my home state. No other motive exists.

As I began to consider the larger question of how the public views and interprets history, I read between the lines of this online exchange and recognized a need to explore this subject in greater detail. To understand the cultural and generational shifts of the present, we sometimes reach into the past for answers from America's heroes. In the process, we often place these heroes on an unreachable pedestal where they no longer resemble one of us. They become nothing short of gods to be worshiped, honored and revered.

The chroniclers of Sevier's life, writers like John Haywood, J.G.M. Ramsey, Lyman Draper, James Gilmore and Carl Driver, envisioned Sevier as a heroic figure. They believed it their mission to "rescue from oblivion" the memory of Sevier's accomplishments. These chroniclers consisted mostly of lawyers, antiquarians and admirers of Sevier. These writers had received little or no training in the study of history. Thus, their narratives did little to place Sevier within the context of his times. Instead, their writings reflected the times in which these chroniclers lived. During the late nineteenth and

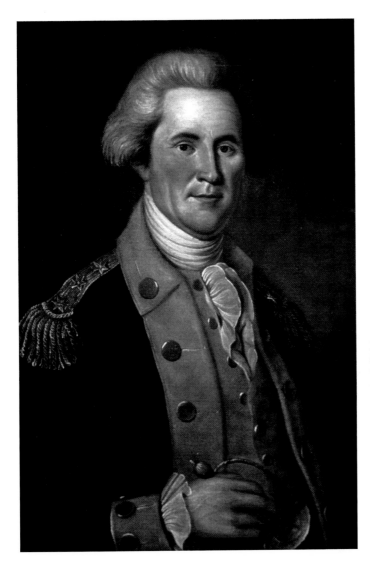

In 1790, John Sevier sat for this portrait by Charles Willson Peale (1741–1827), one of the foremost portrait artists of the early republic. *Tennessee Historical Society Collection, Tennessee State Library and Archives.*

early twentieth centuries, patriotism and virtue often took precedent over critical historical analysis.

Consider for a moment another artist whose work varied greatly from the "warts and all" approach of Sir Peter Lely. Charles Willson Peale, recognized as the foremost portrait painter of the American colonies and Early Republic, painted the portraits of many of our country's founding fathers. George Washington, perhaps his most famous subject, sat for no fewer than fourteen Peale portraits.[579]

When Sevier served as a congressman in Philadelphia from 1789 to 1791, he, too, sat for Peale in a stately military portrait that bears a striking resemblance to Washington. No doubt, "Nolichucky Jack" would have taken delight in the comparison. In a letter to Draper, Sevier's son George Washington Sevier reported that his father "was in politics in every sense of the word one of General Washington's disciples."[580]

In his book, *Charles Willson Peale: Art and Selfhood in the Early Republic*, David C. Ward observed that "Peale's portraits democratized heroism, creating an identity between hero and the audience."[581] Through his portraits, Peale painted a visual record of early American nationalism. In his idealized vision of the past, we see more of ourselves in Peale's portrait of Sevier than we actually see of Sevier himself. We perceive a "Pioneer, Soldier, Statesman."

Sevier's biographers, in many respects, mirror Charles Willson Peale. With their words, they painted a portrait of Sevier that far more resembled Peale's heroic vision of America than Lely's honest reflection of the man sitting right in front of him. In many ways, the memory of Sevier as chronicled by his biographers proves as captivating as the man himself.

This book examines and reflects on these writers and their times as much as Sevier. For me, the journey of researching and writing this history proved both challenging and rewarding. I have truly enjoyed tracing my civic kinship to one of the founders of my home state, and I remain today fascinated and intrigued by "Tennessee's first hero," the legendary John Sevier.

NOTES

PREFACE

1. Gilmore, *John Sevier*, 293–94.
2. "Personal Recollections of Michael Woods Trimble, of Jefferson County, Alabama." 1860. Diaries and Memoirs Collection, TSLA.
3. Kammen, *Mystic Chords*, 299–300.
4. Driver, *John Sevier*, vi.
5. Ibid., vii.
6. Ibid., vi.
7. Ibid., 1.
8. Lynch, "Creating Regional Heroes."
9. Barksdale, *Lost State of Franklin*.

CHAPTER 1

10. Driver, *John Sevier*, 6–7.
11. Ramsey, *Annals of Tennessee*, 108. Sevier's ancestors originated from France with the family name Xavier. According to Ramsey, "About the beginning of the [eighteenth] century they emigrated [*sic*] to England. Valentine Sevier, the father of John, was born in London, and previous to 1740, emigrated [*sic*] to the county of Shanandoah [*sic*], in the colony of Virginia. Here John Sevier was born."

12. Turner, *Life of General John Sevier*, xv.
13. Ibid., xv; 3–5.
14. Silvey, *Children's Books*, 625.
15. Steele, *John Sevier*, 23–24.
16. Silvey, *Children's Books*, 625.
17. Ibid., 26–28.
18. Wilkie, *John Sevier*, 13.
19. Ibid., 16.
20. Ibid., 18.
21. Faris, *Nolichucky Jack*, 6.
22. Ibid., 19–20.
23. Ibid., 9.
24. Ibid., 30–31.
25. Ibid., 9–10.

CHAPTER 2

26. No scholar makes this case more forcefully than Thomas Perkins Abernethy. His 1932 book, *From Frontier to Plantation in Tennessee*, emphasized the importance of land speculation in Sevier's career, and subsequent scholars echoed Abernethy's thesis in their own works.
27. Armstrong, *Notable Southern Families*, 142. One Hawkins family historian cited records indicating that Sevier married "Susan" Hawkins. A.W. Putnam, Sevier's grandson-in-law, also gives the name of Sevier's first wife as "Susan" Hawkins. However, as Armstrong noted, "All historians agree upon her as Sarah Hawkins. [Putnam] may have had a copy of this Hawkins genealogy and have been misled by it."
28. Sevier and Madden, *Sevier Family History*, 221.
29. Armstrong, *Notable Southern Families*, 141–45; Sevier and Madden, *Sevier Family History*, 221; Driver, *John Sevier*, 213; *Knoxville News-Sentinel*, January 1, 1945.
30. Barksdale, *Lost State of Franklin*, 46; see also Washington County Historical Association, *History of Washington County*, 54–56; Pruitt to Draper, September 4, 1851, King's Mountain Papers, Draper Manuscripts.
31. Sevier and Madden, *Sevier Family History*, 221.
32. Willis, *History*, 1.
33. Hyde, "Sarah Hawkins," 1.

34. Ibid., 3–4.

35. Ibid., 1.

36. *Knoxville News-Sentinel*, January 1, 1945.

37. Ibid., January 7, 1945. According to Headman, "The estate of Sevier's father-in-law included many things, valued in British money, including his plate and jewels. John Sevier benefited greatly from Sarah Hawkins Sevier's family. This fortune gave him his start in life, and Sarah inspired him even more."

38. Ibid.

39. *Johnson City Chronicle*, January 17, 1945.

40. "Sarah Hawkins," 364.

41. Ibid., 365.

42. Armstrong, *Notable Southern Families*, 141. According to Armstrong, "Several historians give her death in 1779...but George Washington Sevier, her stepson, said she died in January or February 1780, in Washington County, in what is now East Tennessee."

43. Sevier and Madden, *Sevier Family History*, 221.

44. Although her marker at the Old Knox County Courthouse in Knoxville has Catherine Sherrill Sevier's first name engraved as "Katherine," her original gravestone in Alabama spelled Catherine with a *C*. Most family histories and historical accounts also used the more traditional spelling of "Catherine" in their works.

45. Turner, *Life of General John Sevier*, 68.

46. Ibid., 69.

47. Roosevelt, *Winning of the West*, 1:292.

48. Williams, *Tennessee*, 46.

49. Ibid., xi.

50. Ellet, *Pioneer Women*, 31–32.

51. Ibid., 32.

52. Miller, "These United States," 275.

53. Driver, *John Sevier*, 19–20.

54. Henderson, *"Nolachucky Jack"*, 9–10.

55. Roosevelt, *Winning of the West*, 1:214–15.

56. *Knoxville News-Sentinel*, January 1, 1945.

57. "Sarah Hawkins," 366–68.

CHAPTER 3

58. Driver, *John Sevier*, 1; Roosevelt, *Winning of the West*, 1:211.

59. Driver, *John Sevier*, 1.

60. Dixon, *John Sevier*, 3; John William Gerard de Brahm, "De Brahm's Account," in Williams, *Early Travels*, 193, quoted in Blackmon, *Dark and Bloody Ground*, 10–11.

61. Compton, "Revised History," 14.

62. Haywood, *Civil and Political History*, 53.

63. Ramsey, *Annals of Tennessee*, 734, 736. Ramsey stated, "No one is the *Magnus Apollo* [my leader, authority and oracle] to the frontier man. He is the Magnus Apollo to himself. *Nullius addictus jurare in verba magistri* [not being bound to swear or speak according to the dictates of any master], is his motto."

64. Roosevelt, *Winning of the West*, 1:213–14, 219.

65. Driver, *John Sevier*, 1.

66. Ibid., 10; Brown, *Old Frontiers*, 187; Roosevelt, *Winning of the West*, 1:229; Heiskell, *Andrew Jackson*, 1:314.

67. Turner, *Life of General John Sevier*, vi; Williams, *Dawn of Tennessee Valley*, 353; Driver, *John Sevier*, 11.

68. Roosevelt, *Winning of the West*, 1:223, 227.

69. Ibid., 223.

70. Ibid., 224, 227.

71. Roosevelt, *Winning of the West*, 1:227–29. During a visit to the Tennessee Historical Society in Nashville, Roosevelt reviewed an account of Sevier written by one of the old settlers named Hillsman. In a footnote, Roosevelt remarked, "Hillsman especially dwells on the skill with which Sevier could persuade the backwoodsmen to come round to his own way of thinking, while at the same time making them believe that they were acting on their own ideas, and adds—'whatever he had was at the service of his friends and for the promotion of the Sevier party, which sometimes embraced nearly all the population.'"

72. Haywood, *Civil and Political History*, 53.

73. Roosevelt, *Winning of the West*, 1:218.

74. Caldwell, *Tennessee*, 23-24; Haywood, *Civil and Political History*, 55. Haywood wrote, "The settlers, uneasy at the precarious tenure by which they occupied the lands, desired to obtain a permanent title. For this purpose, in the year of 1772, they deputed [*sic*] James Robertson and John Boone to negotiate with the Indians for a lease; and for a certain

amount in merchandise, estimated at five or six thousand dollars, muskets, and other articles of convenience, the Cherokees made a lease to them for eight years of all the country on the waters of the Watauga."

75. Brown, *Old Frontiers*, 131; Williams, *Dawn of Tennessee Valley*, 353.

76. Brown, *Old Frontiers*, 131.

77. Roosevelt, *Winning of the West*, 1:238–39.

78. Ibid., 1:237–38; Haywood, *Civil and Political History*, 56; Putnam, *History of Middle Tennessee*, 31–32; Brown, *Old Frontiers*, 131. There are some inconsistencies in the literature about this particular exchange. Roosevelt wrote, "After the lease was signed, a day was appointed on which to hold a great race, as well as wrestling-matches and other sports, at Watauga. Not only many whites from the various settlements, but also a number of Indians, came to see or take part in the sports; and all went well until the evening, when some lawless men from Wolf Hills, who had been lurking in the woods round about, killed an Indian, whereat his fellows left the spot in great anger." Haywood stated that these men were named Crabtree. Putnam hinted that the men involved had lost a brother when Daniel Boone's party was attacked and his son killed, but the attack on Boone did not take place until over a year after this time.

79. Justi, *Official History*, 64.

80. Roosevelt, *Winning of the West*, 1:217; West, *Tennessee Encyclopedia*, s.v. "Watauga Association," 1039–40.

81. West, *Tennessee Encyclopedia*, s.v. "Watauga Association," 1039–40.

82. Driver, *John Sevier*, 10; Dixon, *Wataugans*, 16. Although Sevier's biographer Carl Driver noted that "the Watauga Association drew up its constitution in 1771," most scholarly accounts place the date in which the Wataugans agreed upon "Written Articles of Association" as May 1772.

83. Ramsey, *Annals of Tennessee*, 107.

84. Ibid., 134; Roosevelt, *Winning of the West*, 1:232, 234; Caldwell, *Tennessee*, 26.

85. Dixon, *Wataugans*, 22.

86. Driver, *John Sevier*, 10–11.

87. West, *Tennessee Encyclopedia*, s.v. "Watauga Association," 1039–40; Dixon, *Wataugans*, 20.

88. John Murray, Earl of Dunmore, to the Earl of Dartmouth, May 16, 1774, cited in Caldwell, *Tennessee*, 29. See also Bancroft, *History of the United States*, 401; Williams, *Dawn of Tennessee Valley*, 337.

89. Hamer, *Tennessee*, 69, quoted in Dixon, *Wataugans*, 20.

90. Ramsey, *Annals of Tennessee*, 106.

91. Roosevelt, *Winning of the West*, 1:231.

92. Hubta, "Tennessee," 314; Dixon, *Wataugans*, 19.

93. Phelan, *History of Tennessee*, 51.

94. Haywood, *Civil and Political History*, 8.

CHAPTER 4

95. Hall and Westmoreland, *Battle of King's Mountain*, 9. Although official literature published by the Kings Mountain National Military Park uses the plural form of the word (Kings), most early historians and antiquarians used the possessive form to name the battle (King's). It is also noteworthy that the original name for King's Mountain was the possessive form. Both the mountain and a creek on the property were named for a Mr. King, who lived at the foot of the mountain. Throughout history, roads, churches, creeks and communities were often named for a person who either owned the property or who lived nearby; it is for this reason that I chose to employ the apostrophe throughout this book.

96. "Order from George Washington concerning the American victory at the Battle of King's Mountain," October 27, 1780, *State Records of North Carolina*, 15:131–32, cited in Caruso, *Appalachian Frontier*, 251.

97. Caruso, *Appalachian Frontier*, 251; Preston, *Celebration*, 107.

98. Preston, *Celebration*, 107.

99. Jefferson to Campbell, November 10, 1822, David Campbell Papers, Duke University.

100. Driver, *John Sevier*, 60, cited in Dykeman, *Tennessee*, 79.

101. Lynch, "Creating Recreational Heroes," 225–26.

102. Thwaites, *Lyman Copeland Draper*, 1–2; Hesseltine, *Pioneer's Mission*, 4–8.

103. Hesseltine, *Pioneer's Mission*, 9–10.

104. Ibid., 76.

105. "Act to Incorporate," *Charter and Revised Statutes*, 3. Draper helped to establish the Wisconsin Historical Society through "an Act to Incorporate the State Historical Society of Wisconsin" and drafted the charter creating this organization.

106. Hesseltine, *Pioneer's Mission*, 6–7, 22.

107. Ibid., 27.

108. Hesseltine, "Lyman Draper," 23.

109. "Act to Incorporate," *Charter and Revised Statutes*, 3.

110. Hesseltine, *Pioneer's Mission*, 41.

111. Hesseltine, "Lyman Draper," 22–23.

112. Ibid; see also Hesseltine, *Pioneer's Mission*, 48–49, 51–52.

113. Draper, *King's Mountain*, iv.

114. Ibid.

115. General James Sevier to Lyman C. Draper, August 19, 1839, Sevier Family Genealogical Collection, TSLA.

116. Draper, *King's Mountain*, 184, 189–90.

117. Ibid., 196.

118. Ibid., 308.

119. Ibid., 575–76.

120. Ibid., 566–67.

121. Ibid., 561.

122. Dunkerly, *Battle of Kings Mountain*, 98.

123. Draper, *King's Mountain*, 388–389.

124. Ibid., 224; White, *King's Mountain Men*, 202.

125. Dunkerly, *Battle of Kings Mountain*, 64–65.

126. Lyman C. Draper, interview with Silas McBee, December 1, 1843, Draper Manuscripts.

127. White, *King's Mountain Men*, 202.

128. Draper, *King's Mountain*, iv.

129. Ibid. In a footnote, Draper cites "notes of conversations with John Speltz, of Marshall County, Miss., in 1844, a venerable survivor of Major McDowell's King's Mountain men." See also William Snodgrass to Governor David Campbell, September 5, 1845, Draper Manuscripts.

130. "Battle of King's Mountain," 69.

131. Hesseltine, *Pioneer's Mission*, 276.

132. Ibid., vii.

133. Ibid., 290.

134. Ibid., 48.

135. Lyman C. Draper to George W. Sevier, May 3, 1839, John Sevier Collection, Special Collections Library, University of Tennessee, Knoxville, TN.

136. Statement of Colonel George W. Sevier, excerpted from Draper, *King's Mountain*, 282.

137. Mearns, "Review of *Pioneer's Mission*," 497.

138. Hesseltine, "Lyman Draper," 31.

139. Ibid., 26.

140. Hesseltine, *Pioneer's Mission*, 49–52, 58; Ramsey to Draper, October 26, 1846, Draper Manuscripts.

141. Klebenow, *200 Years*, 145.

142. Lawrimore, "Let Us Hasten," 420.

143. Klebenow, *200 Years*, 145.

144. Ramsey, *Annals of Tennessee*, 13. See also Hesseltine, *Dr. J.G.M. Ramsey*, xxxii.

145. Lawrimore, "'Let Us Hasten,'" 422.

146. West, *Tennessee Encyclopedia*, s.v. "James Gettys McGready Ramsey," 774–75.

147. Klebenow, *200 Years*, 145.

148. Lawrimore, "'Let Us Hasten,'" 423.

149. Ibid.

150. Ibid., 424, quoted in Eubanks, "Dr. J.G.M. Ramsey," 229.

151. Eubanks, "Dr. J.G.M. Ramsey," 230.

152. Ramsey, *Annals of Tennessee*, 10.

153. Ramsey to Draper, January 14, 1853, Draper Manuscripts, cited in Hesseltine, *Dr. J.G.M. Ramsey*, 74.

154. Ramsey to Draper, May 27, 1853, ibid., 77.

155. Ramsey, *Annals of Tennessee*, 107.

156. Ramsey to Draper, February 1, 1870, in Hesseltine, *Dr. J.G.M. Ramsey*, 259.

157. Ramsey to Draper, April 28, 1870, ibid., 261.

158. Ramsey to Draper, February 3, 1873, ibid., 273.

159. Ramsey to Draper, May 5, 1873, in Hesseltine, *Pioneer's Mission*, 274–275.

160. Ibid., 276.

161. Hesseltine, *Pioneer's Mission*, 318.

162. Ramsey to Draper, March 11, 1880, in Hesseltine, *Dr. J.G.M. Ramsey*, 323.

163. Ramsey to Draper, July 14, 1880, ibid., 332.

164. Thompson, to Draper, December 24, 1881, Draper Manuscripts.

165. Hesseltine, "Lyman Draper," 20.

166. Hesseltine, *Pioneer's Mission*, 291.

CHAPTER 5

167. Draper, *King's Mountain*, 180–81.

168. "James Blair Pension Statements," November 5, 1832, and October 16, 1837, Draper Manuscripts.

169. Moore, "Ride of the Rebel"; "Blair," Surname Vertical File, TSLA.

170. Moore, "Ride of the Rebel."

171. Green, *John Trotwood Moore*, 71–72. John Trotwood Moore's chief biographer, Claud B. Green, wrote that Moore's approach to the study and the writing of southern history resembled "that of the interested, intelligent layman rather than of the trained historian." Green noted that Moore wrote "amateurishly but always enthusiastically" and that he tried to write history "accurately and entertainingly."

172. Moore, *Draper Manuscripts as Relating to Tennessee*, 3–4, 6.

173. Moore, "Ride of the Rebel"; "Blair," Surname Vertical File, TSLA.

174. Bond, *Old Tales Retold*, 95–96.

175. Ibid., 99.

176. Ibid., 99–100.

177. Ibid., 100.

178. West, *Tennessee Encyclopedia*, s.v. "Samuel Doak," 252; Temple, *Notable Men of Tennessee*, 12.

179. Alderman, *Overmountain Men*, 82.

180. Wills, *In Memorium*, 15–16.

181. Ramsey to Draper, July 12, 1880, Draper Manuscripts.

182. Draper, *King's Mountain*, 176.

183. Alderman, *Overmountain Men*, 83.

184. "Biographical/Historical Note," J. Fain Anderson Letter, MS 1218, University of Tennessee Libraries, Special Collections.

185. Alderman, *Overmountain Men*, 83.

186. Draper, *King's Mountain*, 275.

187. Cox, "Darling Jones'."

188. Scotty Wiseman and Grandpa Jones, "Sweet Lips (Battle of Kings Mountain)," *What's for Supper?*, Monument KZ 32939, LP (1973), trk #2, cited in Keefer, *Folk Music*.

189. "A Tennessee Hero: The Kings Mountain Messenger, Joseph Greer," Joseph Greer Family Papers, TSLA; Alderman, *Overmountain Men*, 115; Ewing, *Treasury of Tennessee Tales*, 121.

190. Alderman, *Overmountain Men*, 115.

191. "A Tennessee Hero," Joseph Greer Family Papers, TSLA.

192. JCC, 1774–89, 18:1048–49.

193. "A Tennessee Hero," Joseph Greer Family Papers, TSLA.

194. Alderman, *Overmountain Men*, 115.

195. Ewing, *Treasury of Tennessee Tales*, 121.

CHAPTER 6

196. Draper, *King's Mountain*, 292.

197. Caldwell, *Tennessee*, 102.

198. Draper, *King's Mountain*, 322; Chandler, *Brief Description*, 5.

199. Logan to Draper, January 28, 1881, and April 18, 1881, Draper Manuscripts.

200. Draper, *King's Mountain*, 322; Chandler, *Brief Description*, 5.

201. Logan to Draper, January 28, 1881, Draper Manuscripts. In a letter to Lyman C. Draper written on January 28, 1881, J.R. Logan acknowledged a lingering bitterness existed toward the British among those who attended the ceremony, and some attendees opposed burying the British soldiers' remains alongside those of the Patriot soldiers who fought against them at King's Mountain. Logan noted, however, a tone of solemn remembrance during the ceremony. Logan wrote, "At the time the monument was set up there was a celebration there, and a sermon delivered by Rev. James S. Adams and other appropriate ceremonies observed."

202. Dameron, *King's Mountain*, 90; Chandler, *Brief Description*, 5–6.

203. Chandler, *Brief Description*, 6.

204. *New York Times*, October 12, 1855.

205. For a more thorough overview of the Kansas-Nebraska Act and the struggle between pro- and antislavery elements in the Kansas Territory, see Nichols, *Bleeding Kansas* and Etcheson, *Bleeding Kansas*.

206. Chandler, *Brief Description*, 6; *New York Times*, October 12, 1855.

207. *New York Times*, October 12, 1855.

208. Ibid.

209. Lynch, "Creating Regional Heroes," 227.

210. King's Mountain Centennial Association, *Battle at King's Mountain October 7, 1780*, 3.

211. Ibid., 3–4.

212. Ibid., 4.

213. Ibid.

214. Ibid., 8.

215. Ibid.

216. Lynch, "Creating Regional Heroes," 229.

217. King's Mountain Centennial Association, *Battle at King's Mountain October 7, 1780*, 8–9.

218. Ibid.

219. "Kings Mountain Centennial Monument," *Commemorative Landscapes of North Carolina*.

220. King's Mountain Centennial Association, *Battle at King's Mountain October 7, 1780*, 12.
221. "Kings Mountain Centennial Monument," *Commemorative Landscapes of North Carolina*.
222. Chandler, *Brief Description*, 7.
223. Ibid.
224. "Kings Mountain Centennial Monument," *Commemorative Landscapes of North Carolina*.
225. Chandler, *Brief Description*, 7.
226. Heiskell, *Andrew Jackson*, 1:269.
227. "Kings Mountain Centennial Monument," *Commemorative Landscapes of North Carolina*.
228. Ibid.
229. Ibid.
230. Chandler, *Brief Description*, 8.
231. *Nashville Banner*, October 7, 1897.
232. Ibid.
233. Ibid.
234. Allison, *Address*, 24; see also White, *King's Mountain Men*, 143.
235. Allison, *Dropped Stitches*, Preface, n.p.
236. Allison, *Address*, 12–13.
237. Ibid., 22–23.
238. Ibid., 23–24.
239. *Nashville Banner*, October 7, 1897.
240. Dameron, *King's Mountain*, 91.
241. Chandler, *Brief Description*, 8.
242. Ibid., 9.
243. Ibid., 9–10.
244. Dameron, *King's Mountain*, 91.
245. Chandler, *Brief Description*, 10.
246. Ibid., 4.
247. Dameron, *King's Mountain*, 90-91.
248. Hoover, "Address."
249. Ibid.
250. Ibid.
251. Ibid.
252. *Tennessean*, October 7, 1980.
253. Ibid.
254. Ibid.

CHAPTER 7

255. West, *Tennessee Encyclopedia*, s.v. "Watauga Association," 1039–40; Roosevelt, *Winning of the West*, 1:212; Haywood, *Civil and Political History*, 98; Dean, *Demand of Blood*, 32.

256. Blackmon, *Dark and Bloody Ground*, 4; Roosevelt, *Winning of the West*, 1:210. King George III issued the Royal Proclamation of 1763 on October 7, 1763, following Great Britain's acquisition of French territory in North America after the end of the French and Indian War. The proclamation forbade colonists from settling past a line drawn along the Appalachian Mountains. By 1768, however, the Iroquois agreed to surrender to the British all the lands lying between the Ohio and the Tennessee Rivers at the Treaty of Fort Stanwix. This treaty gave John Sevier and the early settlers of the Watauga Valley the justification they desired to establish their homesteads beyond the reach of the British colonial empire and in territory that the Cherokee claimed as their own.

257. Dixon, *Wataugans*, 7.

258. Dean, *Demand of Blood*, 31.

259. West, *Tennessee Encyclopedia*, s.v. "Sycamore Shoals State Historic Area," 902; Dean, *Demand of Blood*, 36–37; Brown, *Old Frontiers*, 6; Thornton, *Cherokees*, 41.

260. Brown, *Old Frontiers*, 3–5; Dean, *Demand of Blood*, 36. Dragging Canoe, son of Attakullakulla, was chief of Amo-yeli-egwa, Great Island, one of the smaller Cherokee towns.

261. Cox, *Heart of the Eagle*, 18.

262. Brown, *Old Frontiers*, 6, 13. Brown noted, "Henderson's goods made an impressive appearance in bulk, but the distribution caused much dissatisfaction, for the number of Indians present at the treaty was large. One warrior who received a shirt as his portion complained, 'We have sold the land, and I could have killed more deer upon it in a day than would have bought such a shirt.' The dissatisfaction gained followers for Dragging Canoe, the only chief who had protested the bargain."

263. Brown, *Old Frontiers*, 10; Haywood, *Civil and Political History*, 58–59; Williams, *Dawn of Tennessee Valley*, 407–08; Cox, *Heart of the Eagle*, 21–22; Dean, *Demand of Blood*, 37–38. John Haywood originally attributed Dragging Canoe's speech to Oconostota, but Samuel Cole Williams later noted, "Oconostota was from the outset favorable to the sale and, naturally would not have spoken words that would tend to frustrate the Cherokees' purpose. Further, by all contemporaneous accounts Oconostota was by no

means an orator, and he very infrequently attempted the role." Although Dragging Canoe's exact words are not known, Haywood paraphrased the speech from traditional accounts. This text is a combination of depositions from the accounts of Haywood, Brown, Williams and Dean.

264. Brown, *Old Frontiers*, 131–32.

265. Ibid., 12; McRae, *Calendar*, Deposition of Samuel Wilson, I, 283.

266. Haywood, *Civil and Political History*, 58.

267. Hesseltine, *Dr. J.G.M. Ramsey*, 312.

268. Haywood, *Civil and Political History*, 61.

269. Ramsey, *Annals of Tennessee*, 589.

270. Turner, *Life of General John Sevier*, 74.

271. Driver, *John Sevier*, 38.

272. Roosevelt, *Winning of the West*, 1:1; Morris, *Rise of Theodore Roosevelt*, 417–18.

273. Morris, *Colonel Roosevelt*, 5.

274. Roosevelt, *Winning of the West*, 1:213–14.

275. Roosevelt to Lea, February 25, 1888, Shapell Manuscript Foundation.

276. Roosevelt, *Winning of the West*, 4:217–18.

277. George Washington to Timothy Pickering, September 9, 1798, cited in Barksdale, *Lost State of Franklin*, 115; Foster, *Franklin*, 18-19.

278. Roosevelt, *Winning of the West*, 4:218–19.

279. Ibid., 1:15.

280. Ibid., 10–11.

281. Roosevelt, *Winning of the West*, 3:189–90.

282. Ibid., 3:216.

283. Ibid., 3:190.

284. Morris, *Rise of Theodore Roosevelt*, 393.

285. Roosevelt, *Winning of the West*, 1:10.

286. "Preserving Archives of the State: Robert Thomas Quarles, State Archivist," John Trotwood Moore Papers, TSLA.

287. Morris, *Rise of Theodore Roosevelt*, 417–18.

288. Ibid., 418.

289. Roosevelt, *Winning of the West*, 1:229.

290. Gilmore, *John Sevier*, 12–13.

291. Roosevelt, *Winning of the West*, 1:230; Gilmore, *John Sevier*, 13.

292. Roosevelt, *Winning of the West*, 1:229.

293. Ibid., 230.

294. Ibid., 3:216–17.

295. Morris, *Rise of Theodore Roosevelt*, 419.

296. Morison, *Letters*, 189.

297. Ibid., 192.

298. Morris, *Rise of Theodore Roosevelt*, 419.

299. "James Roberts Gilmore," *Virtual American Biographies*.

300. Ibid.

301. *New York Times*, August 14, 1864, and April 4, 1915.

302. "James Roberts Gilmore," *Virtual American Biographies*; James Roberts Gilmore Collection, Ms.37.

303. Gilmore, *Advance-Guard*, iv–v.

304. Gilmore, *John Sevier*, 9, 11.

305. Ibid., v.

306. Gilmore, *Advance-Guard*, 329.

307. Gilmore, *John Sevier*, vi, viii, 16.

308. Ibid., vi–vii.

309. Ibid., vi.

310. Gilmore, *Advance-Guard*, 39, 241–43.

311. Ibid., 322, 10.

312. Ramsey, *Annals of Tennessee*, 588.

313. Ibid., 589.

314. Gilmore, *Advance-Guard*, 19.

315. Grenier, *First Way*, 160.

316. Phelan, *History of Tennessee*, 64.

317. Ramsey, *Annals of Tennessee*, 264.

318. Evans, "Was the Last Battle," 30–40; Phelan, *History of Tennessee*, 65–66.

319. Gilmore, *Rear-Guard*, 313.

320. Evans, "Was the Last Battle," 35.

321. Ibid., 30.

322. James Sevier to Lyman Draper, August 19, 1839, cited in Evans, "Was the Last Battle," 32.

323. Evans, "Was the Last Battle," 34.

324. Alexander Martin to Benjamin Hawkins, n.d. (appears to have been written circa late December 1782), cited in Evans, "Was the Last Battle," 32.

325. Malone, *Cherokees*, 44; Driver, *John Sevier*, 37.

326. Driver, *John Sevier*, 38.

CHAPTER 8

327. Williams, *History of the Lost State*, 19.

328. Bergeron, Ash and Keith, *Tennesseans*, 34.

329. Toomey, "State of Franklin."

330. Williams, *History of the Lost State*, 30.

331. Ibid., 95.

332. Ibid., 195.

333. Nelson, "Tipton Family," 69; Williams, *History of the Lost State*, 334–35.

334. Williams, *History of the Lost State*, 334; Hale and Merritt, *History of Tennessee*, 2603.

335. Hale and Merritt, *History of Tennessee*, 2599.According to Hale and Merritt's *A History of Tennessee and Tennesseans*, John Tipton had three siblings, Joseph, Mordecai and Jonathan, "though the father was married twice, and there were doubtless other children."

336. Brown, *Old Frontiers*, 192–93.

337. Ibid., 197.

338. Nelson, "Tipton Family," 69; *Knoxville Sentinel*, March 28, 1908; Williams, *History of the Lost State*, 334.

339. Gilmore, *John Sevier*, 66.

340. Hale and Merritt, *History of Tennessee*, 2600.

341. Ramsey, *Annals of Tennessee*, 288.

342. Nelson, "Tipton Family," 70–71.

343. Driver, *John Sevier*, 23; Barksdale, *Lost State of Franklin*, 60; Haywood, *Civil and Political History*, 154.

344. Barksdale, *Lost State of Franklin*, 60; Haywood, *Civil and Political History*, 154.

345. Haywood, *Civil and Political History*, 154.

346. Barksdale, *Lost State of Franklin*, 61.

347. Williams, *History of the Lost State*, 67–71.

348. Ibid., 72–73.

349. Colonel John Tipton to Governor Alexander Martin, May 13, 1785, cited in Quarles, *State of Franklin*, 43.

350. Barksdale, *Lost State of Franklin*, 50; Purcell, *Sealed with Blood*, 79.

351. Purcell, *Sealed with Blood*, 79; Sevier to Caswell, October 28, 1786, cited in Sevier and Madden, *Sevier Family History*, 69.

352. Sevier to Caswell, April 6, 1787, cited in Gilmore, *John Sevier*, 119.

353. John Sevier to both Houses of the General Assembly of North Carolina, October 30, 1788, cited in Sevier and Madden, *Sevier Family History*, 101.

354. Ibid.

355. Corlew, *Tennessee*, 77.

356. Barksdale, *Lost State of Franklin*, 76.

357. Haywood, *Civil and Political History*, 173; Williams, *History of the Lost State*, 109; Ashe, *History of North Carolina*, 62. Haywood erroneously attributes this courthouse confrontation as having occurred in 1786; however, Williams corrects Haywood, and Ashe confirms the date of August 1787.

358. Barksdale, *Lost State of Franklin*, 76.

359. Haywood, *Civil and Political History*, 174.

360. Ibid., 175.

361. Barksdale, *Lost State of Franklin*, 77.

362. John Sevier to Benjamin Franklin, April 9, 1787, cited in Williams, *History of the Lost State*, 165–66.

363. Benjamin Franklin to John Sevier, June 30, 1787, cited in ibid., 166–67.

364. Ramsey, *Annals of Tennessee*, 403.

365. Barksdale, *Lost State of Franklin*, 132.

366. Haywood, *Civil and Political History*, 190, cited in Barksdale, *Lost State of Franklin*, 132. Sevier's Plum Grove plantation was located on the Nolachucky River, about ten miles from Jonesborough, Washington County, now in Tennessee.

367. Williams, *History of the Lost State*, 200, cited in Barksdale, *Lost State of Franklin*, 133.

368. Gilmore, *John Sevier*, 152; Williams, *History of the Lost State*, 200. Although Gilmore quotes Tipton as having said, "Fire and be damned!" Williams merely stated that "Tipton gave only a verbal reply."

369. Williams, *History of the Lost State*, 200–02.

370. Washington County Historical Association, *History of Washington County*, 88.

371. Barksdale, *Lost State of Franklin*, 133–36.

372. George Maxwell and John Tipton to Arthur Campbell, March 12, 1788, Draper Manuscripts, cited in Barksdale, *Lost State of Franklin*, 136.

373. Whitaker, "Spanish Intrigue," 159–60.

374. Ibid., 160. According to Whitaker, in exchange for Franklin's submission to Spanish rule, Sevier requested three things: "money, munitions, and commercial concessions."

375. Parker, "Historical Interpretations," 40–41. In 1786, U.S. secretary of foreign affairs John Jay entered into negotiations with the Spanish Charge d'Affaires, Don Diego de Gardoqui. Their proposed treaty would guarantee Spain's exclusive right to navigate the Mississippi River for

twenty years. The U.S. Congress rejected the treaty, however, under the Articles of Confederation.

376. Henderson, "Spanish Conspiracy," 232.

377. John Sevier to Don Diego de Gardoqui, September 12, 1788, cited in Corbitt and Corbitt, "Papers," 103.

378. Whitaker, "Spanish Intrigue," 160.

379. Powell, *Dictionary*, s.v. "Archibald Henderson," 3:99–100; Henderson, "Spanish Conspiracy," 243. Archibald Henderson's ancestors included Richard Henderson, president of the company that sent Daniel Boone to explore the western lands of Tennessee and Kentucky.

380. Whitaker, "Spanish Intrigue," 158.

381. Parker, "Historical Interpretations," 42–43; Haywood, *Civil and Political History*, 400. "Earlier writers, having no knowledge of this meeting and Sevier's subsequent correspondence, speak of intrigue only in terms of projected attack upon Spanish possessions."

382. Phelan, *History of Tennessee*, 103, cited in Parker, "Historical Interpretations," 43.

383. Phelan, *History of Tennessee*, 97–98, cited in Parker., 42.

384. Gilmore, *Advance-Guard*, 173–74, cited in Parker., 46–47.

385. Corbitt and Corbitt, "Papers."

386. Washington County Historical Association, *History of Washington County*, 90; Williams, *History of the Lost State*, 231.

387. Barksdale, *Lost State of Franklin*, 140.

388. "Deposition of David Deaderick concerning the actions of John Sevier, including related certificate and deposition," October 25, 1788, in Clark, *State Records*, 22:699–701, cited in Barksdale, *Lost State of Franklin*, 140.

389. Washington County Historical Association, *History of Washington County*, 90; Williams, *History of the Lost State*, 231–32.

390. Haywood, *Civil and Political History*, 205; Williams, *History of the Lost State*, 232; Barksdale, *Lost State of Franklin*, 141.

391. Haywood, *Civil and Political History*, 205–06.

392. Ramsey, *Annals of Tennessee*, 428–29.

393. Ibid., 428.

394. Williams, *History of the Lost State*, 233.

395. *Pittsburgh Press*, March 26, 1911; Driver, *John Sevier*, 97–98.

396. "Letter from John Sevier to the North Carolina General Assembly," October 30, 1788, in Clark, *State Records*, 22:697–99.

397. Turner, *Life of General John Sevier*, 102.

398. Barksdale, *Lost State of Franklin*, 4.

399. Ibid., 170.

400. George W. Sevier to Lyman C. Draper, February 9, 1839, and June 17, 1840, cited in Barksdale, *Lost State of Franklin*, 171.

401. Albigence Waldo Putnam Papers, Tennessee Historical Society Collection, TSLA. As one of the founders of the Tennessee Historical Society, Putnam is best remembered for his publication of *History of Middle Tennessee; or, Life and Time of General James Robertson* in 1859 and for his other literary contributions.

402. Putnam to Draper, September 4, 1851, Draper Manuscripts, cited in Barksdale, *Lost State of Franklin*, 171–72, 250n29.

403. Williams, *History of the Lost State*, ix.

404. Ibid., ix–x.

405. Ibid., 110.

406. Gilmore, *John Sevier*, 29–30, 66, 202, cited in Barksdale, *Lost State of Franklin*, 7–8, 193–94n12.

407. Nelson, "Tipton Family," 71.

408. Ibid. Nelson also authored a series of articles detailing the history of the Tipton family that appeared in the *Knoxville Sentinel* on the following days in 1908: March 28; April 4, 11, 18 and 25; and May 2 and 9.

409. Tipton to Draper, September 4, 1851, Draper Manuscripts, cited in Barksdale, *Lost State of Franklin*, 173.

410. Hsiung, 169-171, cited in Barksdale, *Lost State of Franklin*, 173.

411. Pershing, *Life of General John Tipton*, 9; Brown, *Lamb's Biographical Dictionary*, 7:353.

412. Pershing, *Life of General John Tipton*, 9.

413. Barksdale, *Lost State of Franklin*, 4.

414. Ibid., 4–5, 9.

415 Abernethy, *From Frontier to Plantation*, 89; Barksdale, *Lost State of Franklin*, 192n4.

416. Folmsbee, Corlew and Mitchell, *History of Tennessee*, 1:154–160, cited in Barksdale, *Lost State of Franklin*, 12–13.

417. Dykeman, *Tennessee*, 65–76, cited in Barksdale, *Lost State of Franklin*, 12–13.

418. Gerson, *Franklin*, 160.

419. Foster, *Franklin*, 22.

420. Williams, *History of the Lost State*, 249–54.

421. Bergeron, Ash and Keith, *Tennesseans*, 44.

422. Gilmore, *John Sevier*, 302.

423. Barksdale, *Lost State of Franklin*, 9. Barksdale credits Gilmore with creating "East Tennessee's own version of the 'Lost Cause'" and stated,

"John Sevier's failed statehood movement became the forlorn 'Lost State of Franklin.'"

424. Ibid., 16.

425. Parker, "Historical Interpretations," 62.

426. Ramsey, *Annals of Tennessee*, 439, cited in Barksdale, *Lost State of Franklin*, 170. Dr. J.G.M. Ramsey, a Franklinite descendent, described his ancestors as "virtuous and patriotic."

CHAPTER 9

427. Ramsey, *Annals of Tennessee*, 659–60.

428. West, *Tennessee Encyclopedia*, s.v. "John Sevier," 838–40.

429. Driver, *John Sevier*, 119, 132–33.

430. Ibid., 119–120; West, *Tennessee Encyclopedia*, s.v. "John Sevier," 838–40.

431. Quoted in Jackson to Sevier, May 8, 1797, in PAJ 1:136–37. See also Remini, *Andrew Jackson*, 101; Bassett, *Life of Andrew Jackson*, 56.

432. Sevier to Jackson, May 11, 1797, and Jackson to Sevier, May 10, 1797, in PAJ 1:141–42, quoted in Remini, *Andrew Jackson*, 102.

433. Sevier to Jackson, August 29, 1798, PAJ 1:209, quoted in Clayton, *History of Davidson County*, 141.

434. Driver, *John Sevier*, 174–75.

435. Brands, *Andrew Jackson*, 106.

436. Remini, *Andrew Jackson*, 120.

437. Ibid., 121.

438. Clayton, *History of Davidson County*, 142.

439. Jackson to Sevier, October 2, 1803, PAJ 1:367–68.

440. Guy, *Hidden History*, 54.

441. Sevier to Jackson, October 2, 1803, PAJ 1:368, quoted in Clayton, *History of Davidson County*, 142.

442. Jackson to Sevier, October 3, 1803, PAJ 1:368–69.

443. Ibid., 369.

444. Sevier to Jackson, October 3, 1803, PAJ 1:369.

445. Jackson to Sevier, October 9, 1803, PAJ 1:375–77.

446. Ibid.

447. Sevier to Jackson, October 9, 1803, PAJ 1:377.

448. Sevier to Jackson, October 10, 1803, PAJ 1:379.

449. Jackson to Sevier, October 10, 1803, PAJ 1:379–80.

450. Sevier to Jackson, October 10, 1803, PAJ 1:380–81.

451. Jackson to Sevier, October 11, 1803, PAJ 1:384–85.

452. Ibid., 385.

453. Clayton, *History of Davidson County*, 145.

454. Brands, *Andrew Jackson*, 109.

455. Davis, *More Tales*, 73.

456. Statement by Vandyke, October 16, 1803, printed in *Tennessee Gazette and Mero-District Advertiser*, December 21, 1803, PAJ 1:505–06.

457. Ibid., quoted in Brands, *Andrew Jackson*, 109.

458. Affidavit of Andrew Greer, October 23, 1803, PAJ 1:489–90.

459. Davis, *More Tales*, 74.

460. PAJ 1:492–96, *Tennessee Gazette and Mero-District Advertiser*, November 25, 1803, reprinted from *Knoxville Gazette*, issue no longer extant.

461. Sixty, being three times twenty.

462. PAJ 1: 492–96, *Tennessee Gazette and Mero-District Advertiser*, November 25, 1803, reprinted from *Knoxville Gazette*, issue no longer extant.

463. "Veritas" to *Tennessee Gazette* printer, December 14, 1803, PAJ 1:496–502.

464. Sevier to Robertson, November 8, 1803, PAJ 1:490–91. See also James Robertson Papers, TSLA.

465. Gilmore, *John Sevier*, 307.

466. Turner, *Life of General John Sevier*, 218–19.

467. Ibid., 221.

468. Driver, *John Sevier*, 187.

469. Ibid., 188–89; Heiskell, *Andrew Jackson*, 2:588.

470. Phelan, *History of Tennessee*, 247. In 1807, William Cocke announced himself as a candidate for the governor's office, "but so hopeless did it appear to contest the election with Sevier that he was forced to withdraw."

471. Ibid., 248.

472. Ibid.

473. Remini, *Andrew Jackson*, 123–24.

474. Bassett, *Life of Andrew Jackson*, 57.

475. Abernethy, *From Frontier to Plantation*, 164.

476. Williams, *History of the Lost State*, 291.

477. Miller, "These United States," 273.

CHAPTER 10

478. Driver, *John Sevier*, 200.

479. *Journal of the Senate*, 8th Assembly, 1st sess., September 19, 1809, 14.

480. *Wilson's Knoxville Gazette*, April 22, 1809; Driver, *John Sevier*, 200.

481. *Journal of the Senate*, 8th Assembly, 1st sess., September 23, 1809, 29.

482. "SEVIER, John," *Biographical Directory*.

483. Hildreth, *History of the United States*, 260.

484. Driver, *John Sevier*, 203–04.

485. *Annals of Congress*, 12th Cong., 1st sess., 463–70.

486. Driver, *John Sevier*, 207.

487. Ibid., 208.

488. "A History of Tennessee," *Tennessee Blue Book*, 488.

489. Ibid., 488–89.

490. *Calendar of the Correspondence of James Madison*, 137. President James Madison "asks for the appointment of John Sevier as one of the commissioners for running the boundary line agreeably to the treaty made with the Creek Indians."

491. DeWitt, "Journal," 59–60.

492. Ibid., 57; Driver, *John Sevier*, 216–17.

493. Driver, *John Sevier*, 217.

494. *Daily Picayune*, March 29, 1889.

495. Ramsey, *Annals of Tennessee*, 712; Driver, *John Sevier*, 217.

496. Heiskell, *Andrew Jackson*, 1:214.

497. Ramsey, *Annals of Tennessee*, 712; Turner, *Life of General John Sevier*, 127.

498. *Journal of the Senate*, 11th Assembly, 1st sess., October 26, 1815, 143; *Journal of the House of Representatives*, 11th Assembly, 1st sess., October 26, 1815, 177.

499. Heiskell, *Andrew Jackson*, 1:214–15.

500. Ibid., 2:614.

501. Ramsey, *Annals of Tennessee*, 10–11.

CHAPTER 11

502. Kammen, *Mystic Chords*, 100.

503. Ibid., 96.

504. Wheeler, *Historical Sketches*, 449.

505. Colyar, *Life and Times*, 7.

506. West, *Tennessee Encyclopedia*, s.v. "Arthur St. Clair Colyar," 193–94; *Nashville Tennessean*, December 14, 1907; Ball, "Public Career," 106–28.

507. Ramsey to Garrett, December 24, 1874, quoted in Heiskell, *Andrew Jackson*, 1:215–16.

508. Ramsey, *Annals of Tennessee*, 713.

509. Wheeler, *Historical Sketches*, 449.

510. *St. Louis Globe-Democrat*, August 22, 1887.

511. *Daily Picayune*, March 29, 1889.

512. Ramsey to Garrett, December 24, 1874, quoted in Heiskell, *Andrew Jackson*, 1:216.

513. *Acts of the State of Tennessee*, 1889, Number 13, 514–15.

514. Heiskell, *Andrew Jackson*, 1:212.

515. *Chattanooga Daily Times*, June 18, 1889; *Knoxville Journal*, June 18, 1889.

516. *Knoxville Journal*, June 18, 1889.

517. Ibid.

518. Ibid.

519. Ibid.

520. Ibid., June 20, 1889.

521. Ibid.

522. Ibid.

523. Ibid.

524. Heiskell, *Andrew Jackson*, 1:221.

525. Ibid., 359–60.

526. Acklen, *Tennessee Records*, 95.

527. Temple, *John Sevier*, 6–7.

528. Ibid., 26–27.

529. *Knoxville Journal*, June 19, 1889.

POSTSCRIPT

530. King, *Western Drama*, 375.

531. "Biographical Note," John Biggs Alderman Papers, Archives of Appalachia, East Tennessee State University, Johnson City, TN.

532. *Erwin Record*, February 21, 1952.

533. Ibid., July 24, 1952.

534. Ibid., February 21, 1952.

535. Ibid., July 17, 1952.

536. Ibid., January 31, 1952.

537. Ibid., August 7, 1952.

538. Ibid., February 21, 1952.

539. Ibid., January 31, 1952.

540. Ibid., July 24, 1952.

541. Ibid., August 7, 1952.

542. Ibid., June 12, 1952.

543. Ibid., January 31, 1952.

544. Alderman, *From Frontier to Plantation*, 60.

545. Cox, "Gatlinburg's *Chucky Jack.*"

546. Barksdale, *Lost State of Franklin*, 186–87.

547. Ibid.

548. Ibid.; *Kermit Hunter's Chucky Jack*, 10.

549. Barksdale, *Lost State of Franklin*, 186–87.

550. Cox, "Gatlinburg's *Chucky Jack.*"

551. Barksdale, *Lost State of Franklin*, 186–87.

552. *Nashville Tennessean Magazine*, January 19, 1958.

553. Ibid.

554. Ibid.

555. Hunter, "Some Aspects," 3.

556. Maples to White, February 29, 1956, State Historian's Office Records, TSLA.

557. Leiper to White, March 2, 1956, ibid.

558. "Letter written by Robert H. White, April 1, 1958," ibid.

559. White to Foster, November 19, 1959, ibid.

560. Maples to White, March 19, 1956, and White to Maples, March 28, 1956, ibid.

561. White to Maples, March 19, 1957, and Maples to Moore, March 22, 1957, ibid.

562. Hunter to White, September 15, 1957, ibid.

563. Ibid.

564. Hunter to White, August 28, 1957, ibid.

565. White to Hodges, November 8, 1957, ibid.

566. Parker to White, November 18, 1957, ibid.

567. Draft Resolution by Robert H. White, December 5, 1957, ibid.

568. "Resolution," December 5, 1957, Box 17, Folder 17, ibid.

569. Hunter, "Some Aspects," 3.

570. Browning to Scott, November 24, 1952, Governor Gordon Browning Papers (Second Term), 1949–52, TSLA.

571. Hunter to Browning, December 12, 1952, State Historian's Office Records, TSLA.

572. Ibid.

573. Ibid.

574. Browning to Wright, December 19, 1952, Governor Gordon Browning Papers (Second Term), 1949–52, TSLA.

575. Cox, "Gatlinburg's *Chucky Jack.*"

576. *Spartanburg Herald-Journal*, September 9, 1951.

577. "A Resolution to designate 'The Wataugans' as the official historical outdoor drama of the state of Tennessee," *Private Acts and Resolutions*, February 8, 2001, 466; *"Liberty!," A! Magazine for the Arts*, July 20, 2009.

AFTERWORD

578. Swainson, *Encarta Book of Quotations*, 241. Oliver Cromwell's instructions to the court painter Peter Lely, as recorded in Horace Walpole's *Anecdotes of Painting in England*, 1763: "I desire you would use all your skill to paint my picture truly like me, and not flatter me at all; but remark all these roughnesses, pimples, warts, and everything as you see me; otherwise I will never pay a farthing for it."

579. Morgan, *Early American Painters*, 74.

580. Driver, *John Sevier*, 105.

581. Ward, *Charles Willson Peale*, 83.

BIBLIOGRAPHY

PRIMARY SOURCES

Annals of Congress. Washington, D.C.: Library of Congress, 1999.

Calendar of the Correspondence of James Madison. Washington, D.C.: Department of State, 1902.

Clark, Walter, ed. *The State Records of North Carolina*. Vol. 22. Raleigh, NC: P.M. Hale, 1886–1907.

David Campbell Papers. Duke University, Durham, NC.

Draper Manuscript Collection. State Historical Society of Wisconsin, Madison, WI. Cited as Draper Manuscripts.

Ford, Worthington C., et al. *Journals of the Continental Congress*, 1774–1875. Washington, D.C.: n.p., 1904–37. Cited as JCC.

James Roberts Gilmore Papers. Special Collections, Milton S. Eisenhower Library, Johns Hopkins University, Baltimore, MD.

J. Fain Anderson Letter, MS 1218. Special Collections Library, University of Tennessee, Knoxville, TN.

John Biggs Alderman Papers. Archives of Appalachia, East Tennessee State University, Johnson City, TN.

John Sevier Collection. Special Collections Library, University of Tennessee, Knoxville, TN.

McRae, Sherwin, et al. *Calendar of Virginia State Papers*. Richmond, VA: n.p., 1875–93.

Papers of Andrew Jackson. University of Tennessee, Knoxville, TN. Cited as PAJ.

Tennessee State Library and Archives, Nashville, TN. Cited as TSLA.

Theodore Roosevelt to John M. Lea, February 25, 1888, cited in "Theodore Roosevelt Declares His Affinity for the West and His Identification with Its Heroes." Shapell Manuscript Foundation, Beverly Hills, CA, available from http://www.shapell.org/manuscript.aspx?theodore-roosevelt-likes-the-wild-west-daniel-boone-davy-crockett-the-frontier.

NEWSPAPERS

Chattanooga Daily Times
Daily Picayune
Erwin Record
Johnston City Chronicle
Knoxville Gazette
Knoxville Journal
Knoxville News-Sentinel
Knoxville Sentinel
Nashville Banner
Nashville Tennessean Magazine
New York Times
Pittsburgh Press
Spartanburg Herald-Journal
St. Louis Globe-Democrat
Tennessean
Tennessee Gazette
Tennessee Gazette and Mero-District Advertiser
Wilson's Knoxville Gazette

SECONDARY SOURCES

Abernethy, Thomas Perkins. *From Frontier to Plantation in Tennessee: A Study in Frontier Democracy*. Chapel Hill: University of North Carolina Press, 1932.

Acklen, Jeannette Tillotson. *Tennessee Records: Tombstone Inscriptions and Manuscripts*. Baltimore, MD: Clearfield Co., 1994.

Acts of the State of Tennessee Passed by the Forty-Sixth General Assembly. Nashville, TN: Marshall & Bruce, Printers to the State, 1889.

"An Act to Incorporate the State Historical Society of Wisconsin." *The Charter and Revised Statutes Relating to the State Historical Society of Wisconsin.* Madison, WI: Democrat Print. Co., 1884.

Alderman, Pat. *The Overmountain Men.* Johnson City, TN: Overmountain Press, 1986. Reprint of 1970 edition.

Allison, John. *Address Delivered by John Allison on "King's Mountain Day, Oct. 7" at the Tennessee Centennial Exhibition in Nashville, May 1 to Oct. 31, 1897.* Nashville, TN: Press of Marshall & Bruce Co., 1897.

———. *Dropped Stitches in Tennessee History.* Nashville, TN: Press of Marshall & Bruce Co., 1897.

Armstrong, Zella. *Notable Southern Families.* Vol. 4, *The Sevier Family.* Spartanburg, SC: Reprint Co., 1974. Reprint of 1926 edition.

Ashe, Samuel A. *History of North Carolina.* Vol. 2, *1783–1925.* Raleigh, NC: Edwards & Broughton Printing Company, 1925.

Ball, Clyde. "The Public Career of Col. A.S. Colyar, 1870–1877." *Tennessee Historical Quarterly* 12 (1953).

Bancroft, George. *A History of the United States: From the Discovery of the American Continent.* Boston: Little, Brown, 1834–75.

Barksdale, Kevin T. *The Lost State of Franklin: America's First Secession.* Lexington: University Press of Kentucky, 2009.

Bassett, John Spencer. *Life of Andrew Jackson.* Vol. 1. Garden City, NY: Doubleday, Page, 1911.

"Battle of King's Mountain." *American Pioneer* (February 1843).

Bergeron, Paul H., Stephen V. Ash and Jeanette Keith. *Tennesseans and Their History.* Knoxville: University of Tennessee Press, 1999.

Blackmon, Richard. *Dark and Bloody Ground: The American Revolution along the Southern Frontier.* Yardley, PA: Westholme, 2012.

Bond, Octavia Zollicoffer. *Old Tales Retold; or, Perils and Adventures of Tennessee Pioneers.* Nashville, TN: Smith & Lamar, 1906.

Brands, H.W. *Andrew Jackson: His Life and Times.* New York: Doubleday, 2005.

Brown, John Howard, ed. *Lamb's Biographical Dictionary of the United States.* Vol. 7. Boston: James H. Lamb Company, 1900–03.

Brown, John P. *Old Frontiers: The Story of the Cherokee Indians from Earliest Times to the Date of Their Removal to the West, 1838.* Kingsport, TN: Southern Publishers, 1938.

Caldwell, Mary F. *Tennessee: The Dangerous Example, Watauga to 1849.* Nashville, TN: Aurora Pub., Inc., 1974.

Caruso, John Anthony. *The Appalachian Frontier: America's First Surge Westward.* Indianapolis, IN: Bobbs-Merrill, 1959.

Chandler, Helen Deane. *A Brief Description of the Battle of King's Mountain.* Gastonia, NC: Publicity Committee of the Sesquicentennial Committee, 1930.

Clayton, W.W. *History of Davidson County, Tennessee.* Philadelphia: J.W. Lewis & Co., 1880.

Colyar, A.S. *Life and Times of Andrew Jackson.* Nashville, TN: Press of Marshall & Bruce Co., 1904.

Compton, Brian Patrick. "Revised History of Fort Watauga." Master's thesis, East Tennessee State University, 2005.

Corbitt, D.C., and Roberta Corbitt. "Papers from the Spanish Archives Relating to Tennessee and the Old Southwest," *East Tennessee Historical Society's Publications* 9–18 (1937–46).

Corlew, Robert Ewing. *Tennessee: A Short History.* Knoxville: University of Tennessee Press, 1981.

Cox, Bob. "Darling Jones' 'Sweetlips' Turned the Tide of the American Revolution." *Bob Cox's Yesteryear,* April 29, 2013, available from http://bcyesteryear.com/node/626.

———. "Gatlinburg's *Chucky Jack* Was Short-Lived Drama about John Sevier." *Box Cox's Yesteryear,* July 5, 2010, available from http://bcyesteryear.com/node/156.

Cox, Brent Alan. *Heart of the Eagle: Dragging Canoe and the Emergence of the Chickamauga Confederacy.* Milan, TN: Chenanee Publishers, 1999.

Dameron, J. David. *King's Mountain: The Defeat of the Loyalists, October 7, 1780.* Cambridge, MA: Da Capo Press, 2003.

Davis, Louise Littleton. *More Tales of Tennessee.* Gretna, LA: Pelican Pub. Co., 1983. Reprint of 1978 edition.

Dean, Nadia. *A Demand of Blood: The Cherokee War of 1776.* Cherokee, NC: Valley River Press, 2012.

DeWitt, John H. "The Journal of Governor John Sevier." *Tennessee Historical Magazine* 6, no. 1 (April 1920).

Dixon, Max. *The Wataugans.* Nashville: Tennessee American Revolution Bicentennial Commission, 1976.

Draper, Lyman Copeland. *King's Mountain and Its Heroes.* Cincinnati, OH: P.G. Thomson, 1881.

Driver, Carl Samuel. *John Sevier: Pioneer of the Old Southwest.* Chapel Hill: University of North Carolina Press, 1932.

Dunkerly, Robert. *The Battle of Kings Mountain: Eyewitness Accounts.* Charleston, SC: The History Press, 2012.

Dykeman, Wilma. *Tennessee: A History*. New York: Norton; Nashville, TN: American Association for State and Local History, 1984.

———. *With Fire and Sword: The Battle of Kings Mountain*. Washington, D.C.: National Park Service, U.S. Department of the Interior; for sale by superintendent of documents, U.S. Government Printing Office, 1978.

East Tennessee: Historical and Biographical. Chattanooga, TN: A.D. Smith & Co., 1893.

Ellet, Elizabeth Fries. *Pioneer Women of the West*. New York: C. Scribner, 1852.

Etcheson, Nicole. *Bleeding Kansas: Contested Liberty in the Civil War Era*. Lawrence: University Press of Kansas, 2004.

Eubanks, David L. "Dr. J.G.M. Ramsey of East Tennessee: A Career of Public Service." PhD diss., University of Tennessee, 1965.

Evans, E. Raymond. "Was the Last Battle of the American Revolution Fought on Lookout Mountain?" *Journal of Cherokee Studies* 5, no. 1 (Spring 1980).

Ewing, James. *A Treasury of Tennessee Tales*. Nashville, TN: Rutledge Hill Press, 1985.

Faris, John T. *Nolichucky Jack*. Philadelphia: J.B. Lippincott Company, 1927.

Folmsbee, Stanley J., Robert E. Corlew and Enoch L. Mitchell. *History of Tennessee*. Vols. 1–4. New York: Lewis Historical Pub Co., 1960.

Foster, Dave. *Franklin: The Stillborn State and the Sevier/Tipton Political Feud*. Pigeon Forge, TN: Top Ten Press, 1994.

Gerson, Noel B. *Franklin: America's Lost State*. New York: Crowell-Collier Press, 1968.

Gilmore, James Roberts. *The Advance-Guard of Western Civilization*. Spartanburg, SC: Reprint Co., 1974. Reprint of 1888 edition.

———. *John Sevier as a Commonwealth-Builder*. New York: D. Appleton & Co., 1894.

———. *The Rear-Guard of the Revolution*. New York: D. Appleton & Co., 1886.

Green, Claud B. *John Trotwood Moore: Tennessee Man of Letters*. Athens: University of Georgia Press, 1957.

Grenier, John. *The First Way of War: American War Making on the Frontier, 1607–1814*. Cambridge, UK: Cambridge University Press, 2005.

Guy, Joe D. *The Hidden History of East Tennessee*. Charleston, SC: The History Press, 2008.

Hale, Will T., and Dixon L. Merritt. *A History of Tennessee and Tennesseans*. Chicago: Lewis Pub. Company, 1913.

Hall, Reid, and Jack F. Westmoreland. *Battle of King's Mountain, October 7, 1780*. Richburg, SC: Chester County Genealogical Society, 1980.

Hamer, Philip M. *Tennessee: A History, 1673–1932*. New York: American Historical Society, Inc., 1933.

Haywood, John. *The Civil and Political History of the State of Tennessee from Its Earliest Settlement Up to the Year 1796.* New York: Arno Press, 1971. Reprint of 1823 edition.

Heiskell, Samuel Gordon. *Andrew Jackson and Early Tennessee History.* 3 vols. Nashville, TN: Ambrose Print. Co., 1918–21.

Henderson, William A. *"Nolachucky Jack" (Gov. John Sevier.), Lecture of Wm. A. Henderson, to the Board of Trade of the City of Knoxville, January 7th, 1873.* Knoxville, TN: Printed at the Press and Herald steam book and job office, 1873.

———. "The Spanish Conspiracy in Tennessee." *Tennessee Historical Magazine* 3, no. 4 (1917).

Hesseltine, William Best. *Dr. J.G.M. Ramsey: Autobiography and Letters.* Knoxville: University of Tennessee Press, 2002.

———. "Lyman Draper and the South" *Journal of Southern History* 19, no. 1 (February 1953).

———. *Pioneer's Mission: The Story of Lyman Copeland Draper.* Madison: State Historical Society of Wisconsin, 1954.

Hildreth, Richard. *The History of the United States of America.* 6 vols. New York: Harper & Bros., 1848–1852.

Hoover, Herbert. "Address on the 150th Anniversary of the Battle of Kings Mountain," October 7, 1930. Online by Gerhard Peters and John T. Woolley, American Presidency Project. www.presidency.ucsb.edu/ws/?pid=22379.

Hsiung, David C., ed. *A Mountaineer in Motion: The Memoir of Dr. Abraham Jobe, 1817–1906.* Knoxville: University of Tennessee Press, 2009.

Hubta, James K. "Tennessee and the American Revolutionary Bicentennial." *Tennessee Historical Quarterly* 31, no. 4 (Winter 1972).

Hunter, Kermit. "Some Aspects of Outdoor Historical Drama, with Special Reference to *Unto These Hills.* Adapted from an Address at the Annual Banquet of the East Tennessee Historical Society in Knoxville, October 10, 1953." *East Tennessee Historical Society Publications,* no. 26 (1954).

Hyde, Jennie Prather. "Sarah Hawkins: The Forgotten Heroine." Biographical Data Collection, TSLA, 1934.

James Roberts Gilmore Collection, Ms.37. Special Collections, Milton S. Eisenhower Library, Johns Hopkins University, Baltimore, MD, available from http://ead.library.jhu.edu/ms037.xml.

"James Roberts Gilmore," *Virtual American Biographies.* Edited by Appletons Encyclopedia, available from virtualology.com/apjamesrobertsgilmore.

Journal of the House of Representatives at the First Session of the Eleventh General Assembly of the State of Tennessee. Nashville, TN: M&J Norvell, 1815.

Journal of the Senate at the First Session of the Eighth General Assembly of the State of Tennessee. Knoxville, TN: Printed by George Wilson, Printer to the State, 1809.

Journal of the Senate at the First Session of the Eleventh General Assembly of the State of Tennessee. Nashville, TN: M&J Norvell, 1815.

Justi, Herman, ed. *Official History of the Tennessee Centennial Exposition.* Nashville, TN: Press of the Brandon Printing Company, 1898.

Kammen, Michael G. *The Mystic Chords of Memory: The Transformation of Tradition in American Culture.* New York: Vintage Books, 1993.

Keefer, Jane. *Folk Music: An Index to Recorded and Print Resources.* Ibiblio, 1996–2013, available from www.ibiblio.org/folkindex.

Kermit Hunter's Chucky Jack: The Story of Tennessee. Gatlinburg, TN: Great Smoky Mountains Historical Association, 1956.

King, Kimball. *Western Drama Through the Ages: A Student Reference Guide.* Westport, CT: Greenwood Press, 2007.

King's Mountain Centennial Association. *Battle at King's Mountain October 7, 1780. Proposed Centennial Celebration October 7, 1880.* Yorkville, SC: Printed at the Office of the Enquirer, 1880.

"Kings Mountain Centennial Monument, Kings Mountain National Military Park, Blacksburg (SC)." *Commemorative Landscapes of North Carolina.* Documenting the American South, University of North Carolina, available from docsouth.unc.edu/commland/monument/361.

Klebenow, Anne. *200 Years Through 200 Stories: A Tennessee Bicentennial Collection.* Knoxville: University of Tennessee, 1996.

Lawrimore, Erin R. "'Let Us Hasten to Redeem the Time That Is Lost': J.G.M. Ramsey's Role in the Collection and Promotion of Tennessee History." *Libraries & the Cultural Record* 41, no. 4 (Fall 2006).

"*Liberty!* Named Tennessee's State Outdoor Drama." *A! Magazine for the Arts,* July 20, 2009.

Lynch, Michael. "Creating Regional Heroes: Traditional Interpretations of the Battle of King's Mountain." *Tennessee Historical Quarterly* 68, no. 3 (Fall 2009).

Malone, Henry Thompson. *Cherokees of the Old South: A People in Transition.* Athens: University of Georgia Press, 1956.

Mearns, David C. "Review of *Pioneer's Mission: The Story of Lyman Copeland Draper* by William B. Hesseltine." *William and Mary Quarterly* 11, no. 3 (July 1954).

Miller, E.E. "These United States—XII. Tennessee: Three-Quarters of Bewilderment." *Nation* 115 (September 20, 1922).

Moore, John Trotwood. *The Draper Manuscripts as Relating to Tennessee.* Nashville, TN: n.p., 1919.

————. "The Ride of the Rebel." *Blair Magazine* 1, no. 4 (May 1, 1927). Previously published in *Taylor-Trotwood Magazine* (August 1907).

Morgan, John Hill. *Early American Painters: Illustrated by Examples in the Collection of the New-York Historical Society*. New York: New-York Historical Society, 1921.

Morison, Elting E. *The Letters of Theodore Roosevelt*. Vol. 1. Cambridge, MA: Harvard University Press, 1951.

Morris, Edmund. *Colonel Roosevelt*. New York: Random House, 2010.

————. *The Rise of Theodore Roosevelt*. New York: Coward, McCann & Geoghegan, 1979.

Nelson, Selden. "The Tipton Family of Tennessee," *East Tennessee Historical Society's Publications* 1 (1929).

Nichols, Alice. *Bleeding Kansas*. New York: Oxford University Press, 1954.

Parker, Russell Dean. "Historical Interpretations of the Spanish Intrigue in Tennessee: A Study." *East Tennessee Historical Society's Publications* 58–59 (1986–87).

Pershing, M.W. *Life of General John Tipton and Early Indiana History*. Tipton, IN: Tipton Literary and Suffrage Club, 1909.

Phelan, James. *History of Tennessee: The Making of a State*. Boston and New York: Houghton, Mifflin and Company, 1888.

Powell, William Stevens, ed. *Dictionary of North Carolina Biography*. Vol. 3. Chapel Hill: University of North Carolina Press, 1979–1996.

Preston, John S. *Celebration of the Battle of King's Mountain, October 1855*. Yorkville, SC: Miller & Melton, 1855.

Private Acts and Resolutions of the State of Tennessee. Nashville, TN: Department of State, 2001.

Purcell, Sarah J. *Sealed with Blood: War, Sacrifice and Memory in Revolutionary America*. Philadelphia: University of Pennsylvania Press, 2002.

Putnam, Albigence Waldo. *History of Middle Tennessee; or, Life and Times of Gen. James Robertson*. Nashville, TN: Printed for the author, 1859.

Quarles, Robert Thomas, Jr. *State of Franklin*. N.p., 1917.

Ramsey, J.G.M. *The Annals of Tennessee to the End of the Eighteenth Century*. Charleston, SC: J. Russell, 1853.

Remini, Robert V. *Andrew Jackson*. Vol. 1, *The Course of American Empire, 1767–1821*. New York: History Book Club, 1998. Reprint of 1977 edition.

Roosevelt, Theodore. *The Winning of the West*. 6 vols. New York: Current Literature Publishing Company, 1905.

"Sarah Hawkins Sevier Memorial Day." *Tennessee Historical Quarterly* 5, no. 4 (December 1946): 364–68.

Sevier, Cora Bales, and Nancy Sawyer Sevier Madden. *Sevier Family History, with Collected Letters of Gen. John Sevier, First Governor of Tennessee, and 28 Collateral Family Lineages.* Washington, D.C.: n.p., 1961.

"SEVIER, John," *Biographical Directory of the United States Congress, 1774–Present.* Washington, D.C.: U.S. Government Printing Office, 1950.

Silvey, Anita. *Children's Books and Their Creators.* Boston: Houghton Mifflin, 1995.

Steele, William O. *John Sevier: Pioneer Boy.* Indianapolis, IN: Bobbs-Merrill, 1953.

Swainson, Bill, ed. *The Encarta Book of Quotations.* New York: St. Martin's Press, 2000.

Temple, Oliver Perry. *John Sevier: Citizen, Soldier, Legislator, Governor, Statesman.* Knoxville, TN: Zi-Po Press, 1910.

———. *Notable Men of Tennessee.* New York: Cosmopolitan Press, 1912.

Tennessee Blue Book 2011–2012. Nashville, TN: Secretary of State, 2012.

Thornton, Russell. *The Cherokees: A Population History.* Lincoln: University of Nebraska Press, 1990.

Thwaites, Reuben Gold. *Lyman Copeland Draper: A Memoir.* Vol. 1. Madison: Annual Report and Collections of the State Historical Society of Wisconsin, 1854.

Toomey, Michael. "State of Franklin." *North Carolina History Project*, available from www.northcarolinahistory.org/commentary/99/entry.

Turner, Francis Marion. *Life of General John Sevier.* New York: Neale Pub. Co., 1910.

Ward, David C. *Charles Willson Peale: Art and Selfhood in the Early Republic.* Berkeley: University of California Press, 2004.

Washington County Historical Association. *History of Washington County, Tennessee.* Edited by Joyce Cox and W. Eugene Cox. Johnson City, TN: Overmountain Press, 2001.

West, Carroll Van, ed. *Tennessee Encyclopedia of History and Culture.* Nashville: Tennessee Historical Society, Rutledge Hill Press, 1998.

Wheeler, John H. *Historical Sketches of North Carolina from 1584 to 1851.* Baltimore, MD: Regional Pub. Co., 1964.

Whitaker, A.P. "Spanish Intrigue in the Old Southwest: An Episode, 1788–89." *Mississippi Valley Historical Review* 12, no. 2 (September 1925).

White, Katherine Keogh. *The King's Mountain Men: The Story of the Battle, with Sketches of the American Soldiers Who Took Part.* Baltimore, MD: Genealogical Pub. Co., 1966.

Wilkie, Katharine Elliott. *John Sevier: Son of Tennessee.* New York: Messner, 1958.

Williams, Samuel Cole. *Dawn of Tennessee Valley and Tennessee History.* Johnson City, TN: Watauga Press, 1937.

————. *Early Travels in the Tennessee Country, 1540–1800.* Nashville, TN: Franklin Book Reprints, 1970. Reprint of 1928 edition.

————. *History of the Lost State of Franklin.* New York: Press of the Pioneers, 1933.

————. *Tennessee During the Revolutionary War.* Knoxville: University of Tennessee Press, 1974. Reprint of 1944 edition.

Willis, Mrs. Thomas William. *History of the Tennessee Society Daughters of the American Revolution, 1892–1900.* Knoxville: Tennessee DAR, 1991.

Wills, David. *In Memoriam: Memorial Discourse Delivered on the Occasion of the Erection of a Monument to the Memory of Rev. Samuel W. Doak, D.D., at Greenville, Tenn., February 27, 1873.* Atlanta, GA: Constitution Book and Job Printing, 1873.

INDEX

ABOUT THE AUTHORS

Gordon T. Belt is an information professional, archives advocate, public historian and founding editor of The Posterity Project, an award-winning blog devoted to archives and history in Tennessee. Gordon holds a master's degree in history from Middle Tennessee State University and a bachelor's degree in political science from the University of Tennessee–Chattanooga. He is the director of Public Services for the Tennessee State Library and Archives. He previously worked as the library manager for the First Amendment Center, a nonpartisan think tank based in Nashville, Tennessee, and Washington, D.C. Gordon is a past president of the Society of Tennessee Archivists and holds memberships in the Society of American Archivists, National Council on Public History and the Tennessee Historical Society.

Traci Nichols-Belt is the author of *Onward Southern Soldiers: Religion and the Army of Tennessee in the Civil War*, published by The History Press. She is an ordained and licensed minister and holds a master's degree in history from Middle Tennessee State University and a bachelor's degree in political science from Anderson University. Traci is a public speaker whose principal research interest is the Civil War. She has appeared on radio and television to

talk about the role of religion in the Civil War, including the 2012 Nashville Public Television documentary, *Crisis of Faith*, part of NPT's *Tennessee Civil War 150* series, a multipart project coinciding with the sesquicentennial anniversary of the Civil War. Her published works have appeared in the *New York Times* and the *Tennessee Historical Quarterly*.